NadarWarhol:ParisNewYork

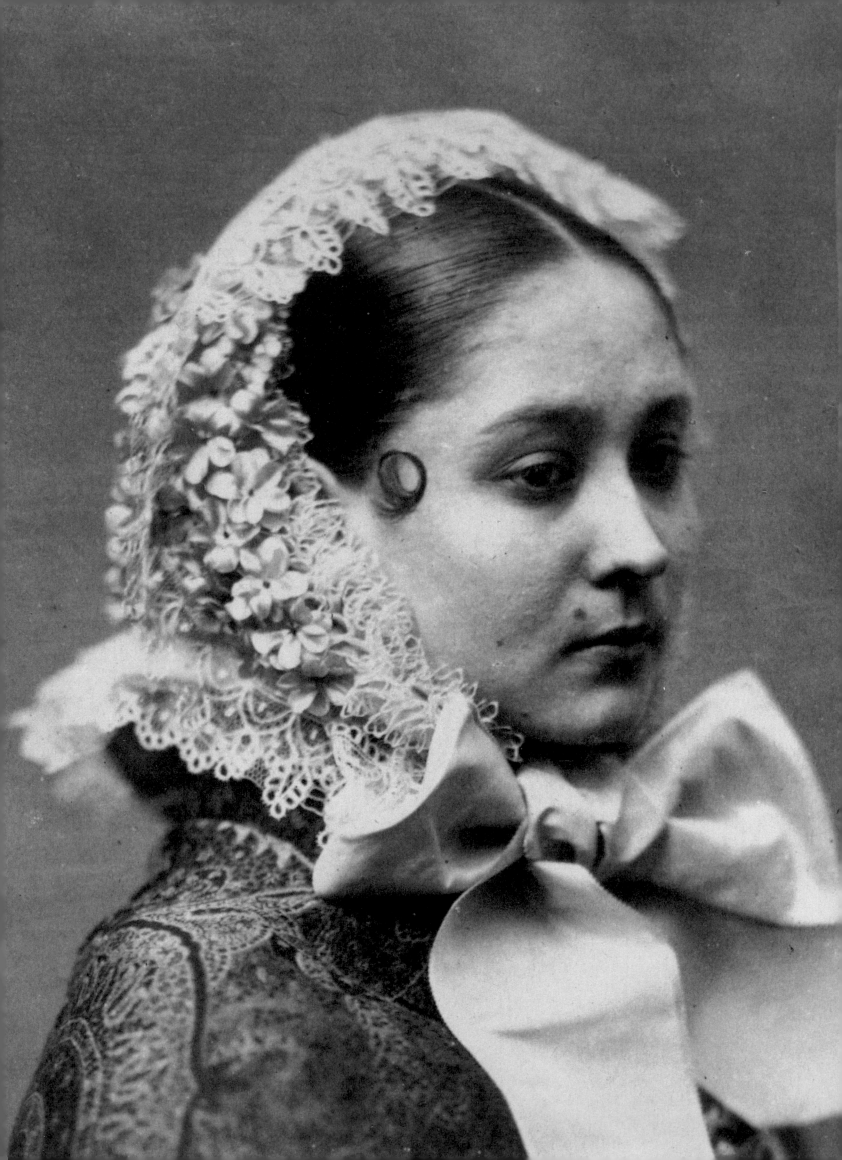

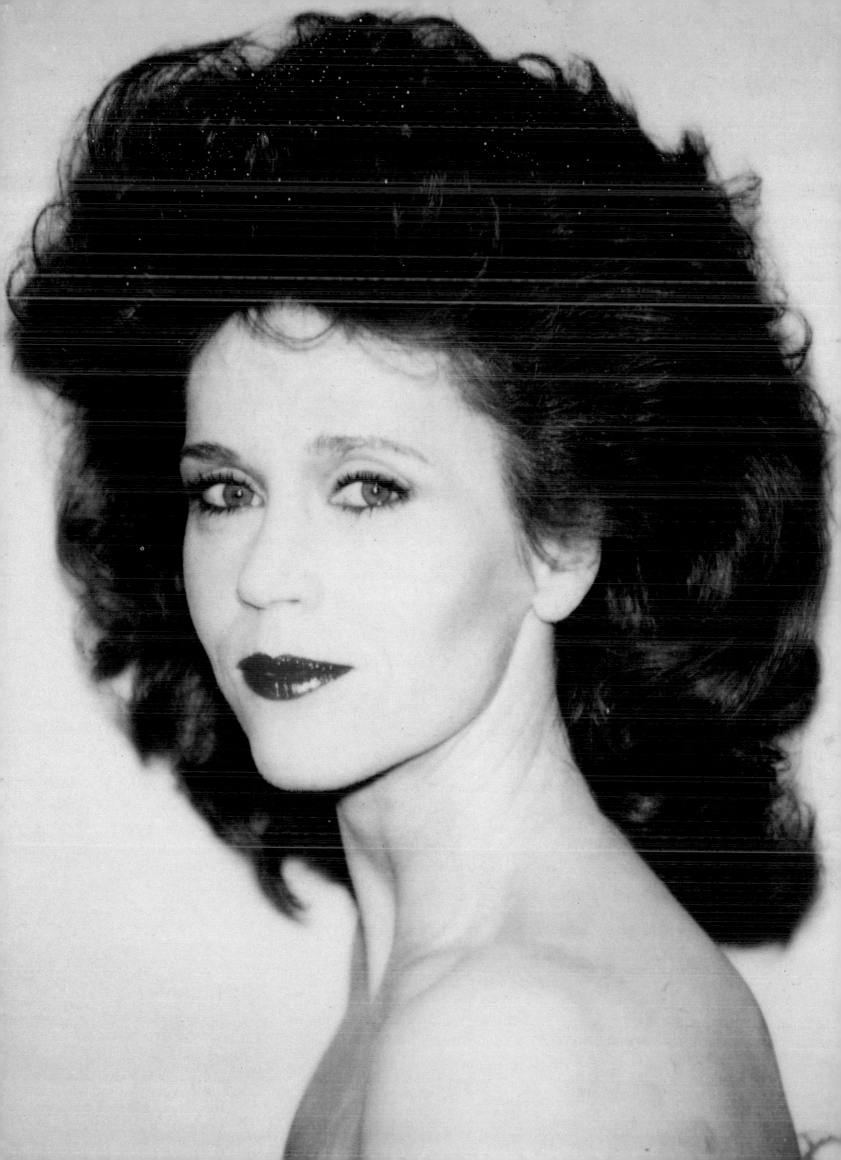

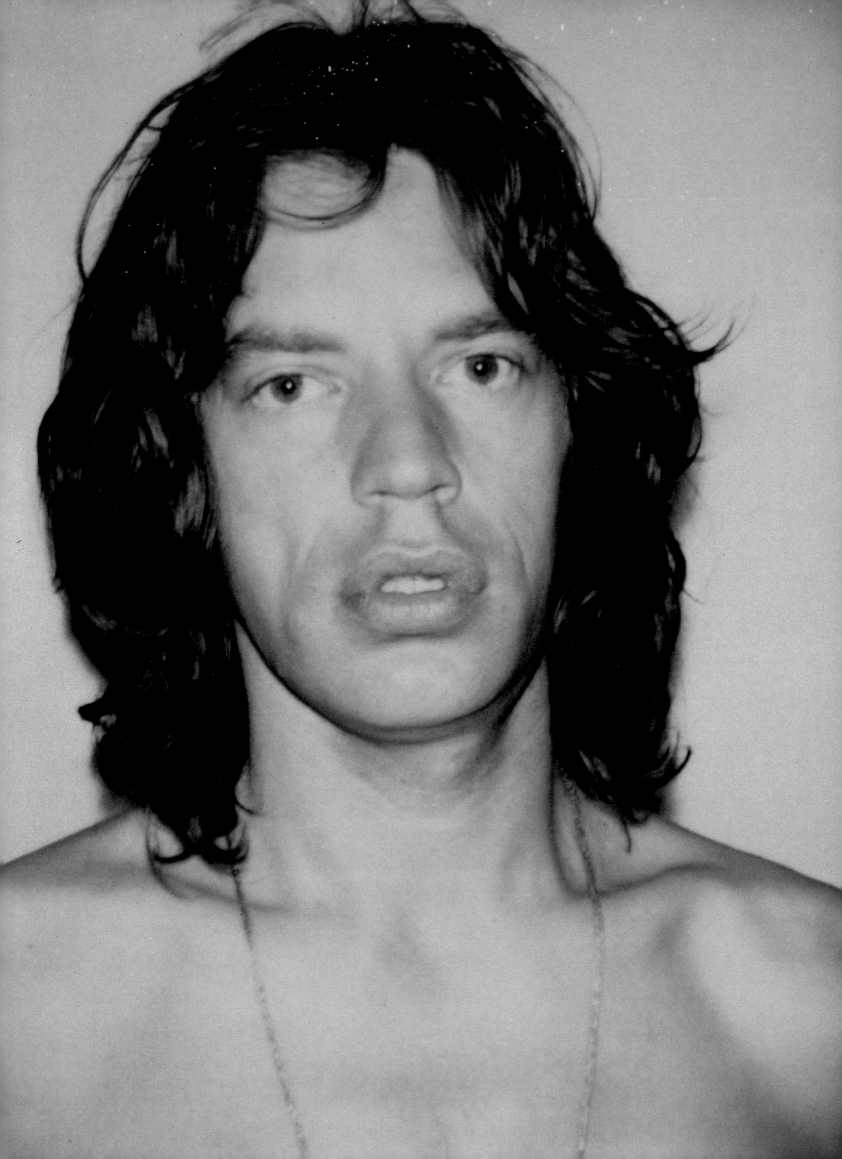

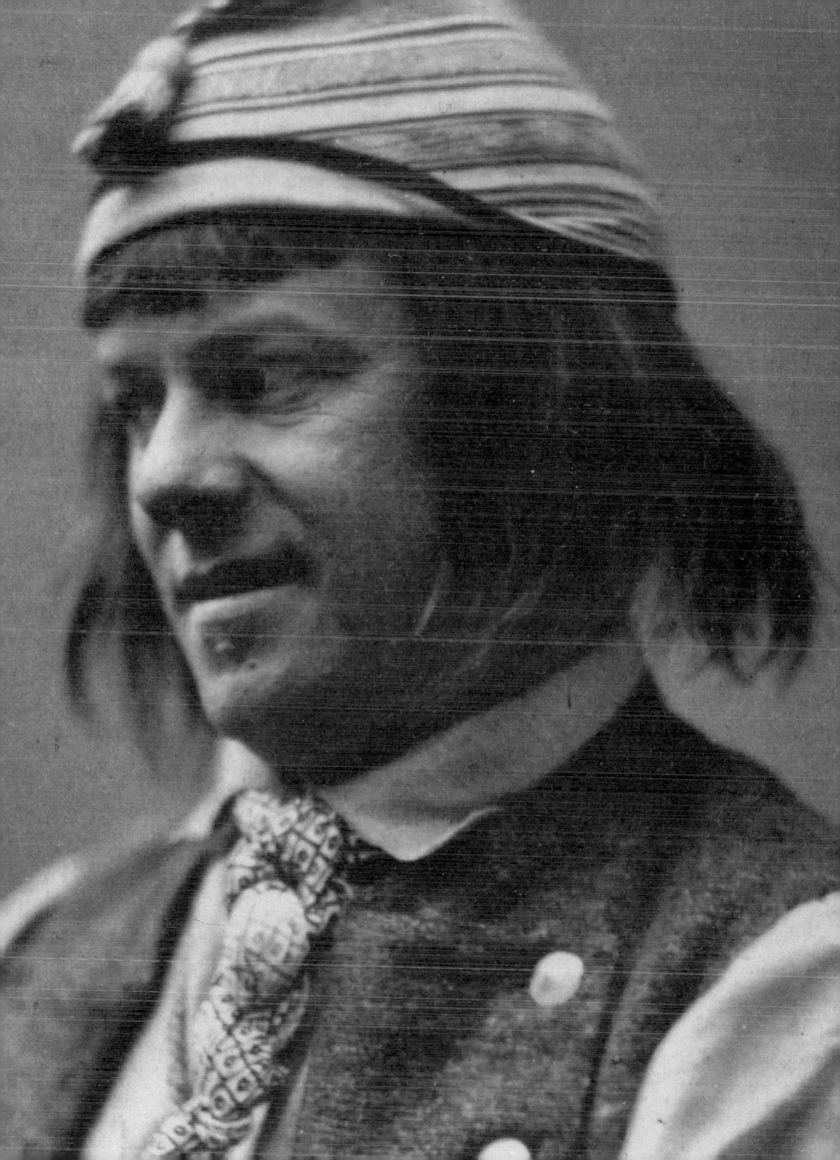

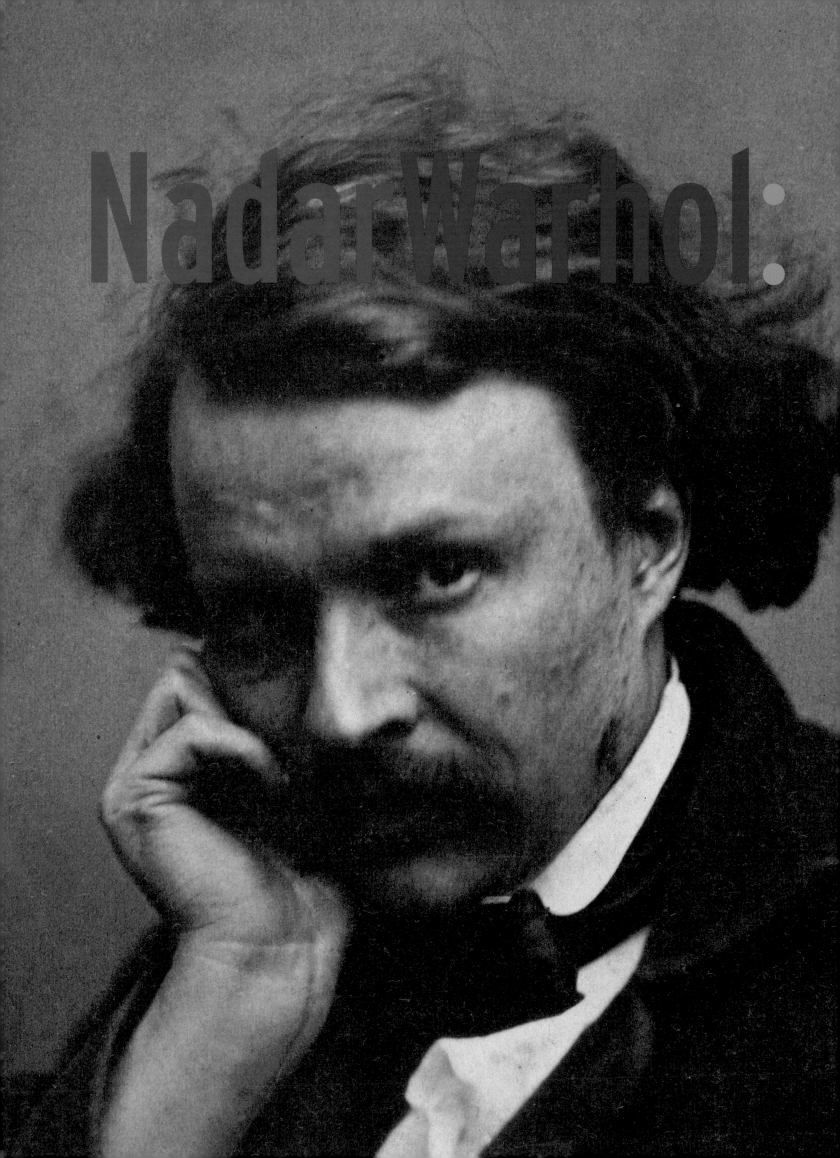

Nadar/Warhol:

ParisNewYork
PHOTOGRAPHY AND FAME

GORDON BALDWIN AND JUDITH KELLER THE J. PAUL GETTY MUSEUM | LOS ANGELES

For Sam Wagstaff, through whom photographs by

both Warhol and Nadar entered the Getty collection in 1984,

and for André Jammes, who saved for posterity

an essential trove of work by Nadar.

VENUES AND DATES OF THE EXHIBITION

NadarWarhol:ParisNewYork

THE J. PAUL GETTY MUSEUM
July 20–October 10, 1999

THE ANDY WARHOL MUSEUM
November 6, 1999–January 30, 2000

THE BALTIMORE MUSEUM OF ART
March 12–May 28, 2000

LENDERS TO THE EXHIBITION

The Andy Warhol Foundation for the
　Visual Arts, New York
The Andy Warhol Museum, Pittsburgh
The Bibliothèque Nationale de France, Paris
The Gilman Paper Company Collection,
　New York
The J. Paul Getty Museum, Los Angeles
The Musée d'Orsay, Paris

© 1999 The J. Paul Getty Museum
1200 Getty Center Drive, Suite 1000
Los Angeles, CA 90049-1687

www.getty.edu/publications

Library of Congress Cataloging-in-Publication Data

Baldwin, Gordon.
　Nadar—Warhol, Paris—New York : photography and
fame / Gordon Baldwin and Judith Keller.
　　p.　cm.
　The J. Paul Getty Museum, July 20–Oct. 10, 1999: the Andy
Warhol Museum, Nov. 6, 1999–Jan. 30, 2000; the Baltimore
Museum of Art, March 12–May 28, 2000.
　　Includes index.
　　ISBN 0-89236-560-9 (cloth). — ISBN 0-89236-565-x (paper)
　　1. Portrait photography—France Exhibitions. 2. Portrait
photography—United States Exhibitions. 3. Nadar, Félix,
1820–1910 Exhibitions. 4. Warhol, Andy, 1928–　．
Exhibitions. 5. Celebrities—France Portraits Exhibitions.
6. Celebrities—United States Portraits Exhibitions.
I. Nadar, Félix, 1820–1910. II. Warhol, Andy, 1928–　．
III. Keller, Judith. IV. J. Paul Getty Museum. V. Andy
Warhol Museum. VI. Baltimore Museum of Art. VII. Title.
TR681.F3B3114　1999
779′.2′07473—dc21　　　　　　　　　　99-21007
　　　　　　　　　　　　　　　　　　　　　　　　　　CIP

Contents

Foreword

The exhibition this catalogue accompanies is devoted to the photographic portraiture of two artists, the nineteenth-century Parisian Nadar and the twentieth-century New Yorker Andy Warhol. In celebrating their individual achievements, the exhibition and the essays in this volume also illuminate the role of the visual artist in the conscious creation of celebrity and the changing nature of fame.

The curators and I are grateful to the lenders to the exhibition: the Bibliothèque Nationale, Paris, the Musée d'Orsay, Paris, the Gilman Paper Company Collection, New York, the Andy Warhol Foundation for the Visual Arts, New York, and The Andy Warhol Museum, Pittsburgh. Without their participation this exhibition would not have been possible.

I add my appreciation to those contributors listed in the acknowledgments along with special thanks to Judith Keller and Gordon Baldwin, Associate Curators in the Department of Photographs, for organizing this unique exhibition and for writing the two major parts of this book, and to Richard Brilliant, the Anna S. Garbedian Professor in the Humanities at Columbia University in the City of New York, for his eloquent introduction.

DEBORAH GRIBBON
Deputy Director and Chief Curator

Preface and Acknowledgments

As men and portrait photographers, Nadar (Gaspard Félix Tournachon, 1820–1910) and Andy Warhol (Andrew Warhola, 1928–1987) have more in common than might be supposed, particularly as adroit manipulators of the media of their day in simultaneously promoting their own reputations and those of their subjects. Any sitter for a portrait by either photographer entered a charmed circle of recognized personalities. Both men emerged from the Bohemias of their day to become photographers after following earlier artistic pursuits; Nadar as a writer and caricaturist, Warhol as a commercial graphic artist, then painter and filmmaker. Where Nadar's multitude of newspaper caricatures and his lithographic *Panthéon* prefigured the photographic roster he later produced, Warhol's magazine, *Interview*, and his films, confirmed and furthered the careers of his sitters. Nadar's subjects, many of whom had substantial intellectual or artistic accomplishments, were drawn directly from an augmented roster of his friends. Warhol's sitters, save for his early patrons and the subjects of his first movies, the so-called Superstars, were more ready-made celebrities, with whom, however, he socialized. Both men befriended and photographed some of the most outspoken figures of their day, such as Alexandre Dumas and Truman Capote, George Sand and Jane Fonda.

Both Nadar and Warhol were important media figures, although, of course, the media changed profoundly and grew exponentially in the period between 1855 and 1965. Nadar would have found incomprehensible Warhol's idea that in the future everyone would have his or her fifteen minutes of fame. Each, however, was the most important visual artist of his century to consciously seek to create and consecrate celebrity, and both were part of the long tradition of fame and the visual arts that is outlined in Richard Brilliant's introductory essay.

Further parallels between Nadar and Warhol lie in the oddities of their respective appearances, their penchants for self-portraiture, their roles as hosts to the cultural heroes of their ages, and the prosperity they achieved with acceptance by the establishments they sought to provoke. Both had pasty-faced complexions and eccentric hair—unruly and flaming red in Nadar's case, artificially platinum in Warhol's. Nadar's studio on the boulevard des Capucines and Warhol's 47th-Street "Factory" were famous rendezvous for the culturally adventurous. Both were interested in multiple images, whether the instantaneously generated photobooth portraits of Warhol's time or the more slowly produced cartes-de-visite of Nadar's.

While we can become equally familiar with their faces as both men shared a penchant for self-portraiture, our knowledge of their lives and work varies considerably. The sources are profuse for Warhol, one of the most written-about figures of the twentieth century and as much a media figure as anyone he portrayed, but rather more spare for Nadar, save for his own prolific writings. Where Warhol was reticent in speech, Nadar was voluble. The catalogue entries that follow necessarily reflect the different types of source materials available for the two artists and for their sitters, as well as their different personalities and times.

WESTON NAEF, CURATOR OF PHOTOGRAPHS, enthusiastically encouraged the idea of an exhibition devoted to the unexpected pairing of Nadar and Warhol when it was first proposed and supported every phase of its planning, including the acquisition of additional Warhol photographs for the Getty Museum collection. In the Department of Photographs, Michael Hargraves is also owed special thanks for providing help with biographical research on Nadar and Warhol's sitters, creating the index, and assisting with many logistical details of the book's production. Julian Cox worked with photographers Ellen Rosenbery and Charles Passela of the Photo Services Department to insure the highest quality of reproductions, aided by photographic technician Rebecca Vera-Martinez. Mikka Gee took care of important miscellaneous details in an expedient manner. With her usual aplomb, Quincy Houghton, Exhibitions Manager, handled the considerable details of arranging for the exhibition to travel to Pittsburgh and Baltimore.

Marc Harnly, Ernest Mack, and Art Domantay of the Paper Conservation Department prepared our photographs by Nadar and Warhol for installation in the exhibition and reproduction in the catalogue. Cory Gooch, assistant registrar, arranged for loans from New York, Pittsburgh, and Paris and saw to their safe arrival in Los Angeles. As always, the staff of the Getty Research Institute Library was of immeasurable help and its collection an indispensable resource.

Sylvie Aubenas of the Bibliothèque Nationale deftly delved through the Nadar holdings there in search of surprising images that might parallel works by Warhol and rapidly responded to further written inquiries. Françoise Heilbrun at the Musée d'Orsay kindly opened her files about Nadar and talked amusingly and, of course, knowledgeably about the photographer. At the Musée Carnavalet, Françoise Reynaud generously shared her knowledge about Nadar and made available for study the work by Nadar in that collection. Pierre Apraxine of the Gilman Paper Company Collection readily responded to the idea for the exhibition and amiably agreed to loan work from that collection. Michel and Michèle Auer hospitably permitted examination of work in their collection. Dale Gluckman of the Los Angeles County Museum of Art was very helpful in identifying fine points of nineteenth-century costume. Both William Peterson and Colin Eisler offered insightful suggestions about how the Nadar texts might be bettered. Avis Berman astutely correlated the name of one of Nadar's sitters with that of a mistress of Whistler's.

In granting access to their expertly organized files, answering a myriad of research questions, and making essential loans, The Andy Warhol Foundation for the Visual Arts, New York, has been an invaluable resource. Timothy Hunt and Sally King-Nero were loyal long-distance colleagues, gracious New York hosts, and helpful manuscript advisers. Vincent Fremont passed on experiences and Neil Printz shared information from his own years of research. Beth Savage coordinated our special presentation requests and Claudia De Fendi assisted in negotiating the

final loan arrangements. At the Andy Warhol Museum, Pittsburgh, Tom Sokolowski, Mark Francis, Margery King, Lisa Miriello, and Sheryl Bryant should be thanked for their help in planning for this exhibition. Mr. Francis was an eager advocate for the project early on and Ms. Miriello patiently responded to our many calls about catalogue details. John Smith and Matthew Wrbican in The Archives of the Andy Warhol Museum were always ready to answer questions about Warhol's photography and his "time capsules."

Gerard Malanga spent a chilly December morning talking about creating paintings and photographs with Warhol in the 1960s. He and Manfred Heiting, who was Warhol's contact at Polaroid in the 1970s, both provided useful insights into his evolving interest in photography. Robert Sobieszek of the Los Angeles County Museum of Art kindly made available his manuscript for an upcoming book on the subject of camera portraiture. Laura Muir of The Metropolitan Museum of Art provided information about Warhol material in that collection. Thanks to Frederick Voss of the Smithsonian Institution's National Portrait Gallery, for discussing Warhol's commissions and sending on documentation from his files. Conversations with astute observers of popular culture, such as John Harris of the museum's Publications Department and Ken Breisch, were a continual source of inspiration, as were conversations with those who first appreciated Warhol's photographic efforts, such as Daniel Wolf and Peter MacGill. The 1992 Pace/MacGill Gallery show *Andy Warhol Polaroids 1971–1986* and Andy Grundberg's essay for that catalogue were part of the stimulus for thinking about Nadar's *Panthéon* alongside Warhol's.

Mollie Holtman, the book's editor, patiently shaped its particular parts and varied writing styles into a whole. Her talents for project management were bolstered by editorial assistance from Tobi Kaplan and Paul Mooradian and photographic research by Cecily Gardner. Pamela Patrusky Mass quickly understood the artistic and cultural parallels we intended and produced an insightful design that, in the graphic tradition of Nadar and Warhol, reveals as much as our words. Everyone's work was gathered, printed, and bound under the ever-diligent eye of production master Stacy Miyagawa.

GORDON BALDWIN

JUDITH KELLER

Associate Curators of Photographs

13

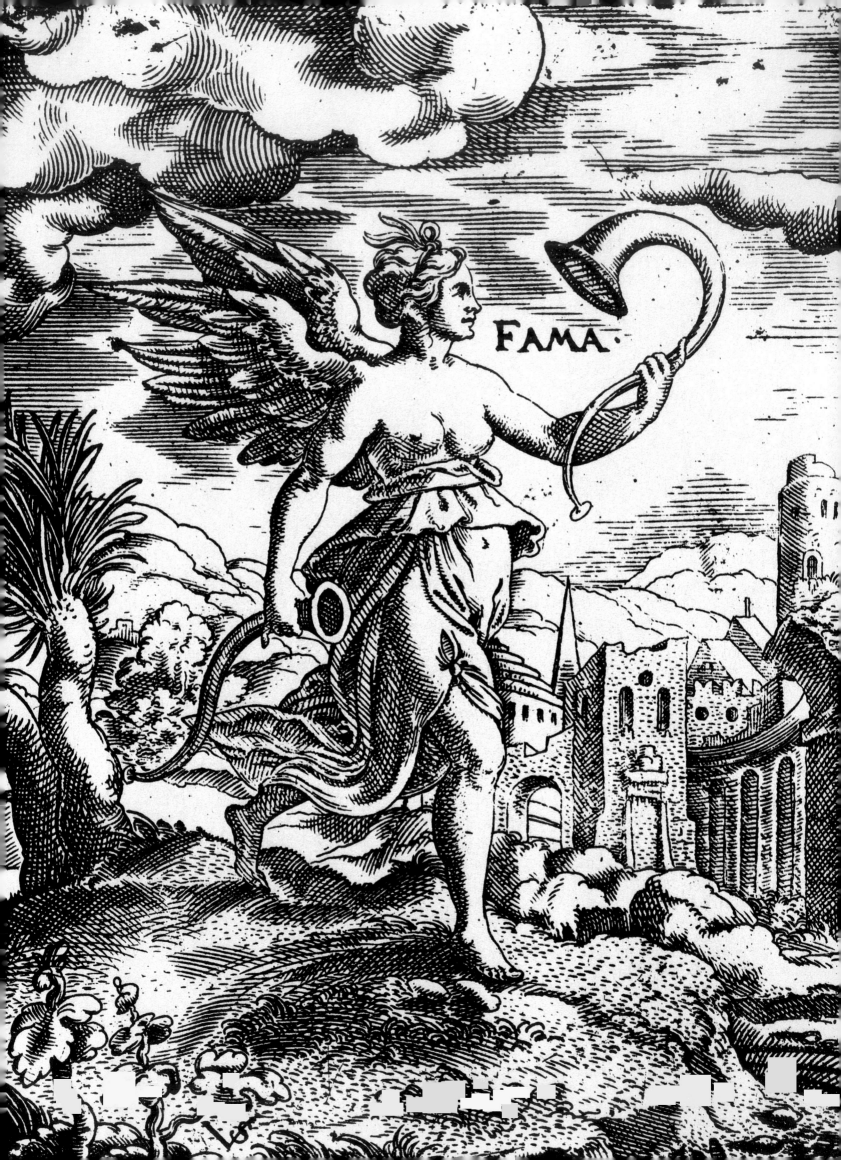

Introduction: Images to Light the Candle of Fame RICHARD BRILLIANT

Oh, who shall lightly say that fame

Is nothing but an empty name,

When but for those, our mighty dead,

All ages past a blank would be.

JOANNA BAILLIE[1]

To celebrate admired members of society has for centuries been a powerful impulse, because individuals so marked were thought to embody the best the society had to offer and constituted a significant measure of its greatness. To serve this end, duly representative images were created not only as a device of contemporary celebration but also as a means of perpetuating the memory of the men and women so distinguished, even as they absented themselves through death. A positive value judgment thus endowed these honorific images with an admirable dignity, transforming them, in effect, into models no less worthy of subsequent emulation than were the original subjects worthy of laudatory portrayal in their own lifetime. Or, at least, that was the way it was until the late nineteenth and twentieth centuries, when the separation of public and private spheres of action broke down and the means of disseminating images of almost anyone became unbounded, and the nature of fame—its constitution, justification, duration, and expression—changed forever.

To be considered "famous" and praiseworthy in modern mass societies seems to require a high degree of image-propagation, as if renown had less to do with a person's achievements than with a mechanism for distributing images, abundantly present in the public eye. Merit is even less essential to the creation of the "celebrity," an intensely public condition dependent on the media's ability to make one person stand out from the crowd in a self-affirming claim for attention. But public awareness was always an essential element in the constitution of fame, although prior to the twentieth century the dimensions of that concerned public were much more restricted. For example, in Classical Antiquity, when the concept of fame in the Western tradition was first formulated, it was understood as the product of a favorable public opinion, the positive evaluation of

FIGURE 1
Virgil Solis the Elder
(German, 1514–1564),
Fame (Fama) (La Renommée),
1550–55. Engraving, 50 x 37 in.,
The Illustrated Bartsch, 1919,
part 1, p. 107, no. 217.

a person's reputation [FIGURE 1]. Indeed, in the *Oxford Latin Dictionary*'s definition of the closely related terms—*fama, celeber, celebratio, celebratus,* and *celebro*—it is assumed that celebrating another and thereby making that person "famous," worthy of honor and praise, expressed the common will.[2] Fame, accruing to an individual as an extension of his being, resembled an epithet for which the crowd, even more than the person so honored, was responsible; and the perception of merit, the deserving of praise were the very foundations of the honor given and earned.

The ancient Romans sought to identify praiseworthy men (*vires illustres*), to make portraits of them for public display and, lest their accomplishments pass from memory, provided them with *testimonia*—brief, laudatory descriptions of their deeds in texts that reconfirmed their right to good reputation and fame. The Roman antiquarian Varro, an aristocrat of the late first century B.C., compiled a series of seven hundred encapsulated biographies of famous Romans. Each one was accompanied by a painted portrait, as if neither text nor image were sufficient by themselves but together would establish both the grounds and the object of praise. Varro's encyclopedic work has not survived. However, he conveyed to the Romans the idea of collecting the images of such worthies in one place, thereby constituting a body of distinction greater than its individual members, in effect a standard of fame. The corporate identity of the great figures of the past informed the collection of statue portraits of long-dead and still-living dignitaries assembled in his Forum in Rome by the first emperor, Augustus. Similar assemblages were to be found in the galleries of portrait statues or sculpted portrait busts of worthy men and women in public and private sites during the Empire.

Varro may have wanted to shape the roster of famous Romans at the end of the Roman Republic and to celebrate them as the Republic gave way to the Empire, but he also had Greek precedents for his historical, laudatory perspective. There was a long tradition of Greek honorific portraits of great statesmen, generals, public benefactors, intellectuals, and athletes. The last category, very much alive even today, celebrated the victorious competitors in the Games, especially those held at the international cult centers of Olympia and Delphi. Statues of winning athletes were erected in their honor and for their cities of origin (e.g., the *Delphic Charioteer*); Greek poets, such as Pindar in the fifth century B.C., wrote odes praising the victors and the glory their exploits had won for city and patron. Increasing professionalism dimmed the athletes' patriotic glory among the Greeks of the post-Classical age but not their personal fame. The Romans, in turn, celebrated victorious gladiators and charioteers—stars of the arena and of the circus, and professionals—in verse, statuary, and mosaic depictions. Only in modern times did athletes again reach such a level of prominence and fame that they were deemed worthy of commemorative portraiture: champion jockeys appear in English paintings by the eighteenth century, as do prizefighters; images of Olympic victors, tennis champions, and stars of football, baseball, and basketball proliferate in various media in the twentieth century. Sometimes their fame is temporary, as one star fades and is replaced by another; their current reputation can be traced in the immensely popular sports cards bearing photographic reproductions of athletes, brief biographies, and statistical records of their accomplishments, avidly collected by young fans of each sport, the modern legacy, perhaps, of Varro's compilation. Halls of Fame for sports such as baseball (Cooperstown, New York) or American football (Canton, Ohio) preserve a more permanent record of famous athletes, their performances often captured on film but still primarily commemorated by portrait busts or reliefs, accompanied by *testimonia* in the "old way."

17

The Greeks also invented the celebrated imagery of the "intellectual," the renowned natural scientist, historian, poet, playwright, philosopher, orator, lawgiver, or teacher, who was thought to define the highest levels of cultural achievement in spirit and mind.[3] Sculpted portraits of these distinguished persons were to be found in great abundance, ornamenting the philosophical schools, especially in Athens, and in the great Libraries of Alexandria and Pergamon, and later in Rome. Their images were also present in upper-class Roman country estates of those, like the Pisones of Herculaneum, who collected portraits and books in the Villa dei Papiri as objects of contemplation, sources of inspiration, and as symbolic tokens of the intellectual life they led, or wished their friends to think they did. Sometimes the intellectual elite were categorically grouped either by affinity, as philosophers or authors, or in all star ensembles, such as "The Seven Sages," whose membership varied over the centuries. This exaltation of the chief protagonists of an intellectual existence was not limited to Greco-Roman civilization, because the Chinese also valued such persons, especially those around the central figure of Confucius and his disciples.[4]

In Greco-Roman culture, intellectuals were greatly esteemed, especially if they were Greek, and their inclusion in the company of distinguished worthies was evidently merited by their own efforts in behalf of society. For the Romans, however, the broad category of illustrious persons, developed by Varro and those who came after him, substantially ignored the intellectuals in favor of royals, statesmen, and captains of battle, figures prominent in the realm of politics and public affairs. Suetonius's *Lives of the Twelve Caesars*, often depicted in the Renaissance and later [FIGURE 2], sometimes with invented images, typified this approach to persons raised into prominence by historical factors, but not necessarily by their own personal distinction. Later histories of kings, queens, princes, prime ministers, and presidents, replete with the appropriate imagery, follow this model, accepting the role as the basis of fame, although it might be enhanced by personal achievement. The influential Greek author Plutarch, in his *Parallel Lives*, written in the second century A.D. only slightly later than Suetonius, compared Greek and Roman political figures whose fame had already been established by history. His perception of their affinity in character and career was leavened with moral judgment, thereby separating fame from virtue, reputation from good repute.

Centuries later, these distinctions, buttressed by Ciceronian concepts of moral obligation and duty, were taken up by Petrarch in *The Triumph of Fame* (circa 1348).[5] To Petrarch an essential

FIGURE 2

Jean Laudel the Elder (French, seventeenth–eighteenth century), *Two Candlesticks with Plaques of the Twelve Caesars*, seventeenth or eighteenth century. Limoges enamel and copper, 7 1/8 x 7 1/8 in. The Walters Art Gallery, Baltimore, 44.52.`1

18

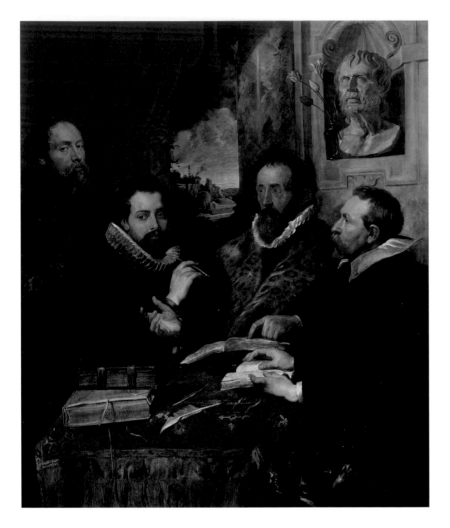

FIGURE 3

Peter Paul Rubens
(Flemish, 1577–1640),
*Four Philosophers with a
Bust of Seneca*, 1611–12.
Oil on canvas, 64⁹/₁₆ x 53³/₄ in.
Pitti Palace, Florence.
Photo: Canali Photobank
Capriolo (Bs), 638.

ingredient of fame, which saves man from the tomb, is worthiness or virtue, equally applicable to rulers, warriors, heroes, philosophers, scientists, and writers. His near-contemporary Boccaccio expressed similar sentiments in his treatise on famous women, *De mulieribus claris* (circa 1359), soon complemented together with the representation of famous men (*uomini famosi*) in a large number of pictorial cycles.[6]

However, the Renaissance frenzy for individual renown soon put aside these moralizing sentiments in the avid pursuit of fame. The rapid development of "The Currency of Fame," the apt title of a recent exhibition at the Frick Collection of Renaissance portrait medals,[7] reveals that both distinguished and notorious persons were represented, or represented themselves, in the fifteenth and sixteenth centuries. Commissioned by a great variety of patrons from different social classes and executed by an equally great variety of artists, these medals, often inspired by Roman coins, circulated very widely and were eagerly collected. In effect, these medals created a new repertory of representation—the celebrity portrait—whose claims for attention were self-substantiated and clearly advertised in the new medium. "Look at me, and do so with care," are demands made upon the viewer not just by the particularities of the portrait and its accompanying legend but also by the complimentary message stamped on the reverse. All the necessary ingredients of the celebrity portrait were now in place: image, name, and "documented" claim to fame, propagated in a virtually unrestricted medium, capable of wide circulation in uniform exemplars. In a sense, when small-scale, inexpensive, popular portrait photography made its appearance as an instrument of image-diffusion in the nineteenth-century carte-de-visite, it was a distant beneficiary of the Renaissance medal. The carte-de-visite may or may not lack visual and artistic distinction, but it made similar, if reduced, claims for attention and recognition, even if its subject had neither fame nor celebrity status. However, many cartes-de-visite were made of famous persons of the late 1850s and the 1860s, and their images were thereby widely dispersed. The vogue for collecting cartes of friends and relatives soon expanded to include political figures, theatrical personalities, cultural heroes, and nearly every class of modern celebrity, including artists. In spirit, the carte-de-visite images resemble the painted portrait miniatures that began in the Renaissance, subsequently flourished in England and France, and eventually spread into Germany, Scandinavia, and the Americas well into the nineteenth century, gradually attaining a more popular level of custom, especially as mementos or tokens of affection.

All over Europe from the sixteenth to the eighteenth century, princes, great magnates, and other claimants of high culture collected and displayed statuary representing the famous figures

of Classical Antiquity, the corpus more or less established by long-standing tradition. These collections, sometimes complemented by ancient coins and gems, could contain both ancient and contemporary works of art, the latter created in an "antique manner." They were often restricted to a limited viewing public but could become known, even famous, by the publication of well-illustrated catalogues. Their illustrations were frequently recycled, ancient celebrities in circulation, as it were, gradually establishing the "standard" iconography of much sought-after exemplars of famous Greeks and Romans, whose images did not appear on name-bearing ancient coins and medallions.[8]

19

The *Pseudo-Seneca* is a product of this late humanist environment, not because the portraits of this type, which survived in considerable numbers, were not legitimately ancient but because the attribution to Seneca was mistaken. So Rubens's painting *Four Philosophers with a Bust of Seneca* [FIGURE 3] in Florence combines a self-portrait, a portrait of the artist's deceased brother, another of the great scholar and neo-Stoic Justus Lipsius (also deceased), and Lipsius's pupil, Wolverius; presiding over them is Rubens's representation of an ancient portrait of "Seneca," the Roman Stoic philosopher. The artist's conceit in this work is reminiscent of Raphael's *School of Athens* (circa 1509–11) in the Vatican, painted almost a century earlier and widely distributed in the engraving by Giorgio Ghisi, a follower of Marcantonio Raimondi [FIGURE 4]. While only a fraction of the size of the painting, it was the form in which most people knew the work. There Raphael portrayed himself among the "greats" of the Classical past and thereby established his claim to belong in their company, together, perhaps, with his great contemporary Michelangelo. This combination of the living and the honored dead, evident in Rubens's *Four Philosophers*, was calculated to blur the distinction between the famous—Rubens and Lipsius—and the others, establishing thereby the bonds of friendship and the mutual pursuit of an intellectual life. Rembrandt and Frans Hals also painted "group portraits"—of physicians, militiamen, syndics of trade, governors of charitable institutions, and other associations—often, but not always, dominated by one or two principals.

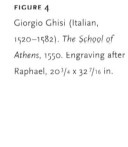

FIGURE 4
Giorgio Ghisi (Italian, 1520–1582). *The School of Athens*, 1550. Engraving after Raphael, 20 3/4 x 32 7/16 in.

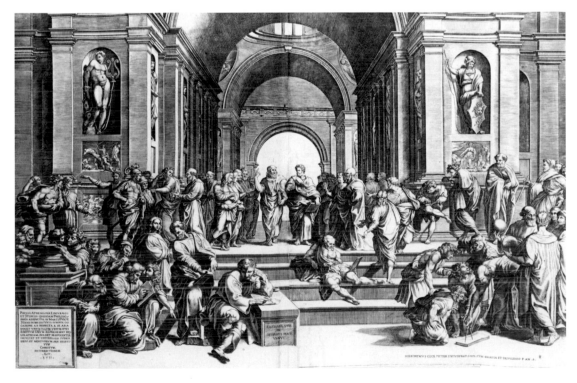

20

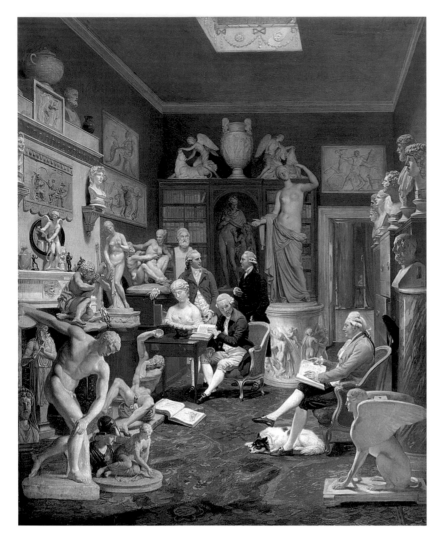

FIGURE 5
Johan Zoffany (German,
circa 1733–1818), *Charles
Townley and Friends in the Park
Street Gallery, Westminster*,
circa 1782. Oil on canvas,
50 x 39 in. Towneley Hall
Art Gallery and Museums
PA/OIL 120, Burnley Borough
Council, Lancashire. Photo
courtesy Bridgeman Art
Library, London/New York.

The groups exist as corporate entities, prior to being depicted, but the northern artists have transformed the collective into an ensemble worthy of such respect that the individual members may also profit, individually.[9]

Membership in distinguished organizations or associations may therefore confer distinction on individuals who, by themselves, might not merit it, a most advantageous situation in capitalist societies not dominated by an aristocratic elite. Since the mid-nineteenth century, group portraits have proliferated with the advent of photography, recording an individual's membership in various boards, chambers of commerce, charitable institutions, clubs, unions, marching societies, ethnic fraternities/sororities, militia units, and a host of other, largely volunteer organizations. Such portraits tend to level the field, reducing most, if not all, internal distinctions. Perhaps that very informality made such group photographs emblematic of an open society, images treasured by the association as a continuing entity and by its members. They also constitute the democratic counterpart to the highly stratified, hierarchical imagery of aristocratic or regal families, tied together by genealogy, fate, and politics, but dominated by the "head of the house."[10]

Another kind of voluntary association came into being with the rise of the academies of art in Italy, France, and England—the constitution of Les Pléiades in France, Voltaire's later Republic of Letters, and the Society of Dilettanti in England. The spirit of the last informs Johan Zoffany's famous portrait, *Charles Townley and Friends in the Park Street Gallery, Westminster* [FIGURE 5], in which the subjects are shown surrounded by the objects of ancient art that gave meaning and importance to their association: a cosmopolitan circle of friends, men of taste and breeding who are self- and mutually selected by class and common interest, secure without regard to becoming either famous or especially well-known, and yet distinguished among "those who count."[11]

With the rise of the cult of artistic genius, a notion closely tied to Vasari's exaltation of Michelangelo in his *Lives of the Most Excellent Architects, Painters, and Sculptors* (1550) and further developed by Joshua Reynolds in the eighteenth century, Romanticism enhanced the position of the artist as a creative individual at the forefront of culture. Representation of artists (mostly painters) and writers (mostly poets) adopted a self-confirming mode of depiction by which they were marked as "artists" by themselves or as members of a distinguished class, a collective of friends by association and/or of friends in fact. French nineteenth-century painters such as Henri Fantin-Latour and Gustave Courbet created group portraits of fellow artists, not only as a public

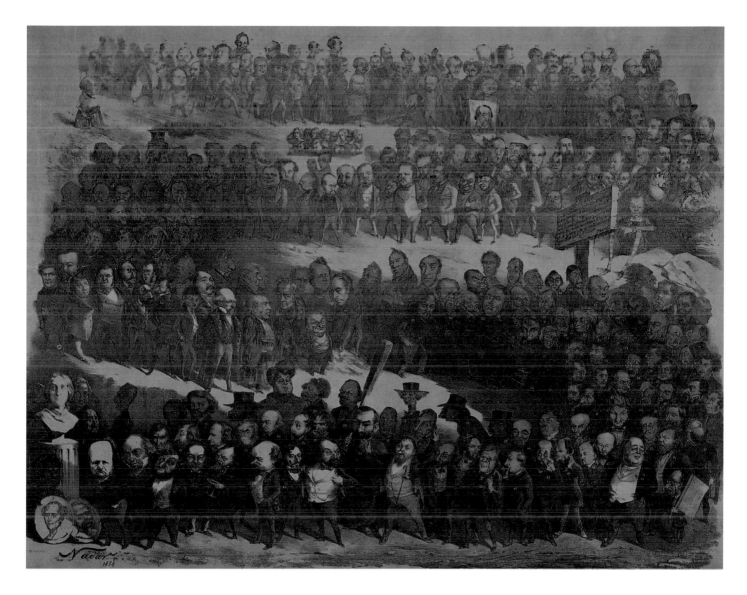

statement of their distinction but also as a means of establishing the "artist" as a celebrity in a society increasingly interested in the creation of "celebrities."[12] Similarly, in England, Julia Margaret Cameron created a series of photographs of distinguished men of letters and other eminent Victorians, such as the historian Thomas Carlyle, whose face is made to seem chiseled out of stone.

An artist's distinction thus involved some degree of separation from society as a whole, whether as a participant in the avant-garde, with its political, ideological posture, or as a resident alien who has separated himself or herself from the norms of society. On one hand, an artist like Nadar, in his *Panthéon* of 1854 [revised in 1858—see FIGURE 6], could create a veritable parade of distinguished subjects by his own deliberate act of selective portrayal, which established an association of the elect. The old Greco-Roman conception of the "pantheon," signifying a site, architecturally defined and dedicated to all the great gods assembled together, seems to have undergone a profound transformation in late eighteenth-century France. In 1791 Condorcet changed the role of Jacques-Germain Soufflot's *Panthéon* in Paris: no longer a grand church in honor of the universal Christian deity, it became the burial place for "les Grands Hommes," distinguished French citizens honored for their own intellectual achievements and celebrated therefore in a permanent memorial comparable to London's Westminster Abbey, with its tombs of similarly

FIGURE 6

Nadar (Gaspard Félix Tournachon) (French, 1820–1910). *Panthéon Nadar*, 1858. Lithograph, 29 x 41¹/₂ in. 84.XM.1624.

22

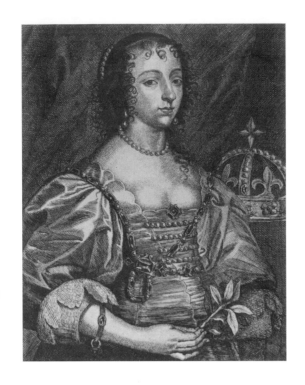

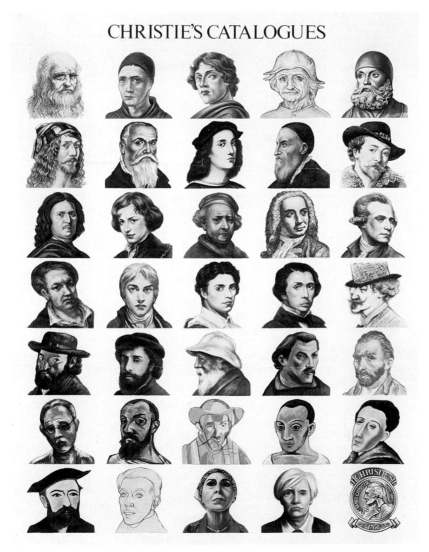

distinguished Britons. The growing nineteenth-century preference for meritocracy over aristocracy firmly established the honorific assembly of such worthies as a cultural icon, reminiscent of Roman practice, but open to a greater range of contributions and contributors. Thus, Nadar's *Panthéon* both assembled and celebrated distinguished Frenchmen (and a few women) as a cohort of living worthies who did not have to wait for death to be honored. On the other hand, some artists whose images are gathered together resemble "all-stars," another, more artificial kind of pantheon. The antecedents for the production of this kind of series of portraits lay in the graphic arts, such as Van Dyck's *Iconography* [FIGURE 7] in the early seventeenth century. It is a set of eighty engravings derived from his portraits of princes, philosophers, and painters. Such a collection of heroes of the art world, brought together by fame and economics, informs the advertisement of its auction catalogues published by Christie's a few years ago in an effort to publicize both its long-standing eminence in the art market and the range of its offerings of artworks [FIGURE 8]. The latter is implicit in the emblematic line-up of great masters whose "characteristic," recognizable portraits follow one another in chronological order from Leonardo da Vinci to Andy Warhol, ending, of course, in an image of James Christie, founder of the auction house in the eighteenth century. The design of the catalogue cover itself shows the influence of Andy Warhol's silk-screened multiple serial portraits of celebrities, which he began producing in the 1960s.

Despite the economic motives of Christie's effort at self-promotion, the assemblage surely confirms the collective status of these famous artists, whose name-value has a direct effect on the market for their works. But the gallery also resembles Varro's ancient model as well

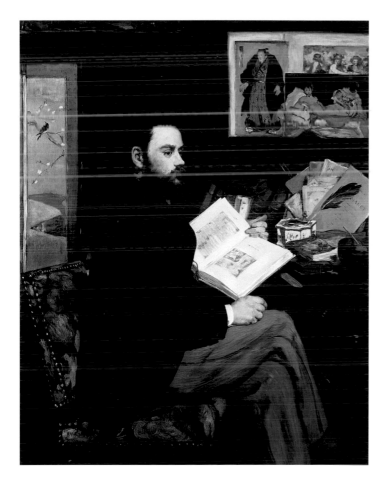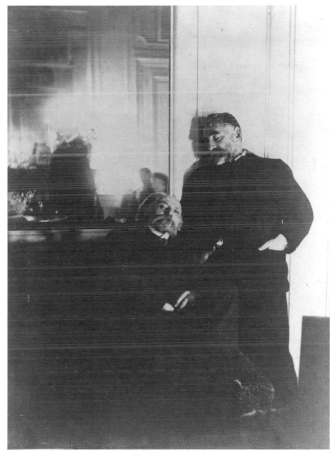

23

as its more recent instantiation in the bibliographical archives that are currently available, replete with complementary portraits, without which the biographies would be seriously compromised. By definition publication of such biographical material, combining archives pertaining to the subject with contemporary portraits, reaffirms the celebrity status of the historical personage, extricated thereby from the anonymity of the past. To be found among the "Who's Who" of the historical record is truly a qualification of fame itself.

The archival record can lift someone from the obscurity of the past and bring him or her up into the strong light of public scrutiny and favorable regard. This can occur even if the particular source of the visual evidence is anonymous, or even worse, banal. Artists representing themselves and/or their friends, however, tend to display their own artistry in the finished work as much as in the distinctive appearance of their ostensible subjects. Whether or not this is an unconscious, or deliberate, manifestation of a personal style, a competitive marker, or the artistic self in action, as many believe, the opportunity to portray other artists involves a high degree of self-referentiality. The means employed will suffice to mark both artist and subject as equally present in the work of art, if differentially defined. So, Manet's *Portrait of Émile Zola* [FIGURE 9] of 1868 is full of visible evidence of the painter's presence and authorship, no less explicit than the image of his friend Zola.[13]

The not-so-casual inventory of Manet's own works within the portrait's pictorial environment suggests the artist's success in achieving a kind of auto-portrait, barely masked. Its strategy relates closely to Edgar Degas's own procedures when the later artist used reflective means to establish his own presence, dimly seen in the mirror behind the figures of his fellow artists, Renoir and Mallarmé, he photographed in 1895 [FIGURE 10].[14] The only distinction among them is to be found

FIGURE 9

Édouard Manet (French, 1840–1902), *Portait of Émile Zola*, 1868. Oil on canvas, 57 1/2 x 44 7/8 in. Musée du Louvre, Paris. Photo: Agence photographique de la réunion des musées nationaux.

FIGURE 10

Hilaire-Germain-Edgar Degas (French, 1834–1917), *Pierre August Renoir and Stéphane Mallarmé*, 1895. Gelatin silver print, 15 3/8 x 11 3/16 in. The Museum of Modern Art, New York. Gift of Paul F. Walter.

24

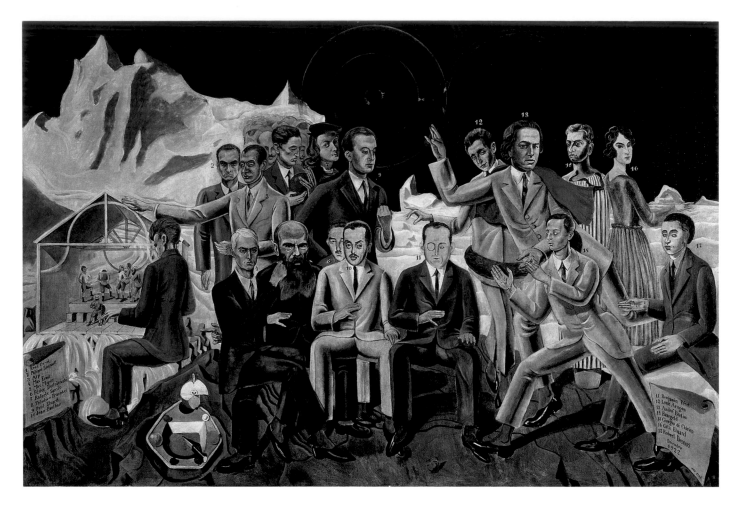

FIGURE 11

Max Ernst (German,
1891–1976), *Au rendez-vous
des amis*, 1922. Oil on canvas,
51¹/₄ in. x 76³/₄ in. Museum
Ludwig, Cologne, ML 76/3219.

in the active or passive nature of their presented roles. Degas, a masterful portrait artist of family groups, has evidently emphasized his own performance as author of the photograph in the mirror behind—the photographer as performer seems almost a cliché of the modern critical perception of photography as an art. But performative idiosyncrasies of a more extravagant sort were used by the Dada artist Max Ernst in his *Au rendez-vous des amis* [FIGURE 11] of 1922 to suggest their alienation from society, and from one another, by assuming self-enabling gestures of such a distinctive nature that, in effect, they both construct and deconstruct a group of "friends" simultaneously.[15]

"We derive such dignity as we possess from our status as art works," Nietzsche once remarked, certainly in recognition of art's power to ennoble the subject in the public eye. Public life, especially in the nineteenth and twentieth centuries, has become both more transparent and more variable in its definition of reputation. The role of the "dandy," perhaps initiated by the Englishman Beau Brummell around 1800, offered an opportunity to a man of fashion to become a celebrity because of the quality of his dress. Brummell's fashionable costume, all in black and white, was adopted by Baudelaire and many of his artistic contemporaries, including Fantin-Latour and Manet, as well as by those men who wished to be in and of society. Once associated with the presence or absence of manners, proper dress soon became a ticket to high society, leading, in turn, to the commodification of fashion and to the dilution of the criteria required for achieving fame or notoriety.[16] To be a celebrity in the public eye might be less a matter of esteem than of envy, but the elevated status often rested on weak foundations, readily open to caricature, one of the great visual sports in England and France in the eighteenth and nineteenth centuries.

Behavior that for any reason made one stand out could be pilloried in print by artists (such as Nadar in his caricatures of the late 1840s and early 1850s) who seized on some salient characteristic of face, figure, comportment, or dress to bring down to size the object of ridicule; the one so attacked, ironically, might become even more of a celebrity because of the ensuing notoriety, especially when lithographic reproductions became available in the popular press or circulated in the form of broadsides for general consumption.[17]

With the invention of printing and the rapid reduction in its cost, woodcuts and engravings representing the portraits of non-aristocratic contemporaries began to proliferate in the fifteenth and sixteenth centuries. The Reformation and Counter-Reformation relied heavily on diffusing portraits of theologians and intellectuals as powerful advocates in the dogmatic disputes of the times, thus bringing fame to some, disrepute to others. Images of Luther, Calvin, Melanchthon, Erasmus, St. Filippo Neri, and many others became abundant, if not always complimentary. Such images circulated as independent prints or gave greater force to pamphlets engaged in political or religious controversy, moving their once-closeted authors into the public arena. Aided by the development of cheap, wood-pulp paper and the process of wood engraving and lithography in the first half of the nineteenth century, illustrated newspapers and periodicals in England, France, and the United States soon created and exploited the celebrity image as a means of enhancing circulation among an ever-more-avid public, often defining their political orientation through such representation. Publishers soon used the power of the printing press to create and destroy reputations, to make and unmake public figures, and to shape public opinion; photography only enhanced this power by its greater claims to veracity, its ability to reveal the nature of a mass, industrial society as well as its monumental individuals. Prints, based on drawings and sketches, retained their preeminence as a means of ironic commentary and ridicule, perfected in the art of caricature by Cruikshank and Rowlandson in England, by Henri Monnier, Honoré Daumier, and Gavarni in France. Caricature seems to have proved Shakespeare's observation that, "Reputation is an idle and most false imposition; oft got without merit and lost without deserving."[18] "Reputation"—good or bad—is necessary to the constitution of the celebrity status. It takes the form of public packaging, effected by words and images, often having little to do with the private person, as if such concepts of private personhood had any reality separate from the public's perception of "the celebrity." On occasion, the package itself may seem empty, as if, in Gertrude Stein's words, "There is no there there."

There are only two things people want to keep from public scrutiny: their real, private self; or the fact that they have not a private self of any particular interest. Now my instinctive guess is that everyone is nursing the fear that the real them doesn't amount to very much worth knowing. The famous fear it most, but everyone, I think, suspects that they might not exist in any interesting way beyond their public and superficial selves.
JERRY DISKI [19]

Caricature may have been an unwelcome intermediary between fame and celebrity, but the photograph in black and white has been both a leveler of the distinctions among us and a maker of stark documents that keep the ephemera of our transient existence from disappearing. Henri Cartier-Bresson, more than most, captured the essence of modern life in black-and-white images of an arresting quality. He seemed to raise the level of the ordinary onto a much higher plane of

JOSEPH P. BRADLEY (*left*)
(1813–1892)
Associate justice, U.S. Supreme Court
Courtesy Library of Congress, Brady-Handy Collection

SIMON BRADSTREET (*right*)
(1603–1697)
Governor of Massachusetts Bay Colony;
husband of Anne Bradstreet
Engraving by H. W. Smith

DIAMOND JIM BRADY (*left*)
[James Buchanan Brady]
(1856–1917)
Financier, playboy
Courtesy Free Library of Philadelphia

MATHEW B. BRADY (*right*)
(c. 1823–1896)
Photographer
Photograph by L. C. Handy

BRAXTON BRAGG (*left*)
(1817–1876)
Confederate general
Engraving by John A. O'Neill

THOMAS BRAGG (*right*)
(1810–1872)
Confederate Attorney General
Courtesy New-York Historical Society

FIGURE 12

Dictionary of American Portraits: Four Thousand Forty-Five Pictures of Important Americans from Earliest Times, Hayward and Blanche Cirker, eds. (New York: Dover Publications, 1967), p. 72.

existence, and significance, as an act of celebratory redemption—at least on his part. He portrayed the famous—including Mahatma Gandhi, Henri Matisse, Georges Braque, Jean-Paul Sartre, and William Faulkner—who were famous before he photographed them, and who wished to remain famous afterwards; and he photographed the unknown and unnamed—POWs returning from World War II, Mexican prostitutes, Harlem ladies dressed in their Sunday best—who remained so afterwards, even if he dated the photographs and identified the nationality of his subjects; and always he exhibited a sensitivity to the authenticity of his subjects, to the aura of their presence, and to the environments that defined the contexts of their being. In effect, Cartier-Bresson changed the temporal dimension of the snapshot by waiting.[20]

Some thirty years ago, the *Dictionary of American Portraits* was published, edited by Hayward and Blanche Cirker. It contains 4,045 pictures of important Americans from earliest times to the beginning of the twentieth century, persons deemed for various reasons to possess some degree of historical importance, but not because of the perspicacity of their portraits [FIGURE 12]. In this regard, the images duly entered resemble the photographs of criminals who may or may not have been infamous, but whose appearance on wanted posters was characterized by a grim, if vivid, banality. History, writ large, lies behind the portraits of those four thousand "important" Americans and justified their inclusion in this vast compilation of images, whose very size challenges the notion of fame itself. There was no art to their being famous and in most cases little or no artifice. For the criminals, on the other hand, guilty or not, these "mug shots" alone preserve the record of their existence and constitute their otherwise undistinguished history. If fame sometimes has created something out of nothing, then nothing may, sometimes, contribute, at least temporarily, to notoriety, if not to fame.

35. Boulevart des Capucines

Nadar:
A Photographer in Bohemia

GORDON BALDWIN

His Life

In 1820 in Paris, the man who, by the force of his considerable will, would become famous under the pseudonym Nadar, was born Gaspard Félix Tournachon, the son of Victor Tournachon, a publisher, and Thérèse Maillet.[1] His parents did not legalize their union until 1826, the year after the birth of their second son, Adrien. Both parents were from Lyon, where Nadar's grandfather had started a successful family printing and publishing firm in 1770. Nadar's father moved the business to Paris in 1817, where it initially flourished but subsequently faltered because of the financially unwise publication of books having intellectual and scholarly merit but limited public appeal.[2] Nadar's childhood was spent in highly urban surroundings, the center of Paris during the restored Bourbon monarchy. He vividly remembered the easygoing atmosphere of this period and events collateral to the revolution of 1830, which replaced a Bourbon king of France with an Orleanist king of the French.[3] His schooling began in Paris and continued at a pension attached to a school in Versailles, where he stayed until the collapse of his father's business in 1833, an event brought on by the publication cost of an unwieldy history of French law. Nadar's subsequent studies in Paris were terminated when his father, now seriously unwell, moved the family to Lyon in 1836; he died the following year, leaving his son a legacy of liberal and republican political opinions and his wife little money.

Apparently inspired by some general, if undefined, humanitarian ideals, Nadar began to study medicine in Lyon. Concurrently he started to write short snippets of prose for a local newspaper, among them a highly colored account of the fleshy chaos of a dissecting room where ninety students were wreaking bloody, small-scale havoc at once. He also wrote a short gothicizing romantic novella and paid for its insertion in another paper that then hired him to review a play by Victor Hugo. With a gathering sense of personal possibility he separated himself from his family and stultifying Lyon and moved to Paris in 1838. There he haphazardly continued to study medicine, but more important, found employment with two of the many, sometimes short-lived, small newspapers that enriched the Paris cultural scene.

Nadar at eighteen in Paris was a young man with virtually no resources save unremitting energy, ferocious curiosity, and an extraordinary appearance. He was red-haired and moustached, pasty-faced, and, at five feet ten inches, very tall for the period. His attenuated, spindly limbs—

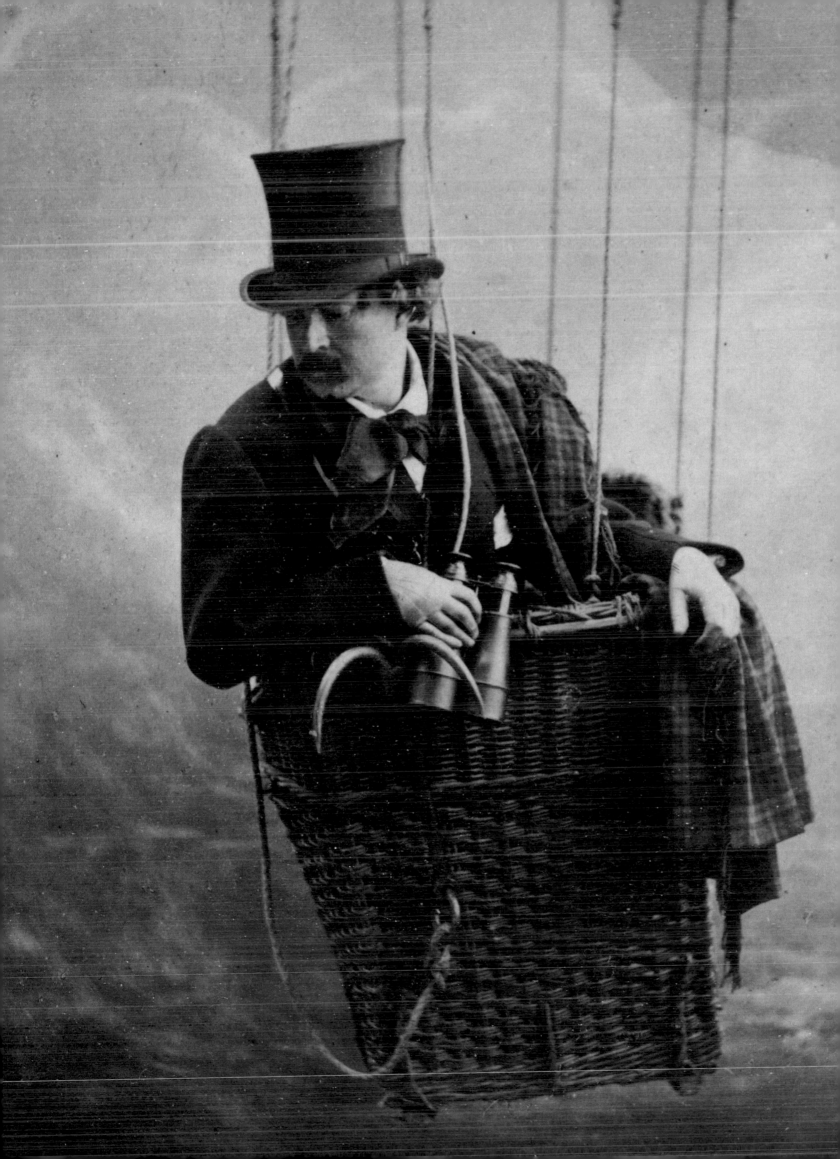

like those of a daddy longlegs—and buggish eyes made him conspicuous, despite his dislike of drawing attention to his personal appearance.[4] Dumas, who first met him at about this time, initially thought him unattractive. But Nadar had one further great gift: an extraordinary font of goodwill, and with it a talent for making and keeping friends. Nadar now came into contact with a small, loosely articulated circle of artists, musicians, journalists, poets, and other writers centered around the lithographic artist Karol d'Anelle, a Polish émigré, who, when he was able, fed and housed many of the group's raffish members. Nadar was an integral part of this band of urban gypsies, composed not of tinkers, knife-sharpeners, sign-painters, and fortune-tellers, but of playwrights, newspaper critics, picture-painters, and poets. These original Bohemians and the women with whom they formed liaisons, however temporarily, professed to live for love, art, their friendships, and freedom of expression. Privation and early death from malnutrition or tuberculosis were the darker components of their existence. The circle soon included the impoverished writer Henri Mürger, whose later short stories, particularly *Scènes de la vie de Bohème*, would embellish, romanticize, and aggrandize the place and time. Mürger's stories were first published in the mid-1840s as installments in newspapers and were later loosely linked by him into a successful play; its opening night in 1849 was attended by Nadar and many of the persons on whom the characters were modeled.[5] Nadar himself later described these men as "without overcoats or soles on their shoes, but doubting nothing, neither the future nor their genius, nothing except [the wherewithal to purchase] their dinner that evening."[6] The ethos and values of the Bohemia of the very early 1840s had a lifelong effect on Nadar's beliefs and behavior. Its trust in and respect for its fellows, its camaraderie and communality, and its sympathies with the underprivileged continued to constitute his intellectual underpinnings despite the changing nature of his circumstances. He would be unremittingly loyal to the citizens of this artistic republic, some of whom, such as his friend Baudelaire, proved to be the most creative Frenchmen of the nineteenth century. Nadar would outlive nearly all of them.

When the wide variety of work Nadar undertook for a myriad of mostly ephemeral small newspapers did not pay enough to assuage one in a succession of enraged landlords, he slept at least part of one winter in the streets, and one day had nothing to eat but a raw potato.[7] His journalistic endeavors ranged from gathering press-worthy tidbits at the stock market, the legislature, and, particularly, the theater to writing reviews, sketches of daily life,[8] and essays, the opinionated political contents of which brought him under police surveillance. At about this time he adopted the spiky pseudonym Nadar (Tournachon transformed into Tournadar and then into Nadar), which he would use for the rest of his life. He became so famous that when Victor Hugo wrote him from the island of Jersey in 1864, the name Nadar on the envelope without an address was all that was necessary to assure delivery.[9] In 1846, while continuing to write, including a political novel, and with no formal training in art, he began to draw caricatures of the most significant figures in the worlds of art and politics [FIGURE 1]. These, too, were published in newspapers, such as the satirical journals *La Silhouette*, *Le Corsaire-Satan*, and, later, *Charivari*. Caricatures comprised the illustrative components that filled these often-slender journals.[10]

In the 1840s, at a time when the cult of the individual, in part fostered by the dandyish stance of men like Baudelaire, was rapidly developing, there was a nearly insatiable public appetite for drawings of public figures. Nadar carried out his search for sitters in the course of his daily round of cafés, restaurants, concert halls, theaters, the homes of friends, and the lobbies of the legislature.

He came into contact with and sketched many of the people who would become the subjects for his camera in the following decade. In 1847 he produced a modest gallery of men and women of letters for newspaper publication, the first of his several compendiums of celebrity. Despite his constant activity, he was scarcely any richer than when he first came to Paris, and his financial distress was compounded when he was joined there by his mother and brother, for whom he also had to attempt to provide.

Nadar seems to have taken no direct part in the revolution in February 1848 that replaced the bourgeois monarchy of Louis Philippe with a republican government, but he was delighted with the realization— at least temporarily—of some of his political ideals and with the lifting of press censorship. His own political action in 1848 was to join a bizarre and idealistic amateur military expedition to free Poland from Russian domination. With a group of five hundred fellow volunteers, mostly Polish refugees, he set off on foot from Paris, but with the others was stopped outside Berlin by the Prussian government. After brief imprisonment he was set free to walk home again. No sooner had he arrived in Paris than he was sent as a spy by the new French government to assess Russian influence in Germany. Disguised as a painter, this time he presumably traveled by train. By summer's end he was home and again at work as a caricaturist.

In 1849 he began to contribute biting satirical drawings, as did Gustave Doré, to the *Journal pour rire*, like *Charivari* published by Charles Philipon, who became a friend, a gentle if teasing mentor, and, by inventing new publications to showcase Nadar's talents, a benefactor. Despite consistent employment by these papers and by *Le Journal*, where he worked alongside Théophile Gautier, Nadar was in prison for debt for nearly a month of the following year, no doubt partially caused by his perennial, improvident generosity. Incarceration convinced him of the inhumanity and futility of imprisonment as a corrective measure and gave him even greater sympathy for the downtrodden. Released and returned to work, he innovatively strung together a series of sketches of an imaginary, opportunistic, political booby to produce a pungent forerunner of the comic strip.

When Napoléon III's coup d'état in December 1851 overturned the republican government, and in so doing dashed Nadar's dreams of democracy and obliterated what had been a relatively

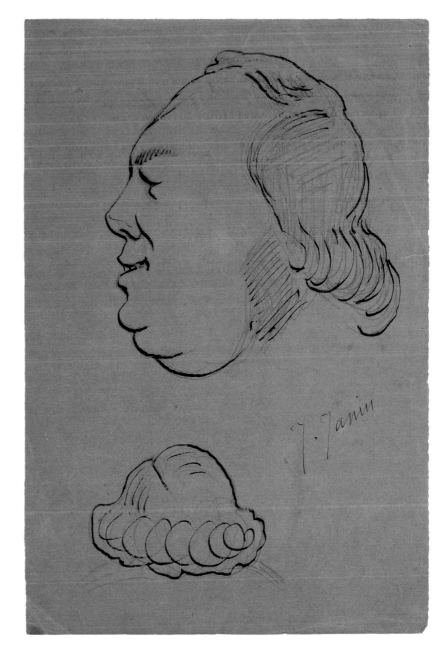

33

FIGURE 1

Nadar, *Caricature of Jules Janin*, circa 1848. Pen-and-ink drawing, 9¹/₂ x 6¹/₄ in. 84.GG.790.217 [compare p. 102].

34

FIGURE 2

Nadar, *Portrait of Adolphe Crémieux*, circa 1858. Grease pencil with gouache and stomp, 12¼ x 9¼ in. Bibliothèque Nationale de France, Paris, Département des Estampes et de la Photographie, P189348, No. 88 réserve, boîte 8, [compare p. 107].

free press, Nadar could no longer use politics as a subject for drawings. In a marriage of the visual and verbal, he began a series of drawings of cultural figures with massive heads and shrunken bodies—*portraits charges*—that he accompanied by wry biographical sketches, which he sometimes wrote from suggestions made by the sitters themselves [FIGURE 2]. He linked these authors and journalists, who were often eager for the publicity, in single-file parades of six or seven figures across the pages of Philipon's *Journal pour rire* in a series entitled *lanterne magique* that started to appear in 1852. By now he had hired draftsmen and engravers to assist him in transforming drawings from his sketch pad to the printed page. For fleshy fodder for these weekly productions Nadar had already assembled a haystack of images, which gave him the idea to order them all into a series of four large-scale lithographs of cultural figures, thus giving more permanent form to his work than the newspapers provided. This grand venture, the *Panthéon Nadar* [see Introduction, FIGURE 6], would propagate both the fame of his sitters and himself and would lead to his photographic career. Meanwhile he continued with other journalistic enterprises, among them the *Nadar-Jury*, a critique in caricatures with captions of the painting salon of 1852. In it and those that he wrote and drew in later years Nadar advocated the revolutionary role of the Romantic artist and the concomitant political role of the art critic.

Nadar's brother Adrien would spend his life unsuccessfully fighting his dependency on his celebrated older brother for money or employment. An occasional hand in Nadar's nascent atelier, he had failed as a portrait painter and needed a vocation. As photography in Paris, particularly portraiture, was evidently booming in 1854, Nadar sent Adrien to the already distinguished practitioner Gustave Le Gray for lessons and found financing to set Adrien up in a portrait studio. Having the idea from the outset (as he later said) that he, too, would become involved in whatever photographic business resulted, Nadar learned photography as well, but from the firm of Adolphe Bertsch and Camille d'Arnoud. In the apartment where he had moved with his mother the year before he set up a darkroom and then photographed a few friends. However, his energy was principally directed to the laborious process of completing the first lithograph for the *Panthéon Nadar*. Assistants reworked his initial sketches and then rendered them in grease pencil onto the lithographic stone, larger than any yet employed in that medium. Infrequently,

when sketches of sitters were unavailable, photographs were used as sources.[11] The first of the four projected plates finally appeared in March 1854. It consisted of a swooping serpentine parade of a,19 portraits charges of eminent poets, journalists, publicists, novelists, and historians, led by Victor Hugo and passing in review before a bust of George Sand. Sadly, because of its high cost, initial sales were slow despite enthusiastic newspaper reviews by Gautier and other friends, and in October the government enjoined further sales because an unidentified sitter complained that he had not given permission for his image to be published.

Perhaps because Nadar was so accustomed to being insolvent, he was able to ignore the large debt he had incurred in the production of the *Panthéon* and propose marriage to Ernestine-Constance Lefèvre, a woman who, at eighteen, was half his age. Surprisingly, her starchy Protestant family, after negotiations that must have been prickly, agreed and the couple were wed in September 1854. Despite an initially stormy period caused partly by Nadar's domineering mother, with whom they lived at first, the marriage would prove to be a happy one, with Ernestine's ever-dwindling dowry and perennial common sense coming often to Nadar's rescue. The projected three further plates of the *Panthéon* abandoned (it was revised and reissued in 1858), he plunged back into making caricatures and *portraits charges* for Philipon's publications, stopping briefly to write two pantomimes in which his friend the mime Deburau appeared. When the photographic studio that he had set up for Adrien began to fail, Nadar stepped in and spent the last four months of 1854 working in tandem with his brother to make portraits of some of the same persons who had figured in the *Panthéon*. These joint images, which are few in number, mark the real beginning of Nadar's career as a photographer, the aspect of his life that is most remembered.

As always, the brothers did not get along, and in January 1855 Nadar set up his own portrait studio at 113, rue Saint-Lazare, where until now he had been living with his wife and mother. Happily, from the point of view of marital tranquillity, his mother shortly moved elsewhere.[12] The building had a very large ground-floor garden onto which opened a modest living space, but it also seems to have had a top-floor atelier, served by one of the first elevators in Paris.[13] It is probable that Nadar used both, according to the season and weather, to make the portraits of his friends that he now undertook.[14] The atmosphere was far from formal. His softhearted propensity was to shelter all varieties of strays, and the garden was as filled with Nadar's animals— including dogs, sheep, rabbits, a donkey, and peacocks— as the house was filled with friends and an eclectic and discriminating selection of furniture and objets d'art. The range of Nadar's sitters, even in this rue Saint-Lazare period, was wider than has usually been noticed, extending outside the somewhat self-congratulatory circle of artists, poets, writers, and musicians who were his friends to include philosophers and princes, ambassadors and *cocottes*. The sensitive, carefully thought-out, and ingeniously lit portraits he made of these sitters during the years from 1855 to 1860 constitute the height of his achievements as a photographer and collectively form a resplendent gallery of the most culturally significant and creative Parisians of the period.

Nadar's absorption in photography did not preclude any of his already existing pursuits between 1856, the year his son Paul was born, and 1859. A whirligig of productivity, he published collections of his early stories, edited three different newspapers (a monthly and two weeklies) at once, and incessantly drew caricatures and wrote articles. He stopped long enough only to take his brother to court, to enjoin Adrien from capitalizing on Nadar's reputation by using the pseudonym Nadar and to force him to advertise himself as Adrien Tournachon, rather than Nadar the younger

(*Nadar jeune*). Nadar won the lawsuit on appeal by persuasively arguing that successful portrait photography was not merely a mechanical process but a subtle and ineluctable combination of intuition about light, psychological insight, and rapport with the sitter, united to produce an "intimate resemblance."[15] Just as he was unique and induplicable, so also was the name he had invented and the production of his studio. As Anne McCauley has pointed out, the court case itself provided welcome publicity for Nadar's studio and for his defense of the photographer as a unique artist.[16]

Nadar's portrait business thrived, and in 1860 he needed larger quarters. Therefore he rented a space in a building also occupied by other photographers on the fashionable boulevard des Capucines. He spent a fortune he did not have on expanding, remodeling, and elaborately furnishing the building, transforming it into a sumptuous emporium of cast iron and glass, used as they had been in Paxton's architecturally innovative Crystal Palace, which Nadar had seen at the Great Exposition of 1851 in London. The structural iron of the building was painted red, the color of Nadar's hair and of his name when printed on stationery and the mounts of cartes-de-visite (see p. 29).[17] Across the face of the building sprawled a gas-lit replica of his signature, the large scale of which approximated that of his celebrity. Like all such grandiose projects the costs of the studio were vastly over budget, and it was finished much later than anticipated, not opening until September 1861.[18] The conspicuous building and the reputation of its maker attracted growing numbers of sitters, many of whom were far removed from the Bohemian circle of subjects who had comprised Nadar's original clientele, although few of the newcomers were directly associated with the reactionary court of Napoléon III. As the studio prospered the debts diminished.

Even before the delayed opening of the boulevard des Capucines studio, Nadar's photographic interests had broadened. In 1858 from a balloon stationed near the Arc de Triomphe he made the first aerial photographs. His initial efforts had been spoiled by adverse chemical reactions between the gases escaping from the bottom of the balloon and the collodion coating on his glass negatives. He experimented with making photographs by artificial light—portraits at first, then images of the sewers and catacombs of Paris, the first underground photography ever attempted [FIGURE 3]. For the sewer project he employed very long wires connected to electric batteries above ground, producing a dim but adequate light, and for the catacombs, magnesium flares, which were brighter. With exposures that lasted as long as eighteen minutes he could not animate these scenes with people and resorted to wooden mannequins with human clothes.[19] The Parisians joked that if Nadar could not be found in heaven above he might be in hell below.

Balloons were not simply intended for aerial photography. Nadar became deeply interested in the question of flight and was soon convinced that the answer was in heavier-than-air machines. Paradoxically, he attempted to raise money for experiments with primitive helicopters by staging balloon ascensions, which were already a form of popular entertainment. Most spectators paid to watch from enclosures encircling the launching place. A higher tariff was charged for the few who wanted to ride with the aeronauts. As always, Nadar thought in terms of maximum scale and determined to build the largest balloon possible. Seven kilometers of silk were required to fabricate a balloon, named the Géant, which was 147 feet high and 82 feet in diameter.[20] The wicker cabin suspended beneath it was of two stories, with a platform above and chambers below, including a darkroom. Nearly two hundred thousand people witnessed the Géant's first ascension in early October 1863. The eleven passengers included a princess, who paid for the privilege. The ride was smooth and uneventful but relatively short, as the balloon came down

37

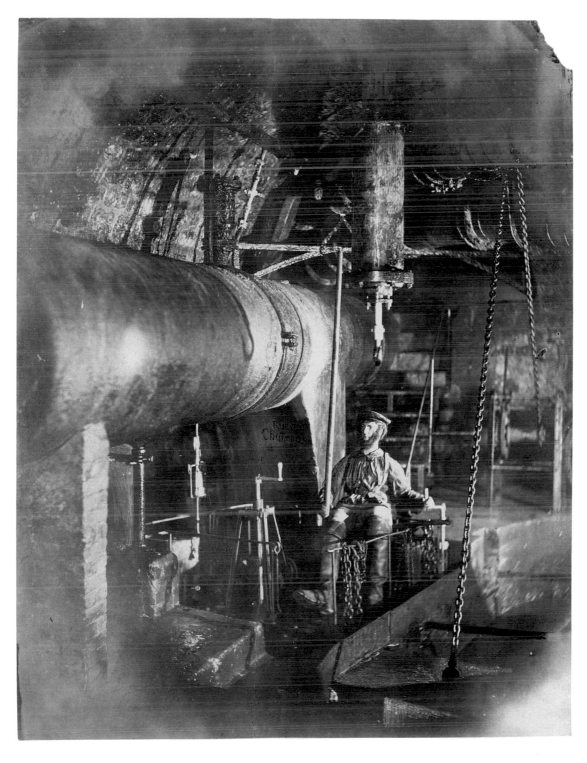

at Meaux, about twenty-five miles away. The second ascension in late October began and ended badly. To Nadar's annoyance, just before the balloon was to lift off he was unexpectedly forced to meet, for the first time, Napoléon III, whose person and repressive regime he loathed. Once aloft, the balloon was initially blown by a brisk breeze over to Belgium, but during the night, while the nine passengers (including Ernestine, whom Nadar had wanted to stay at home) seem to have consumed a good deal of wine, the wind changed and their course altered to the east. When the sun rose and the gas in the balloon warmed and expanded to dangerous proportions, they attempted to descend by letting some of the gas escape. Instead they began to fall, then

FIGURE 3

Nadar, *Rue du Châteaudun*,
1861. Albumen print,
9 5/8 x 7 3/8 in. 84.XM.436.493.

plummet, and suddenly a strong wind caught the balloon sideways, carrying it horizontally across the landscape and dragging the gondola and its passengers along the ground for several kilometers and across a small river. Nadar barely saved himself and Ernestine by sheltering her body in a corner of the platform while desperately holding onto the ropes on either side of her. The weight of the river water caught in the cabin of the balloon slowed and ended their nightmarish ride.[21] The bedraggled and badly bruised passengers learned they had crashed nearly four hundred miles from Paris in the kingdom of Hanover, whose king kindly looked after their hospitalization and recuperation. Undaunted by disaster and intent on raising money to promote heavier-than-air flying machines, before he sold the salvaged Géant, Nadar staged a few more ascents in 1865 and 1867, including one each in Amsterdam and Lyon.

Although in Nadar's aeronautical enterprises he had financial backers like Jules Verne, whose novel of 1865 about flying, *From the Earth to the Moon*, had a hero whose name was an anagram of Nadar's, the tremendous costs Nadar incurred once again left him burdened with debt. The profits from his portrait studio were insufficient to pay his bills, which included fees from the lawsuits arising from the crash of the Géant. His potential income was diminished by his reluctance to mass-produce the wildly popular cartes-de-visite, which he thought inartistic, that were making his photographic rivals, such as Disdéri, rich.[22] His attention to the day-to-day conduct of business had been lackadaisical because of his preoccupation with ballooning and continuation of his other pursuits, including caricature and journalism. Because he had left many of the portrait sittings, save those for such special clients as Sarah Bernhardt, George Sand, Édouard Manet, and Alphonse Daudet, to studio assistants, it was necessary to advertise that he was once again personally involved on a daily basis.[23] Despite the prizes he had won and his exhibitions in foreign cities, by 1866, as he wrote to George Sand, after thirteen years of making portraits, he was bored "with this imbecilic profession."[24] By selling possessions—once he had money Nadar was a relentless accumulator of objects as well as pets—some funds were realized. However, the financial situation was only resolved when Ernestine obtained funds from her family, but wisely made their use conditional on her own active participation in the firm. The care, patience, and good humor she brought to what now was effectively their enterprise reinvigorated Nadar and carried them through the end of the 1860s.

The Franco-Prussian war of 1870, which Nadar had opposed, brought about the fall of Napoléon III, which delighted him. During the siege of Paris that ensued he aided the provisional government by again turning to ballooning in order to survey enemy troop positions from aloft and to send official mail and the dispatches he wrote to foreign newspapers outside of the surrounded city. As usual he expended funds he did not have, this time in the service of a patriotic cause. The Commune followed the siege, and with it chaos and deprivations compounded by the second siege that suppressed it. Nadar was left exhausted and in bad health. In the face of declining studio revenues he was forced to retrench by moving the business, which Ernestine now thought of as a legacy for their son Paul, to simpler quarters in the rue d'Anjou. Nadar lent part of the premises on the boulevard des Capucines that he still leased for the first exhibition mounted by the Impressionists. Although some of them, such as Monet, were friends, his own taste remained faithful to earlier, more academic standards. The look of the portraits made in his studio during this period, often the work of assistants, became increasingly commercial and conventional—more like the productions of Nadar's contemporaries—but the business recovered.

Nadar, now well past fifty, and Ernestine lived more frequently outside Paris at a country house at Sénart, where from 1875 to 1885 Nadar wrote books and articles about his experiences and opinions and sheltered less fortunate survivors from the Bohemia of the 1840s. Paul was very gradually allowed to assume control of the business that he, in fact, was conducting. After Ernestine's debilitating strokes in 1886 and 1887, Nadar's solicitous attention to his wife, whom he had come to think of as the personification of goodness, was unceasing. In unhappy echo of Nadar's troubled relation to his brother Adrien, there were continual financial disputes with his son Paul, from whom he expected an income. This discord was exacerbated by Paul's attachment to Marie Degrandi, an actress his parents thought unworthy of him but whom, after eighteen years of parental resistance, he married in 1894. Finally, in 1895, Nadar wholly relinquished the name he had made famous and the balance of the existing business to his son. Two years later he was strapped for cash when Paul was late in paying the agreed-upon annuity, and bravely, at seventy-six, he started a short-lived portrait studio in Marseilles. In deteriorating health, he went on writing reminiscences, publishing his memoir of the early days of photography, *Quand j'étais photographe*, in 1900, the year in which the Exposition Universelle in Paris featured a retrospective of his work. In 1903 his brother Adrien died after spending ten years in a mental institution. In 1904 Nadar and Ernestine were again living in Paris, where she died in early 1909. Nadar sent a congratulatory telegram when Louis Blériot successfully flew a plane across the English Channel the same year, wholly vindicating his fifty-year-old belief in heavier-than-air machines. On his death in 1910 five funerary orations and three hundred obituaries paid tribute to a long and lucky life filled with events and accomplishments, an operatic life with at least four acts and careers—as writer, caricaturist, photographer, and aeronaut. Among his friends had figured the most important cultural figures of nineteenth-century France, whose fame his photographs had promoted, celebrated, and consecrated. Famous as both he and his subjects were, Nadar's overriding concern had always been the advancement of human progress, and, as his contemporaries realized, his most salient characteristic was an inexhaustible and well-meaning power of will.[25]

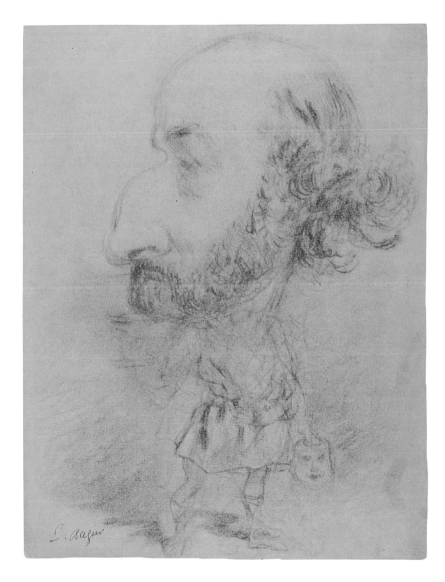

39

FIGURE 4

Nadar, *Portrait of Émile Augier*, circa 1852. Charcoal drawing, 12 3/4 x 9 9/16 in. 84.GG.790.117 [compare p. 119].

His Portraiture

In 1863, in one of his florid inventories of self, Nadar enumerated his several vocations before he finally entered "the Botany Bay of photography": "a former maker of caricatures, an impertinent and untrained sketch artist, a trawler for the little newspapers, and a mediocre author of several novels, disdained most of all by himself."[26] These earlier pursuits necessarily informed the photographic portraits he made. His eye had been trained and exhaustively exercised by the years in which he studied and transcribed faces onto paper, in however exaggerated form. When he photographed persons whom he had earlier caricatured, there were sometimes simple and direct correspondences between drawing and photograph. In the instance of Émile Augier, the caricature is a profile that exaggerated the dramatist's beaky nose, which the photograph, also a profile, emphasized [FIGURE 4; compare p. 119]. Augier is a conspicuous example, but in other cases as well Nadar, having seized upon a prominent physical feature for a drawing, could not ignore the same physiognomy in a photograph.

A more important legacy of his draftsmanship is the isolation of the sitter against a plain background. As has been noticed elsewhere, silhouette is essential in these portraits. Because the photographs are lit so that the sitters do not cast shadows onto the backdrop, they resemble drawings of figures on an empty sheet, which forces the viewer to concentrate on the person alone, not on his or her placement in a space. While Nadar's graphic work is flat and linear, photography gave Nadar the opportunity to use light to sculpt the figure. Often the graduated tone of the backdrop, subtly darkening from top to bottom, parallels the shift from the light tones of the sitter's face and neck linen to the darker clothes below. This simplicity of setting is a hallmark of a Nadar portrait that differentiates it from much of the overwrought portraiture of the 1850s and 1860s and gives it an essential modernity. Other portraits of the period are often cluttered with furniture and painted backdrops to suggest vocation, atmosphere, social station, or affinities with painterly precedents [FIGURES 5, 6]. Nadar places his subjects in an austere and neutral setting, a seemingly empty stage isolated in what was in fact his cluttered studio.[27] The effect is to remove the sitter from a particular era, to make the ambience of the portrait timeless. Similarly, having minimized the setting, Nadar usually downplayed the sitters' wardrobes, particularly if they were men. While it may have been cold in the studio or garden when he photographed Alexis-Joseph Perignon, Gustave Mathieu, and Auguste Vitu (see pp. 77, 71, and 58) so that overcoats were desirable for warmth, the choice of garment may also have been dictated by a desire to simplify

FIGURE 5
André-Adolphe-Eugène Disdéri (French, 1819–1889). *Portrait of a Seated Girl*, circa 1858. Salt print, 9 1/2 x 7 3/16 in. 84.XM.365.24.

40

and solidify the figure. Much men's clothing of the period was dark, but apparently Nadar specifically asked his sitters to dress in dark colors and blacks because lighter colors—blues, for example—did not register properly on the collodion negative materials. The severity of black imparts dignity and implies seriousness of purpose.[28] Although some sitters, such as Eugène Scribe (see p.115), exhibit sartorial flourishes, it is clearly not the clothes that are on view here, except perhaps the uniform of Maréchal Serrano (see p. 95). In the portraits of Aimé Millet, Sarah Bernhardt, Leopold, Count of Syracuse, and to a lesser extent, Benoît-Hermogaste Molin (see pp. 87, 117, 99, and 78), where the sitters are enveloped in drapery, their clothing offers little clue as to status or the period, although allusions are made to earlier art.

By these intentional simplifications attention is directed almost exclusively to the face. Oddly, given their expressive power in traditional portraiture, hands are almost never overtly displayed in Nadar's portraits, but are usually concealed in folds of clothing, tucked in pockets, coats, or vests, or curled over the edge of a table or chair.[29] Because the sitter's hands and arms are held close to the body, with a complete absence of dramatic gesture, except perhaps in the case of Théophile Gautier (see p. 62), an impression of quiet self-possession results. The body itself, whether standing or sitting, is usually somewhat slanted away from the camera, which mildly enlivens the image and makes it marginally less formal.[30]

Having centered the viewer's attention on the subject's face, Nadar wished to make the best of it rather than recording the minutiae of facial topography. Aware that the usual result of making a shiny, hard-surfaced albumen print from a collodion-on-glass negative was an overly critical sharpness of detail, he flattered his sitters by making salt prints, which had softer surfaces and were less precise. Similarly, he seems to have used a lens that produced a slightly less than crisp focus. These factors, combined with the gentleness of the overhead light (in all save his earliest portraits and those made with a primitive form of electric lighting), smoothed foreheads and erased minor facial disfigurations—even if the direction from which the light came exaggerated circles under the eyes. Nadar's sitters appear as attractive as possible.

Nadar's stated principal aim in portraiture was not appearance, but character. He sought (and found) intimate resemblances, moments when the sitter revealed his innermost character. As he said, this aim could only be achieved through the photographer's perspicacity, his insight

41

FIGURE 6

Hippolyte Lazerges (French, 1817–1887) and Adolphe-Jean-François-Marin Dallemagne (French, 1811–after 1872), *Antoine Louis Barye*, circa 1865. Albumen print, 8 3/8 x 6 5/16 in. 84.XP.960.5 [compare p.81].

42

into the sitter's nature, his quick rapport with the sitter, and his tact in penetrating habitual social masks to bring out essential qualities.[31] The clear mark of his presence — rather than one of his assistants — at any sitting is the engagement of the subject with the camera, with Nadar. His long familiarity with many of his subjects was of as great a value as his ability to employ a line of seemingly diverting conversational patter, specifically tailored to draw out the subject, to arrive at and quietly seize the moment when the sought-after familiar and favorable characteristics were expressed. By placing these captured essences in splendid isolation, like a diamond on velvet, Nadar so strongly emphasized these faces, stances, and revealed characters as to transcend the temporal celebrity of specific accomplishments and to achieve iconic fame. The solemn stillness that surrounds these figures is not hermetic, but oracular. No action save being is necessary.

Nadar Catalogue

44 **Ernestine Nadar**
1854/55
Salt print
9³/₄ x 6³/₄ in.
84.XM.436.3

Ernestine-Constance Nadar, née Lefevre (1836–1909), seems at least suspicious and perhaps annoyed at being closely scrutinized by her husband's camera. As this photograph was made near the time of their wedding, it may have been her first sitting—for him or anyone. Over the long years of their marriage he would photograph her repeatedly, and her expression would soften from anxiety to amiability. Despite his occasional lapses in fidelity, their marriage would finally prove to be happy, as is evident from the endearments with which she closed the letters that she wrote to him while on vacation on the coast of her ancestral Normandy.[32] His letters to her are similarly affectionate. She would have much to put up with from this man sixteen years her senior; his financial irresponsibility would continually alarm her Protestant soul and his unremitting loyalty to his artistic friends would try her patience. Her energy and practicality would help to stabilize the running of the studio in the 1860s and 1870s despite Nadar's profligate expenditures of time and money on unrelated activities, principally ballooning. She was continually concerned about providing their son Paul with a viable business as an inheritance. Her devotion to their family interests would be repaid by Nadar's unfailingly solicitous attention to her welfare in the twenty years after a stroke incapacitated her in 1887. He came to refer to her as an angel, of unbounded goodness and perfection, as having been always better than he.[33] She died at seventy-one in 1909 and he, just short of ninety, died a year and a half later.

This staunch and plucky woman with her arms folded against the onslaught of the lens, is seated aslant on a straight chair that gives her additional backbone. Over her white bodice with its starched and scalloped flat collar she chose to wear a sober, short-sleeved jacket of dark, vertically banded velvet. A ring and an earring are her only jewelry. The even lighting on her face and the visible shadow she casts on the back cloth mark this as a photograph of Nadar's earliest period, made while or just after the brief period when he worked in collaboration with his brother Adrien.

Ernestine Nadar 1854/55

Ernestine Nadar in Ballooning Costume circa 1863

Attributed to Nadar
**Ernestine Nadar in
Ballooning Costume**
circa 1863
Nine albumen prints
on one mount
Each, 3³/₈ x 2³/₁₆ in.
84.XM.436.492

However much she may have deplored Nadar's enormous expenditures on his ballooning experiments, as they depleted if not destroyed the finances of the photographic studio on which the family depended for a living, Madame Nadar backed him in the enterprise. Women's clothing of the 1860s, particularly the fashionable, enormous crinoline skirts, was clearly unsuitable for balloon ascensions, so she adopted men's clothing tailored to her specifications, including a soft-brimmed bowler hat into which her hair could be tucked. Among her accessories in some of these nine poses are what appear to be a case for binoculars and the anchor for a balloon, used when descending, as if it were a grappling hook, to attach to a tree or the ground.

Her support of Nadar's aeronautics was not limited to dressing in men's clothing and posing as if she merely intended to ride in a balloon. On the second ascension of the enormous Géant, on October 18, 1863, she accompanied her husband and the seven other passengers, who were unexpectedly seen off from Paris by Napoléon III and the king of Greece. When turbulent winds obliged Nadar and his companions to forcibly land the craft the next day in Germany, the still partially inflated balloon dragged the cabin section along the ground for a long distance and across a small river, seriously injuring all its occupants. Nadar apparently saved both his life and Ernestine's by shielding her body in a corner of the ropes.[34] For that ascension she had worn some sort of normal women's clothing.[35] Her garb in these nine photographs in the carte-de-visite format indicates that, always practical, this brave woman intended to be more suitably dressed in the future. This set of photographs becomes a testament to her undaunted survival.

Nadar himself was not much interested in the production of cartes-de-visite, finding them to be a commercial exploitation of the medium with few redeeming values, but those he did make, in a bow to financial realities, were staged against the plain backgrounds that he utilized for his larger-scale portraits. These, then, were made somewhere other than in his studio, but because it seems unlikely that his wife would have posed for another photographer, may be attributed to Nadar.

47

**Three Self-Portraits
as an Aeronaut**

circa 1863
Albumen print
cartes-de-visite
$3^{1}/_{2}$ x $2^{3}/_{16}$ in.;
$3^{1}/_{8}$ x $2^{3}/_{16}$ in.;
$3^{1}/_{16}$ x $2^{3}/_{16}$ in.
84.XC.873.5906
84.XM.436.394
84.XM.343.1

Despite their small scale, these three cartes-de-visite were meant by Nadar to promote his extremely costly ballooning ventures, the paradoxical, eventual intent of which was to prove that heavier-than-air machines were the way to conquer air. The circulation of images of himself seemingly rising into the sky in the gondola of a balloon might attract more paying spectators to the balloon ascensions he staged. Since cartes-de-visite sold for low prices, the sale of these images in themselves would not have produced significant income to defray aeronautical expenses. Instead they were likely given away as publicity, although Nadar used the back of one of these to write a note urging his assistants to make a certain Madame Grandet at home in the studio.

The photographs are a mixture of self-aggrandizement and profit seeking, and at least to a modern eye, they are also humorous for their incongruities. The woven basket in which Nadar poses is likely a laundry hamper, suspended on ropes in the studio.[36] It is too small to comfortably carry a man for any distance, particularly if he were kneeling inside it as Nadar, who was five feet ten inches, must be doing. To give a modest illusion that he is flying, he has had a backdrop of clouds painted to put behind his pretend balloon. He may have chosen dandyish clothes—including the silk top hat and the Scotch plaid that is jauntily tossed over one shoulder—in order to imply that ballooning was a safe, even gentlemanly enterprise, in which money could be judiciously invested. His binoculars advertise the view to be had from on high and the anchor adds a note of authenticity. Despite his earnest expressions, it is hard to imagine that he was not having fun while making these photographs, even if they were meant to serve an enterprise that he took very seriously.

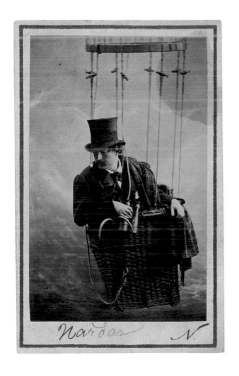 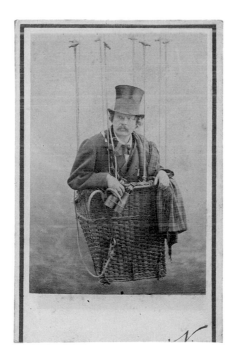 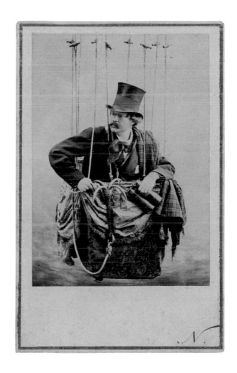

Three Self-Portraits as an Aeronaut circa 1863

50

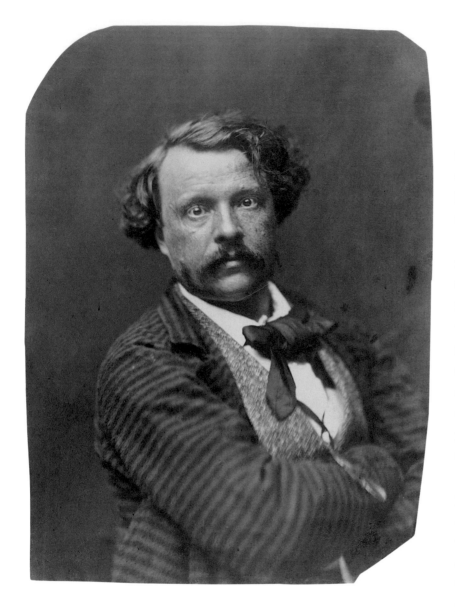

Self-Portrait
1856/58
Salt print
7 1/8 x 5 1/4 in.
84.XM.436.22

Self-Portrait
1856/58
Salt print
9 1/4 x 7 1/4 in.
84.XM.436.7

In the self-portrait on the left, Nadar's myopia makes him appear to be intensely staring at the camera, producing the (accurate) impression of his unremittingly forceful personality. Suspended on a velvet ribbon, his eyeglasses dangle over one of his wrists. To give an impression of spontaneity he may have intentionally arranged for them to be visible, since in the process of crossing his arms they would more naturally have fallen between his arm and chest. This image has something of the look of a person trying out an attitude in a mirror, and it is possible that a mirror was used to study its composition. The close-in intimacy of the photograph is the result of its edges having been (very roughly) cut down so that the head and shoulders fill most of the frame.

Nadar's figure in the self-portrait at the right is statuesque in its immobility. His arms are (again) folded and his hands lost in the folds of his sleeves, as if he were resistant to the idea of showing his hands. His expression is unyielding, his gaze directed offstage. For a photographer who was so gifted in drawing out the essential traits of his sitters he seems determined here to create a particularly serious presentation of himself. The result is uncharacteristically inexpressive.

Although by this time Nadar was an entrepreneur, in keeping with his self-image as an artist and a Bohemian his clothes in both these photographs are informal combinations of disparate elements. At left a soft horizontally striped jacket is coupled with a woven, patterned vest. He wears a silk tie and white shirt in both images. At left, the tie is loosely knotted into a bow with drooping ends, at right it is so askew as to appear to be barely tied at all. At right, his long, baggy, fashionable coat resembles a painter's smock.

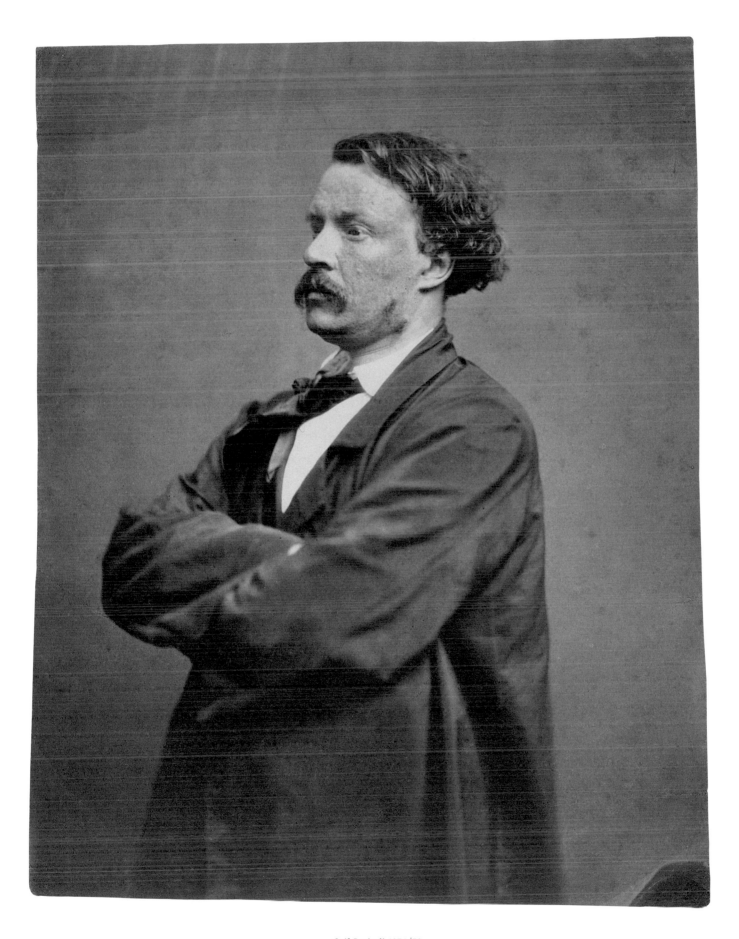

Self-Portrait 1856/58

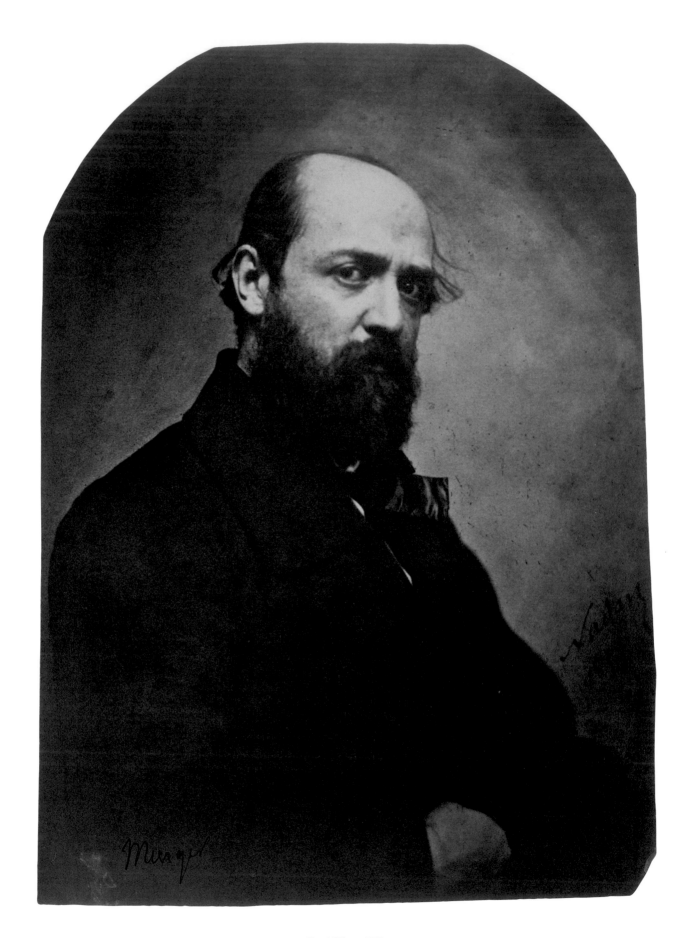

Henri Mürger 1857

Henri Mürger

Negative of 1857
Later salt print
9¹/₈ x 6¹/₂ in.
84.xm.436.316

The turbulent life of the writer Louis-Henri Mürger (1822–1861) originated and epitomized the durable myth of a starving artist struggling to survive in a garret in Paris. When Mürger was twenty and thought himself a poet, his father, a tailor who disapproved of his son's artistic aspirations and companions, threw him out, leaving him dependent on his meager salary as a part-time secretary to a Russian diplomat. He found shelter with his friends, who were not-yet-famous poets, artists, writers, and musicians. The short stories Mürger wrote about the antics of this circle—their attempts to attain artistic recognition, their transitory love affairs, their windfall extravagances, their desperate attempts to stave off destitution and the illnesses that accompany poverty—made him famous. His tales were serialized in newspapers between 1845 and 1849, published as a book, *Scènes de la vie de Bohème*, and stitched together to make a play. Mürger's stories are the source for Puccini's opera of 1896, *La Bohème*, which perpetuated (and further romanticized) the legend. These ironic accounts encapsulated and celebrated the Bohemian milieu in which both Nadar and Mürger were conspicuous figures. Nearly abandoning journalism, which had provided him intermittent income, Mürger wrote more Bohemian sketches, occasional plays, and

novels, including one about his current mistress and two others about life in a village, on the edge of the forest of Fontainebleau, where he had lived for a few years. Only his vignettes of artist's lives are now remembered.

Through mutual friends who were the shared subject matter for Mürger's stories and Nadar's caricatures and through employers in common, such as the newspaper *Le Corsaire*, and through the public and private places where both lived, Nadar and Mürger's lives were thoroughly entwined in the 1840s. Their deep friendship ended only when Mürger, weakened by hardship and dissipation, at the age of forty died in Nadar's arms. Shortly afterward Nadar joined two friends in writing a memorial book that included Mürger's letters. It may have been at this time that Nadar rephotographed his 1857 portrait of Mürger to make this tombstone-shaped print.[37] Mürger's beard and moustache flow down into his clothes to form a black pyramid above which his strong nose, deep eyes, and great domed forehead float. Hair wisps away to the one side, softening his worn features. Mürger appears much older than his thirty-five years and his eyes are oddly wary as he looks over toward the camera and one of his closest friends.

53

54 **George Sand**
circa 1864
Albumen print
9 1/2 x 7 1/4 in.
84.XM.436.91

By the time Nadar photographed the prolific Romantic writer George Sand (1804–1876) she was famous. To her real accomplishments as a writer of novels, essays, articles, memoirs, plays, and letters, she had added celebrity derived from her unorthodox mode of life; as a young woman, she had occasionally smoked cigars and worn men's clothes in public.[38]

Born Amandine-Aurore-Lucile Dupin, Sand's lineage was a tangled mix of patrician and plebeian. She was largely brought up by her aristocratic, although illegitimate, paternal grandmother on an estate at Nohant that Sand inherited (and cherished); she would intermittently reside there for the rest of her life. She compensated for her haphazard early education and five years in a convent school by voracious reading in philosophy and literature. After the first two years of their marriage in 1822, her husband Casimir Dudevant, a country gentleman and vastly her intellectual inferior, was chronically unfaithful and often drunk. In 1831 she fled to Paris and in order to earn money turned to writing, at first in collaboration with Jules Sandeau, from whose name she derived her pseudonym. In the following two decades she published a profusion of novels, essays, articles, memoirs, and pamphlets. Her fiction was usually drawn from the details of her incredibly turbulent private life, including her numerous extended liaisons with distinguished men, most notably the poet Alfred de Musset and the composer Frédéric Chopin. The beliefs set forth in her essays, although unremittingly idealistic, were shifting tides of religious mysticism, socialism, and feminism. Despite frequent emotional crises and changes of scene she was steadily productive and her writing, which was characterized by its fluidity and vitality, its versatility of style, and its expansiveness of spirit, sold well. Throughout her life her friendships were with the most distinguished writers, musicians, and poets of her time.

Surprisingly, Sand and Nadar do not seem to have come in contact until 1853, when she refused to sit for a drawing he proposed to make of her in order to include her in the lithographic *Panthéon*.[39] Their friendship developed quickly, however. She was named as a godmother for Nadar's son Paul, presumably shortly after his birth in 1856.[40] The same year Nadar dedicated his first collection of stories to her "with fervent enthusiasm and profound respect," while she described him in a preface to one of his later books as "a great logician and a man of firm will."[41] Sand chose this dress of watered silk with passementerie embellishments in jet at the shoulders and wrists for some of the portraits Nadar made of her on this occasion.[42] Her hair is held in a netted cap and she is clearly corseted.[43] At sixty, her hard-won tranquillity is evident in the sympathetic benevolence of her expression.

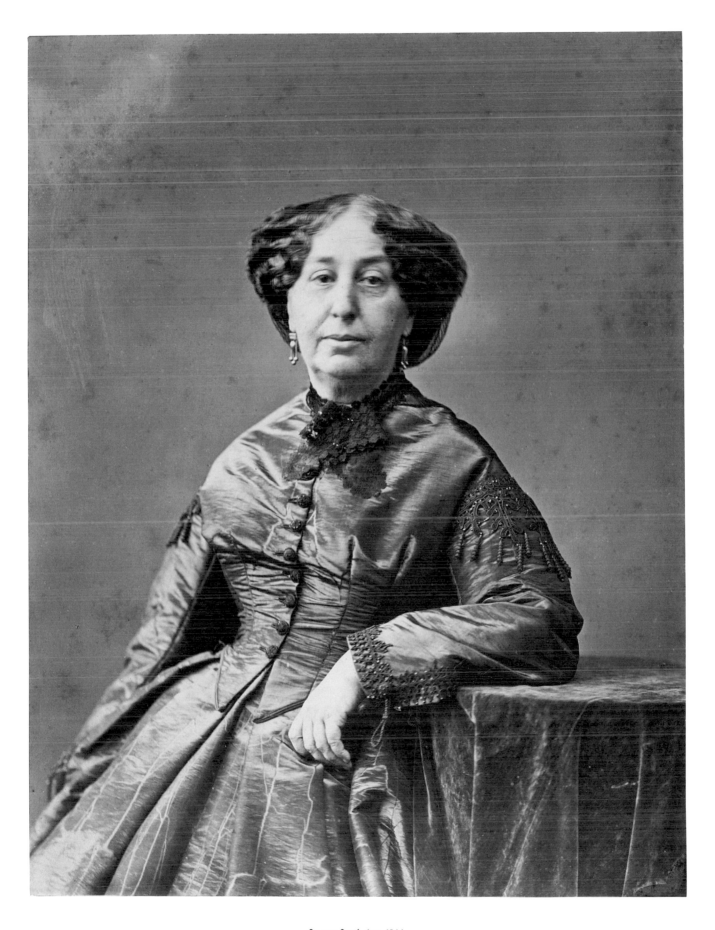

George Sand circa 1864

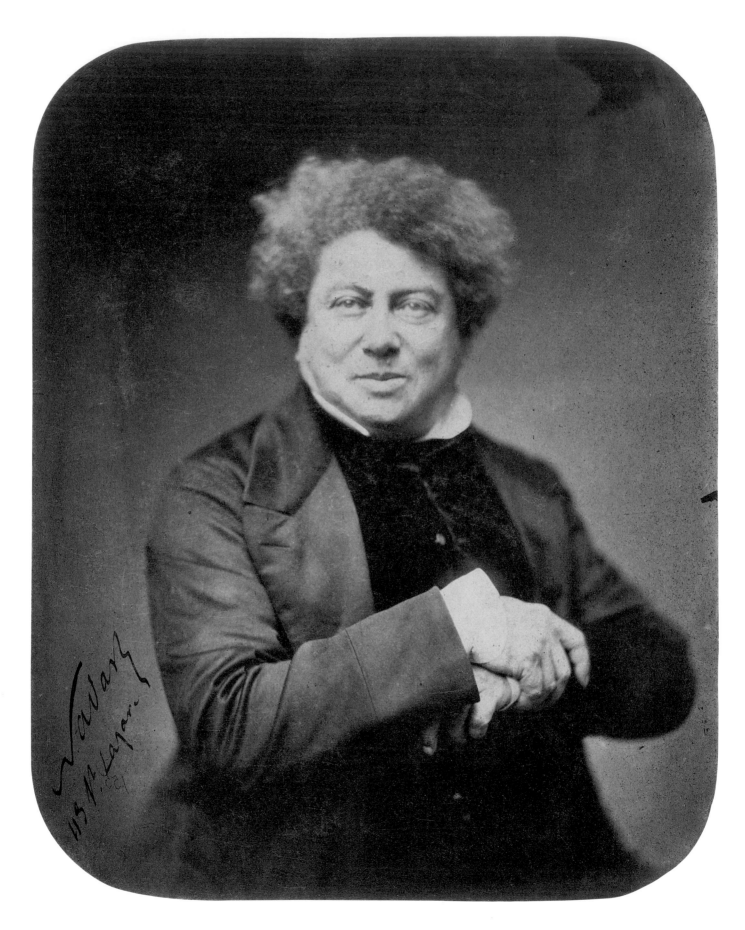

Alexandre Dumas 1855

Alexandre Dumas

1855

Salt print

9 1/4 x 7 3/8 in.

84.XM.262.4

The life of the prolific writer Alexandre Dumas (1802–1870)[44] was as filled with incident as one of the torrent of plays and novels that poured from his mind and pen for forty years. Among his immediate ancestors were an aristocrat, an innkeeper, a general, and a slave. Arriving in Paris in 1822 with no money, little education, slight experience as a notary's assistant, and a desire to write plays, his handsome calligraphy landed him a daytime job as a librarian. A mixture of love, death, political intrigue, and (shallow) historical detail made his melodramatic play *Henry III and His Court* a sensation in 1829. No longer a librarian, Dumas repeated his successful recipe in a horde of plays and a host of novels, of which the most famous are *The Three Musketeers* and *The Count of Monte Cristo*. Assistants, often uncredited, enabled his lucrative productivity, which was necessitated in part by his complicated, quasi-promiscuous domestic arrangements and by his prodigious expenditures on parties, mistresses, yachts, and a chateau. His prose style was vivid, if slapdash, more like lithography than engraving; his imagination, fertile if slightly infantile. The man was adventurous and affable, gregarious and popular, and a brilliant marathon talker. Recent critical opinion more highly values the plays than the novels, but the latter are perennial favorites, at least for the young.[45]

Because Nadar's father, Victor Tournachon, was the publisher, in the very early 1830s, of one of Dumas's first plays and of an essay about France, the soon-to-be-famous author

and the boy who would grow up to become Nadar met early on.[46] Their contact was limited until Nadar emerged into the Parisian literary world on his own, although when Nadar was seventeen, living in Lyon and first trying to write for newspapers, he reviewed a comic opera with a libretto by Dumas.[47] By the 1850s they were in frequent contact; they contemplated writing a play together, disputed the merits of various actresses, dined together, and once went to the races in a carriage with an actress and her Circassian servant, whose flashy tribal dress Nadar found embarrassing.[48]

The solidity of the pose in Nadar's portrait bespeaks Dumas's gigantic frame, which was no doubt augmented by his gourmandism. The sitter's hands are visible (rare in Nadar's portraiture), comfortably folded over the back of the low chair that he straddles. Dumas's hair foams electrically above his broad forehead, catching the light that fully illuminates his broader cheeks and jowly neck. For a voluble and expansive man his facial expression is unusually restrained, amiable but momentarily still and subdued, with full lower lip in voluptuous contrast to the intensity of his eyes. He is clearly a man of the world, at ease anywhere, even in front of the camera. This print was affectionately inscribed by Dumas to Henri Mürger, after whose early death in 1861 it probably reverted to Nadar, who was present when Mürger died.

57

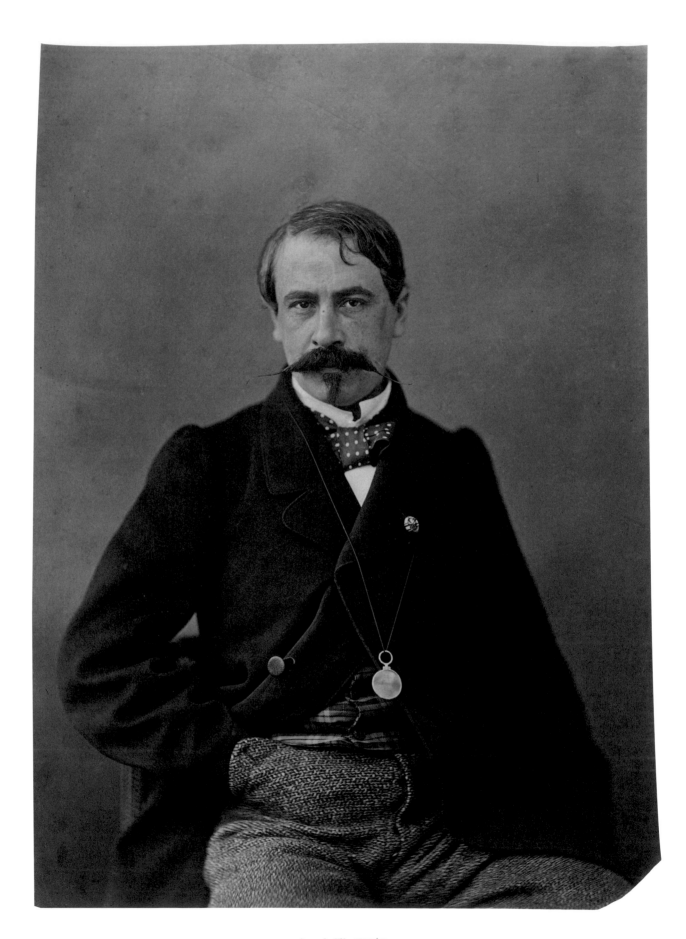

Auguste Vitu 1860/61

Auguste Vitu

1860/61

Salt print

9 11/16 x 7 1/16 in.

84.XM.436.35

While nominally employed as a minor government functionary at the very beginning of the 1840s, Auguste Vitu (1825–1891) wrote comedies for second-rate Paris theaters. By 1842 he had begun to contribute articles to several of the short-lived literary and artistic newspapers of the period, including *Corsaire-Satan* and *Charivari,* for which Nadar also occasionally worked. By 1844 both were journalists and living in garrets in the narrow rue des Canettes, across which they carried on aerial conversations.[49] Vitu, like Nadar, was a member of the Societé des gens de lettres. He once collaborated on a novel with Mürger, but despite his Bohemian friends and origins, with time Vitu became increasingly conservative politically. A jack-of-all-literary-trades, he revolved through the editorships of several small newspapers and was by turns editor, political or military historian, drama or literary critic, and writer of fiction and financial manuals. His strongly expressed opinions occasionally led to legal problems; he was prosecuted for exciting enmity among citizens and for defamation of character. The latter charge led to a fine and a month-long prison sentence in 1872. The widespread variety of his activities resulted in the real erudition that informed his vivacious writing.

By the time Vitu sat for Nadar in 1860, his appearance betrayed his political opinions. His pointed and waxed mustache and goatee, modeled on those of Napoléon III, labeled him as the Bonaparte sympathizer that he was. Nadar detested the reactionary politics of the Second Empire and lamented the fact that a man as spirited as Vitu should sink so low.[50] That verve is reflected in the intensity of his gaze. His clothing is natty. His close-cut heavy coat with piped edges, plaid vest, salt-and-pepper tweed trousers, and polka-dot cravat mark a man careful with his appearance, at odds with the fact that his hair appears to want washing. A monocle hangs from a cord secured in his lapel by a decorative button. It is perhaps a measure of the growing distance between him and Nadar that he appears somewhat inscrutable, determined to hold his own against the camera.

59

Marceline Desbordes-Valmore April/May 1854

Marceline Desbordes-Valmore

April/May 1854
Salt print
$7^3/_4$ x $5^7/_8$ in.
84.XM.436.141

That Nadar was able to persuade Madame Desbordes-Valmore (1786–1859) to sit for him at the very beginning of his career as a photographer had much to do with the reputation he had already gained as a caricaturist of literary and artistic circles. Her career, to which she had been late in coming, was nearly over. Although her name is now obscure, she was in her day a well-known Romantic poet, highly praised by her peers.

When her artisan father lost his money and vocation during the French Revolution, she sailed with her mother to Guadeloupe, where they hoped that they would find shelter with a supposedly rich relation. The relative proved impecunious and the mother soon died of yellow fever. Returning alone to France, Desbordes-Valmore became an actress and singer to capitalize on her attractive appearance, intelligence, and supple voice. She had considerable success, but about 1816 her voice so deteriorated that it caused her, she later wrote, to cry.[51] She gave up the theater shortly after marrying a less than wholly talented actor, and soon began to publish poetry and an occasional novel. Writing proved to be her lasting métier.

Her verse, like her character, was characterized by its sweetness of spirit. Much of it tended to reverie—principally to musings on the sufferings and vagaries of love; love lost, found, renounced, and unrequited. Some of this work was inspired by a man with whom she had had a child before her marriage, but more by later palpitations of her heart. Rather than idylls of love, her poems are often elegies, though some concern themselves with family life and her childhood. Reflecting the music she continued to hear in her head, words were less images than notes to her.[52]

When Nadar photographed her she was sixty-eight. She came to the studio with her husband somewhat reluctantly, citing her age and "the cruelty of the sun."[53] The resigned sadness of her weathered face bespoke not only climate, but also the difficulties of her eventful life and of the deaths in recent years of her brother, two sisters, two daughters, and most of her closest friends. A more conventional woman would have worn mourning clothes. Her garments seem an odd combination of elements: the wide tartan bonnet strings over the cotton-embroidered muslin at her throat, the two-tiered white-work cuffs foaming out above her wrists, and the black lace mitts. On her head she wears a black lace kerchief, held by round ornaments, and a patterned scarf or bonnet. Nadar has focused the camera so carefully on her face and figure that the curved chair on which she sits and its shadow on the wall recede into imprecision. In later photographs even these indications of setting would wholly vanish because of his desire to concentrate attention on the person, not on incidental details of place. Five years later Nadar would photograph her on her deathbed.[54]

This is the only known print of this image.

61

Théophile Gautier circa 1856

Théophile Gautier

circa 1856

Salt print

10 1/2 x 7 3/4 in.

84.XM.436.127

In the turbulent universe of Paris intellectual life in the nineteenth century, Théophile Gautier (1811–1872) was so indefatigably active as to sometimes appear more a constellation than a single star. Industriously, he wrote three substantial novels, five ballets, eight volumes of poetry, twelve plays, a dozen travel accounts, about forty books of short stories, and literally thousands of newspaper articles of literary, theater, opera, music, and art criticism. To all this writing he brought an extensive vocabulary, an encyclopedic knowledge derived from prodigious reading, and a distinct artistic empathy developed in part from his early studies as a painter. Although recent critics have complained that he was not above publishing the same phrase twice, they acknowledge his abilities to write about nearly anything with a high degree of perceptiveness.[55] He can perhaps be summarized as an adept and ardent champion of aesthetic individualism.

Gautier was often photographed, by Nadar and others, and Nadar thought him photogenic and handsome.[56] They were close friends who had known each other since 1839,[57] and Nadar referred to the writer as "the good Gautier," "the faultless Théo, the invaluable and charming poet, cradled in the haze of his oriental somnolence."[58] By setting the camera low and close to Gautier so that he towers over it, Nadar so heroicized his sitter that he resembles the massive sculpture of Balzac that Rodin made at the end of the century. Wrapped in a wool plush coat with his disheveled hair capped by a brocade smoking cap, Gautier has struck, with Nadar's encouragement, a Napoleonic pose, as if gazing at a distant horizon.[59] Nadar's use of raking light from above and to the side throws Gautier's prominent features into high relief. Starting from the stark white of the linen at his throat, his substantial form melts floorward into the dark. The cooperation between photographer and poet has the overall effect of causing Gautier to seem more formidable than perhaps he actually was, to make him into a mythic figure deserving a prominent place in Nadar's pantheon of literary Paris. Although it was always in Nadar's interest to sell prints of his portraits by emphasizing the importance of his sitters, it was his sincere belief in his friend's genius that led him to make a monument of Gautier.

63

64 **Alphonse Daudet**
circa 1861
Salt print
8³/₄ x 6¹³/₁₆ in.
84.XM.436.498

Dreamily romantic and physically frail, Daudet (1840–1897) sat for Nadar in the early 1860s soon after the launch of his career as a poet, playwright, and writer of fiction. Born in the south of France, he arrived in Paris at age seventeen with the intention of becoming a writer. His first volume of poetry, *Amoureuses*, was published a year later in 1858, his second in 1861, and his third and last in 1863. Taken up by the Empress Eugénie, for five years he was the private secretary of the duke de Morny, a highly placed political operative who was an illegitimate half-brother of Napoléon III, and who also sat for Nadar. Daudet's exposure to the corrupt world of politics in which Morny moved would later provide him with material for some of his novels. He was a prolific and versatile writer, shuttling with facility from comic novels to plays, from journalism to personal memoirs, from satires on academia to stories for children. All these met with popular success but their superficiality has not commended them to more recent critics.[60] His most famous work, *Lettres de mon moulin*, a collection of short stories in the form of imaginary letters, celebrated the traditional folklore and rustic vigor of his native Provence.

First published in newspapers, their charm, sensitivity, and pastoral simplicity have made them a staple of French literature. Among his friends were Flaubert, Turgenev, Zola, and the Goncourt brothers.

In Nadar's portrait Daudet's pose seems wholly unassuming, his right hand toying with the fringe on the arm of the chair in which Nadar sometimes posed sitters in the early to mid-1860s in his boulevard des Capucines studio. The apparent informality of the pose is not accidental, but the result of Nadar's intention to show the modesty of a very young poet of amiable temperament and diffident demeanor. The light that Nadar arranged falls from the upper left, crisply delineating the smooth lines of Daudet's forehead and cheek, and so illuminates his hair as to turn its color from black to brown. His gaze is directed to some farther part of the studio but is not without intensity. Ten years later, as a well-known writer, Daudet would again face Nadar's camera, but this time head on, self-confidently, the beard that had been a wisp luxuriantly tumbling past his jaw and obscuring his chin and sensuous lips.

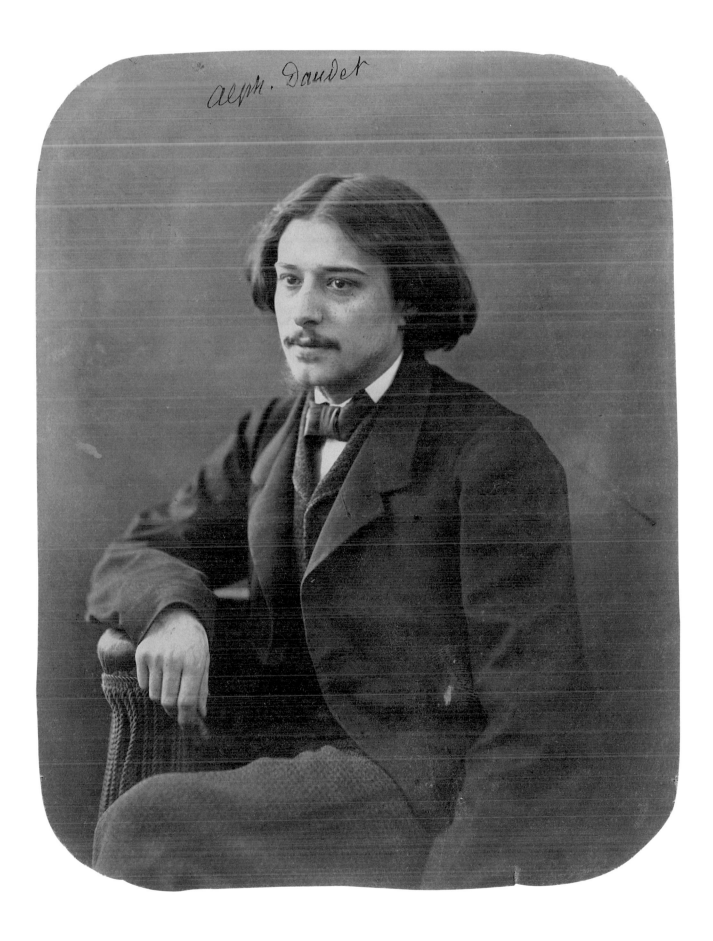

Alphonse Daudet circa 1861

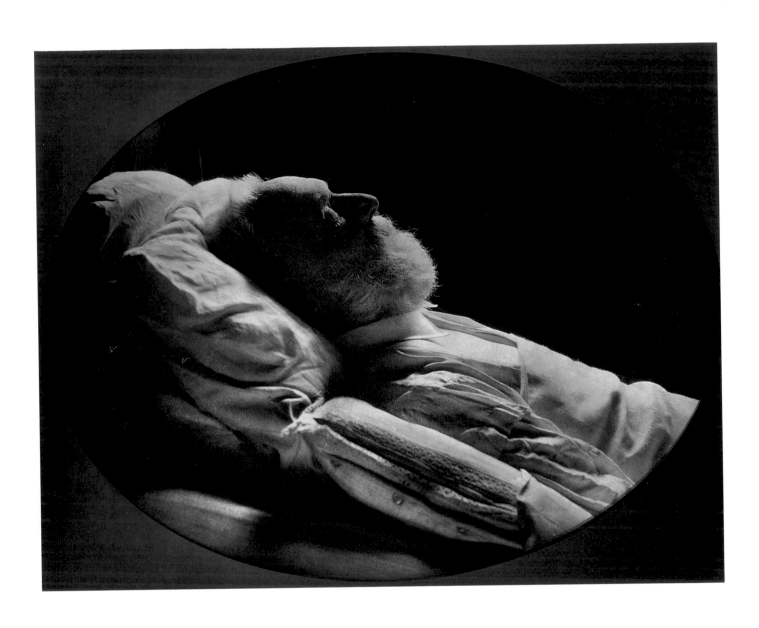

Victor Hugo on His Deathbed 1885

**Victor Hugo
on His Deathbed**

1885
Woodburytype
by Paul Nadar,
circa 1920s
7³⁄₈ x 9¹⁄₂ in.
84.XM.1037.11

Poet, playwright, novelist, and polemicist, Victor Hugo (1802–1885) was thought during the nineteenth century to be France's greatest writer. As Hugo was the son of a general in the Napoleonic wars who was often posted outside France and whose marriage was unstable, the writer's childhood and education were geographically and emotionally fragmented. He began to write while still a schoolboy, and his fervid and fluent poetry, an early manifestation of Romanticism for which he would be a noteworthy spokesman, was first published when he was twenty. His first novels soon followed. Controversy and censure surrounded his plays: the preface to *Cromwell* in 1827 was a Romantic declaration of war against Classicism, the opening night of *Hernani* in 1830 was close to being a riot, and *Le Roi s'amuse* in 1832 was banned after its first performance. The hunchbacked bell ringer in his novel *Notre Dame de Paris* is an indelible character; the chase through the sewers in *Les Misérables,* an unforgettable scene.[61] His personal life was troubled. His wife was conspicuously in love with another man; his favorite daughter drowned and another went mad. Politically he evolved from royalist to imperialist to republican and wrote in support of each political position. A talented amateur artist, he was interested in photography and at one point contemplated illustrating a book of his poems with photographic negatives.[62] By the time of his death he was revered. His body lay in state under the Arc de Triomphe, and he was interred in the Panthéon.

After the middle of the 1860s Nadar was seldom in the studio himself except when persons who were important to him appeared there for sittings. Such was the case with Victor Hugo, whom Nadar thought admirable for his defense of personal liberty and for his literary preeminence, placing him at the head of the procession of writers in both a strip of caricatures in 1852 and in the lithographic *Panthéon* of 1854.[63] Because Hugo was an outspoken opponent of Napoléon III's assumption of imperial power in 1852, he was forced into exile and only returned to France after the fall of the Second Empire in 1870. Nadar photographed him then and again in 1884.[64] When Hugo died in 1885 Nadar went to his deathbed to make a final image to memorialize the great man, as he had similarly commemorated George Sand, Marceline Desbordes-Valmore, and Gustave Doré. The whole aura of Hugo's being seems to have come to reside in his glowing beard in this uncannily illuminated portrait. A sketch by Nadar of the death chamber shows that black drapery was tied across a window behind the bed and then to one of the bedposts in order to visually isolate Hugo's recumbent figure against a somber background.[65] A mirror was used to reflect light back from the window to provide detail in the shadow area. Paul Nadar made this print in the 1920s from his father's negative of 1885.

67

Auguste Vacquerie
circa 1865
Salt print with
ink wash
10 1/8 x 8 1/8 in.
84.XM.436.449

In a strip of caricatures in 1852 Nadar portrayed Victor Hugo with a train of persons hitched to his coattails as he starts to climb Montparnasse.[66] After Hugo's engine, Auguste Vacquerie (1819–1895) is next in line, with Hugo's sons and other disciples following after. Nadar's joke refers to Vacquerie's adulation of the great writer and to the fact that Vacquerie voluntarily followed Hugo when he was forced into exile on the island of Jersey after Louis Napoléon's coup d'état of 1851. Vacquerie, a poet, playwright, collector of paintings, and an occasional art critic of real verve, had been admitted to Hugo's intimate circle as a very young man. His connection to Hugo was strengthened by his brother Charles's marriage to Hugo's daughter Léopoldine, although the couple soon drowned in a boating accident. While on Jersey, Vacquerie continued to write for the stage, grew the beard he wears in Nadar's portrait, and having learned photography from Hugo's son Charles, made a series of photographs documenting Hugo, Hugo's wife, their companions in exile, himself, his cat, and the local landscape.[67] Thus for a short time Vacquerie was a photographer, one of the very few of whom Nadar made a portrait.

In order to compete with more traditional portraiture, photographers of the 1850s and '60s frequently employed artists to embellish their images. In this practice Nadar was not an exception, although few painted photographs from his studio have survived.[68] In this example the surface of the print is nearly entirely covered by layers of various density of reddish-black ink, which has the overall effect of coarsening the image. Although the ink has been skillfully applied, particularly in the hair and beard, the subtlety of expression around Vacquerie's eyes has been lost and the shape of his mouth distorted.[69] The retoucher also radically changed the shape of Vacquerie's left sleeve, painting out a billowing wrinkle in order to simplify the silhouette. These "artistic" interventions distance the viewer from the sitter and are in seeming disharmony with Nadar's photographic aesthetic. With his photographic sensibilities Vacquerie may have rejected the painted proof, causing it to remain in Nadar's studio.

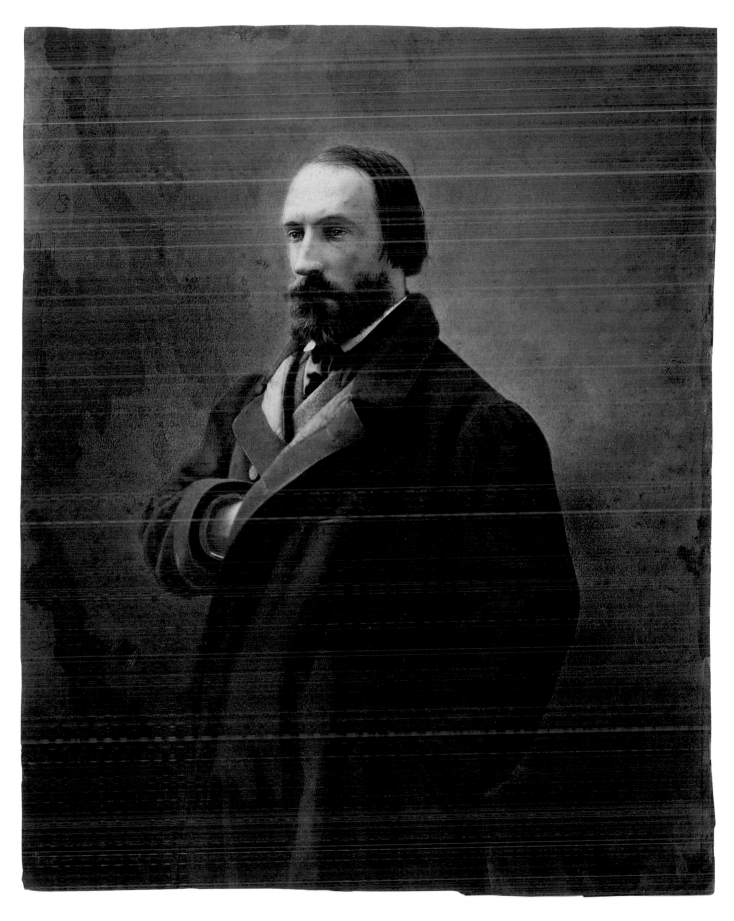

Auguste Vacquerie circa 1865

70 **Gustave Mathieu**
1855–59
Salt print
9 7/32 x 7 3/16 in.
84.XM.439.19

Many of Nadar's sitters were already famous when he photographed them; others became well known later in their lives. But throughout his portrait-making career some people whose images he made have now passed into obscurity. The poet and editor Gustave Mathieu falls among these. Neither his birth nor death dates are now known. Aside from this photograph, the remaining records of his life are slight. He published at least one volume of poetry in 1855, *La Légende du grand étang, veillée,* and contributed to an anthology of poetry published in the spring of 1853, *Chants et Chansons de la Bohême.*[70] It is this second volume that links him to Nadar and his circle. Not only did it include poems by friends of Nadar like Henri Mürger and Charles Vincent, it was illustrated with twenty-six "pretty"—as it said on the title page—drawings by Nadar. These had been rendered as woodcuts by Noël Eugène Sotain (born 1816), who also worked extensively for Gustave Doré. The three of Mathieu's poems in the collection dealt with rustic revelry, the coming of spring (in rhymed couplets), and a romantic ruined castle. In the later 1850s

and perhaps into the 1870s Mathieu edited almanacs related to winemaking and once collaborated with Auguste Luchet on a vinicultural publication.

Weary, if not haggard, Mathieu looks out at the viewer from Nadar's portrait with an expression made inscrutable by the cloud of moustache and beard that wholly obscures his mouth. His slight figure is nattily clothed, in tartan vest, nubbly tweed trousers, dark jacket, and overcoat. (The overcoat may have been desirable for warmth, because at this period many of Nadar's portraits were made in the garden of the rue Saint Lazare studio.) The brilliant white of his starched shirt and collar, separated by his stiff ribbon cravat, forms abstract slashes across the surface of the photograph, more intensely brilliant than the highlighted forehead and nose of his deeply shadowed face. Mathieu may no longer be a known name, but the fact that this is a mounted edition print indicates that Nadar thought there was public interest in his image.

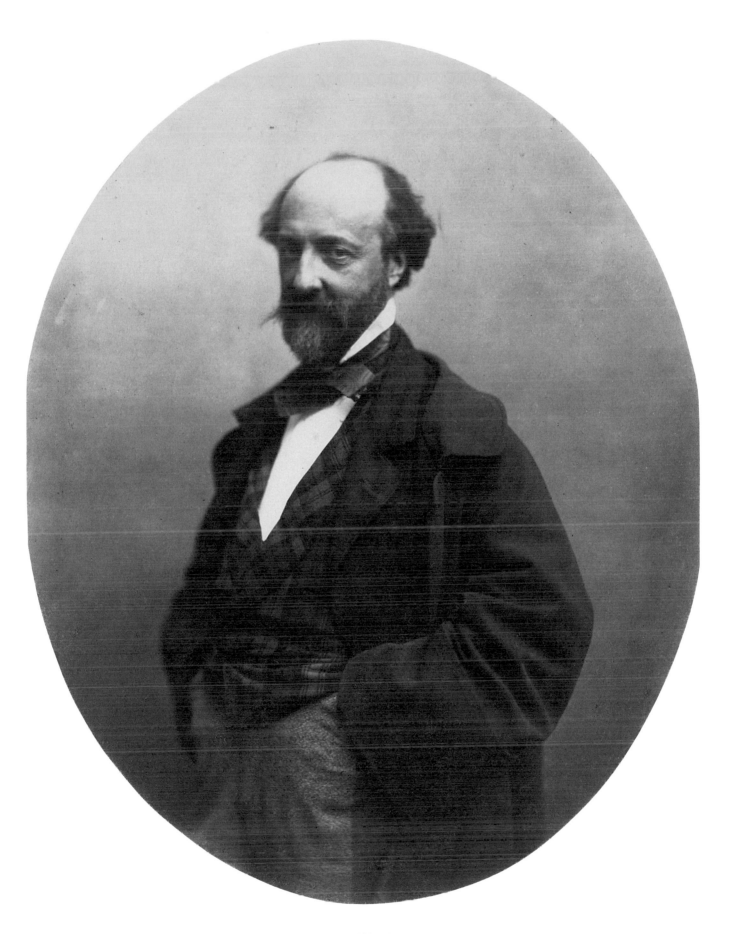

Gustave Mathieu 1855–59

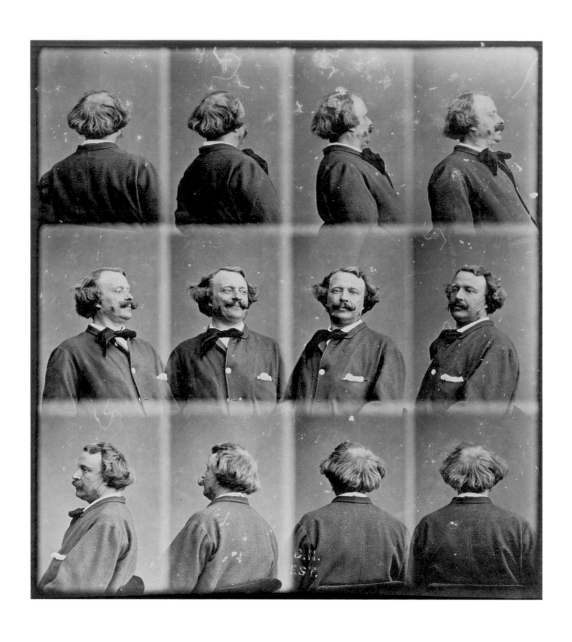

Self-Portrait circa 1864

Self-Portrait

(study for a
photo sculpture)
Negative circa 1864
Later albumen print
5 $^3/_4$ x 5 $^1/_4$ in.
Bibliothèque
Nationale de
France, Paris
Département des
Estampes et de
la Photographie
Est. Eo 15b petit
folio tome 1

*Note: Exhibited only
in Los Angeles.*

The exact genesis of this series of self-por-
traits is unknown, but it seems to be closely
related to an enterprise in photo-sculpture
that was described by the journalistic gadfly
Théophile Gautier in January 1864 in the
Moniteur universel.[71] Given Nadar's voracious
intellectual curiosity, his particular concern
with intersections between science and art,
and his interest in the 1840s in phrenology, it
is no surprise that a photographic technique
for conveying a head from 360 degrees would
catch his imagination. About 1856 he made a
photograph of the back of the head and nape
of the neck of the actress Marie Laurent, and
he also sketched the ragged haircut on the
back of the head of Jules Janin (see fig. 1).[72]

The procedure that Gautier described,
the invention of a Mr. Villème, was for mak-
ing a sculpture from twenty-four separate
negatives taken simultaneously in a rotunda
and then projecting these in sequence onto
a magic lantern screen. A craftsman then
traced the series of projected silhouettes with
a pantograph that transcribed the tracings
onto a block of soft clay that he rotated in

sequence with the projections. Gradually as
the excess clay fell away, like segments of
an orange from a core, a crude sculpture of
a head appeared. Discontinuities were then
smoothed out to produce a fully rounded head.
The finished clay head could then be cast in a
variety of materials.

It is likely that Nadar simply rotated him-
self in a swivel chair to obtain the twelve
negatives in one camera that he printed on
a single sheet. In the production of cartes-
de-visite four poses were captured on a sheet
that was then quartered to make individual
cards, but here the intention is different.
Like Villème, Nadar wanted to convey the
three-dimensionality of the human head.

The effect is that of a viewer walking
around the photographer, scrutinizing him
from all angles. In this way the passage of
time is built into the object, anticipating the
human motion studies of Muybridge, the photo
booth strips of Warhol, and motion pictures.

73

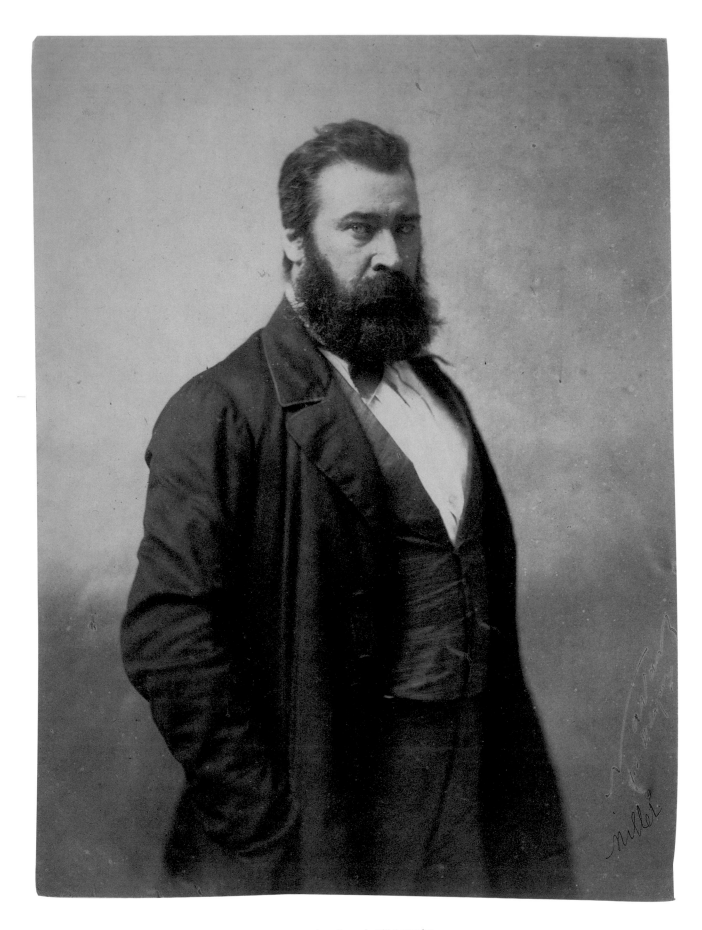

Jean-François Millet 1856/58

Jean-François Millet

1856/58

Salt print

10 ³/₈ x 7 ³/₄ in.

84.XM.436.40

Dressed in his city clothes, Jean-François Millet (1814–1875) seems more a well-fed, if somewhat rumpled, provincial banker than a painter of proletarian life. Although he was born into a Norman peasant family of modest means and both of his parents worked in the fields, his education by local priests gave him a healthy appetite for reading. His father early on recognized his son's artistic talents, and after instruction from two local painters in nearby Cherbourg, Millet moved to Paris. There in 1837 he was admitted to the École des Beaux-Arts and enrolled in the studio of the history painter Paul Delaroche. Millet disdained the older artist's work but acquired a mastery of means in his atelier. Millet's submissions to the Paris salons in the 1840s and early 1850s were as frequently rejected as accepted, and occasionally met with hostility from the critics. With great determination he persevered as a painter, despite illness, penury, and the death of his first wife. He stated "Art is not a pleasure-trip, it is a battle, a mill that grinds."[73]

The work Millet could sell in the early Paris period often depicted nudes, gamboling fauns, and nymphs, but in the salon of 1848 his painting of a farm laborer, *The Winnower*, won the praise of Théophile Gautier and was indicative of the work that would make him famous. His dislike for urban life, the violent disruption caused by the Revolution of 1848, and the cholera epidemic of 1849, together with his nostalgia for what he saw as the virtues of country life, led him to settle in the rustic village of Barbizon on the edge of the forest of Fontainebleau, twenty-four miles from Paris. Gardener in the morning, painter in the afternoon, he soon became the mainstay of a group of artists that included Rousseau, Barye, and Diaz, the latter two whose portraits he drew.[74] His paintings celebrated the dignity of manual labor, the humanity, endurance, and piety of the field worker. The 1850s brought him critical acceptance and modest prosperity, despite his financial ineptitude and the cost of raising the nine children he and his second wife had produced.

Nadar's portrait of Millet perfectly corresponds with a contemporaneous description of Millet as "a long, strong, deep-chested man with a full black beard, a grey eye that looks through and through you."[75] The figure Nadar gives us is biblical in the seriousness of purpose shown by the sitter, although among his intimates Millet was amiable and occasionally serene. (The painter and photographer had met before when Millet was the subject of a good-natured Nadar caricature in 1852 in which the painter is depicted outdoors in front of an easel, holding palette, rake, shovel, and hoe.[76]) Millet said of photographic portraiture that "this art would never reach perfection till the process could be performed instantaneously and without the knowledge of the sitter. Only in that way, if at all, could a natural and life-like portrait be obtained."[77] Although he sat for other photographers, it is tempting to think that Millet may have had the stern formality of Nadar's portrait in mind when he made this statement, perhaps having a milder self-image than this picture gives.

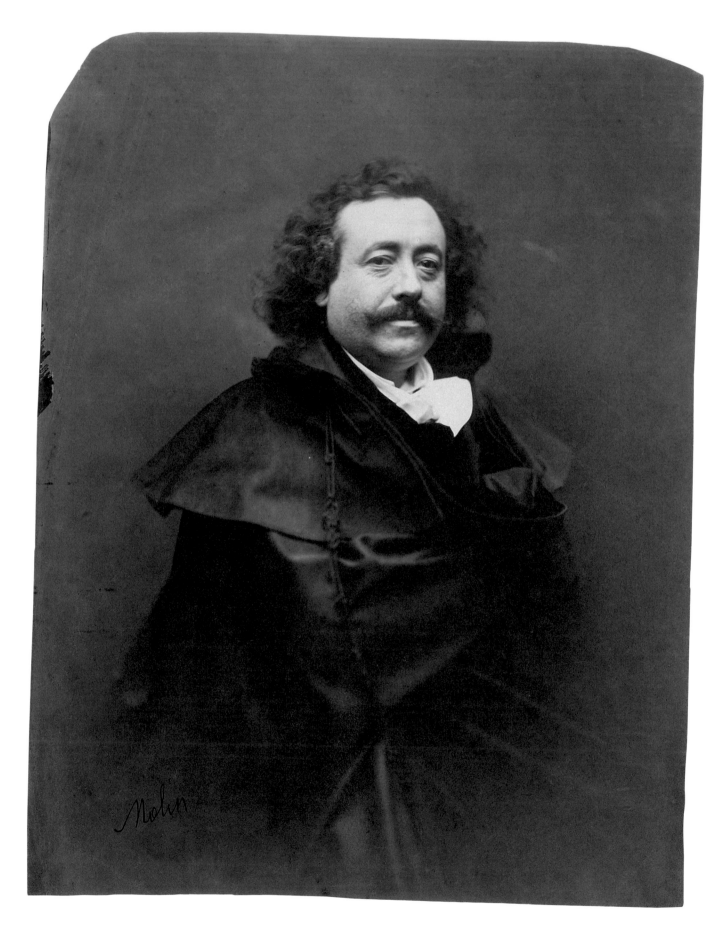

Benoît-Hermogaste Molin 1858

Benoît-Hermogaste Molin
1858
Salt print
9 7/8 x 7 1/2 in.
84.XM.436.404

The painter Molin (1810–1894) was born at Chambéry in Savoy, then one of the mainland parts of the kingdom of Sardinia. In 1831 he enrolled in the École des Beaux-Arts in Paris, becoming a student of Baron Gros. Naturalized as a French citizen in 1834, from that date until 1847 he consistently exhibited at the Paris salons, showing both religious subjects and portraits. His sitters were often titled, including Egyptian princelings, and his success in depicting nobility led him to European royalty when in 1848 he was appointed court painter to the House of Savoy, then rulers of the kingdom of Sardinia and, later, of Italy. Like Nadar, he sought to present the unadorned essence of his sitters in his portraits.[79] By 1860, when Savoy was annexed to France, Molin had returned to Chambéry, where he became a curator of the local museum and resumed sending work to the Paris salons.

The friendship of Molin and Nadar dated to the early 1840s, and by 1860 the photographer owned two works by the painter.[80] As both men were portraitists, both brought a high degree of consciousness about the posing of subjects to this 1858 sitting in Paris, where Molin must have been visiting from Italy. In order to recall portraiture in the grand manner, such as that of Van Dyck, Nadar has chosen to engulf Molin in a glamorous and voluminous cape of some shiny fabric, embellished by only a complicated knotted and looped double cord. As Molin's right arm holds the cape across his body and his left is concealed beneath the garment, it must have been Nadar who puffed up the end of Molin's cravat to provide an additional flourish of white fabric at the neck. Molin's head, the only part of his body that shows, is fully lit, concentrating all attention on his face. The scimitars of his eyebrows are counter-balanced by the circles beneath his eyes. There is some disparity of expression between eyes and mouth. He regards the camera directly but with a degree of reserve, fully aware of how he is being presented, perhaps a little amused by the appropriated grandeur, but not wholly enthusiastic about the bravado of his stance.

80 **Antoine-Louis Barye**
1855–59
Salt print
8 3/16 x 6 3/16 in.
84.XM.436.12

Called the "Michelangelo of the menagerie" by Théophile Gautier,[81] Barye (1796–1875) was about sixty when he posed for Nadar. The son of a Parisian jeweler, after apprenticeships with an engraver and a jeweler, from 1812 to 1814 he was a conscript in Napoléon's army. He studied with the sculptor Bosio and the painter Baron Gros while enrolled in the École des Beaux-Arts, and for eight years he worked for the goldsmith Fauconnier, producing a series of small-scale figures. He studied animal anatomy thoroughly, in books, in laboratories, and at the zoo. When a lion died, he and Delacroix dissected it. The statue of a tiger devouring a crocodile that he exhibited at the salon of 1831—thought (wrongly) by some to symbolize the triumph of the July monarchy (1830–1848) over its opponents—first brought him widespread attention. The inherent violence of its struggle was characteristic of many of his works, whether small or large. His subjects included pythons crushed by lions, wounded boars, horsemen felled by bulls, and the occasional hero from French history. His distinctive combination of realism and romanticism and his artistic erudition made him one of the most important French sculptors of the nineteenth century. Early work by Barye was so often refused by the salons that from 1838 until 1850 he refused to submit anything. Although lack of sales from these exhibitions posed financial problems, his work found

official sanction, and payments, in the form of governmental commissions, from Louis-Philippe in the 1830s and from Napoléon III in the 1850s. For the latter he made statues to embellish the emperor's additions to the Louvre. In his later years Barye sometimes lived and painted landscapes at Barbizon, where his friends included J.-F. Millet and Théodore Rousseau.[82]

His stern-visaged appearance in Nadar's portrait reflects a notably taciturn personality, a man who when he taught drawing, rarely spoke to his students and corrected their work by retouching it.[83] Nadar has posed him against an uncharacteristically dark background into which the artist's clothes virtually merge. However, the light on his high, domed forehead, retroussé nose, his linen, cuffs, and subtly spaced buttons relieve what would otherwise be an overly somber portrait. The overall effect of self-contained, if melancholy, dignity, of a man who has survived adversity and is beholden to no one, accords well with contemporary descriptions of Barye.[84] His connection with Nadar was probably established through painters who were friends of both. Barye was seldom photographed. This image by Nadar, one of the few existing portraits, was later used as the basis for an etching.[85]

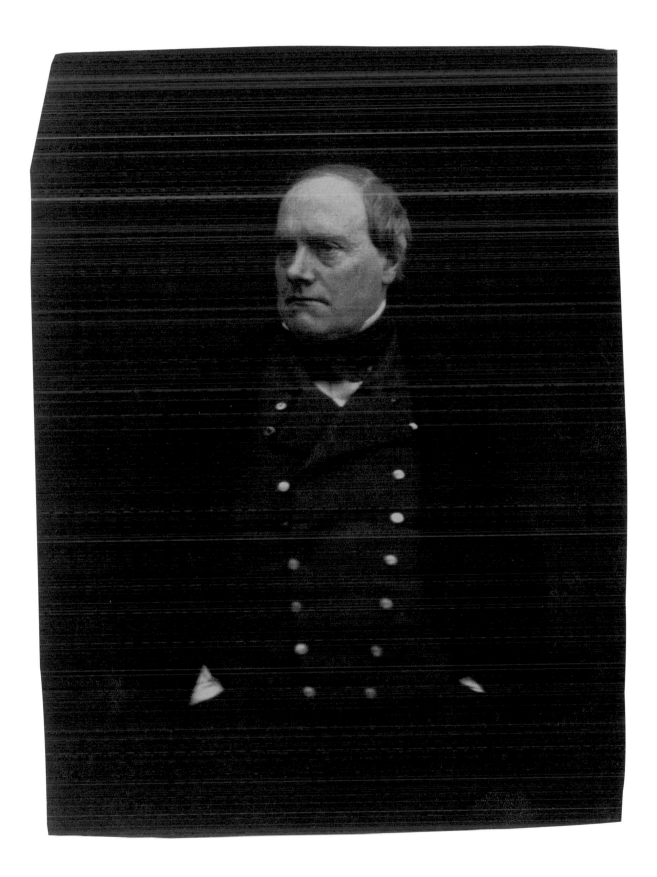

Antoine-Louis Barye 1855-59

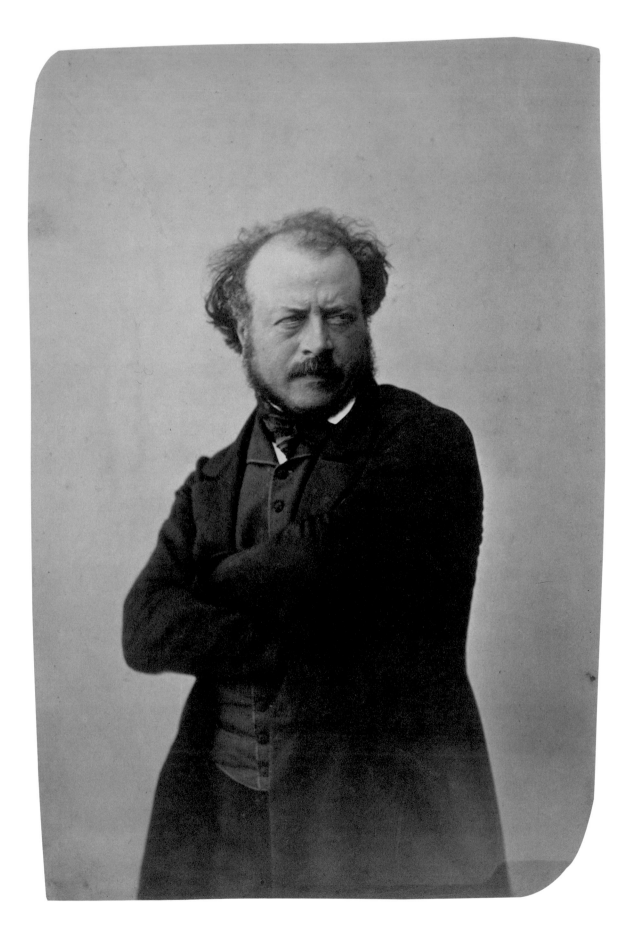

Auguste Préault 1854/55

Auguste Préault

1854/55

Salt print

9⁵/₁₆ x 6³/₄ in.

84.XM.436.9

"The fever of poetry, the drunkenness of beauty, the horror of vulgarity, and the madness of glory possessed and tormented Préault."[86] Thus was the fiery sculptor Antoine Augustin Préault (1810–1879) described by a favorably disposed critic of his day. Préault first seriously studied sculpture with David d'Angers, who expelled him from his studio for disorderly tendencies and an innate resistance to being taught. After further study elsewhere Préault exhibited in the salon of 1833. His work was highly Romantic, characterized by exaggerated forms, proportions, and modeling. These qualities, which Nadar admired, effectively barred Préault from further salons until 1848, when he again began exhibiting. Success came to him after 1852, during the Second Empire, when he received governmental commissions. Included among these were statues of saints for the exteriors of three Parisian churches, a heroic figure for one of the Paris bridges, and retrospective portraits of Mansart and Le Nôtre for Versailles. Modern critics have valued his reliefs, often executed in terra-cotta or bronze, more highly than his freestanding figures in marble.[87]

Nadar's portrait of Préault captures the sculptor's turbulent energy through the torsion of the pose. Préault turns his body to his right, his head slightly to the left, and his eyes farther to his left. His folded arms wrap round his body, momentarily holding in check his considerable physical and intellectual power, the better to be unleashed. He takes forceful possession of the space in which he stands. By using strong overhead diagonal light to shape the large dome of the head and cast half the face into shadow, Nadar has emphasized the gravity of Préault's presence. The expression on his face, with his eyebrows clenched about the bridge of his nose, implies the man's abrupt manner. His gaze, directed off-stage, is penetrating, appraising, and critical. It is evident that Préault had strong opinions and expressed himself with vigor. His contemporaries collected his better lines: "Don't recommend sagacity to a sage; you don't cut meat for a lion," and "Silence is the virtue of the feeble," are examples.[88] Nadar might well have relished such conversation over dinner and would have agreed wholeheartedly with Préault's dictum "One does not photograph physiognomy."[89] In tacit liaison, sitter and photographer have produced a portrait that reveals the essence of the man rather than his mere appearance.

83

84 **Gustave Doré**
1856–58
Salt print
9 1/4 x 7 3/8 in.
84.xm.436.98

The illustrator Gustave Doré (1832–1883) was a child prodigy as an artist, who filled the margins of his school notebooks with drawings and by the age of thirteen had already published a group of three lithographs.[90] At sixteen he arrived in Paris and, while continuing to go to school, was hired to draw caricatures for *Le Journal pour rire,* as Nadar was already doing. Nadar gave advice to the young Doré, and a lasting friendship ensued. Doré became famous—as he wished to be—for his draftsmanship by producing an enormous body of work to illustrate a wide variety of literary classics, including works by Dante, Cervantes, La Fontaine, Rabelais, Balzac, Milton, and Tennyson. When he turned to painting, his work in that medium was less well received in France than in England, where he went each year from the 1860s to the 1880s. Queen Victoria bought a work from the permanent London gallery he had established to show his painting.

Pen or pencil always in hand and in use, Doré's industriousness was a source of wonder to his contemporaries. He produced about ten thousand drawings and became rich in doing so, although he also spent wildly. His illustration was characterized by its imaginative power, its sometimes grotesque exaggeration, its fantastic inventiveness, and its wide range of subject material. His drawings often teem with activity, whether of spectators at a boat race, workers on the London docks, or mice gobbling grain. To facilitate the reproduction of his drawings Doré usually drew directly on woodblocks that were then engraved by a small crew of craftsmen that he had formed, befriended, and employed.

This portrait was made at Doré's second sitting for Nadar; the first occurred two years earlier, in 1854. His exceptionally high forehead is flooded with light that cascades down the smooth right side of his face and lands on his wrist. If his lower lip is perhaps petulant, his eyes seem intent on what lies beyond the camera's range. The arabesque of the large-checked scarf loosely knotted around Doré's neck contrasts with his checked trousers and adds panache to his image. From this and a variant pose in which a bolt of patterned material was slung from shoulder to shoulder and down around an arm,[91] it can be concluded that this sitting was interactive and playful, which accords with contemporary descriptions of Doré's boyishness.[92] Nadar himself referred to Doré's casualness and lucidity (*dégagé et clair*), made him the subject of several caricatures, and by 1860 had acquired seven of his works.[93] Doré sat for Nadar again in the 1860s, and for the British masters Julia Margaret Cameron and Oscar Rejlander in the 1870s, and was last photographed, on his deathbed, by Nadar in 1883.[94]

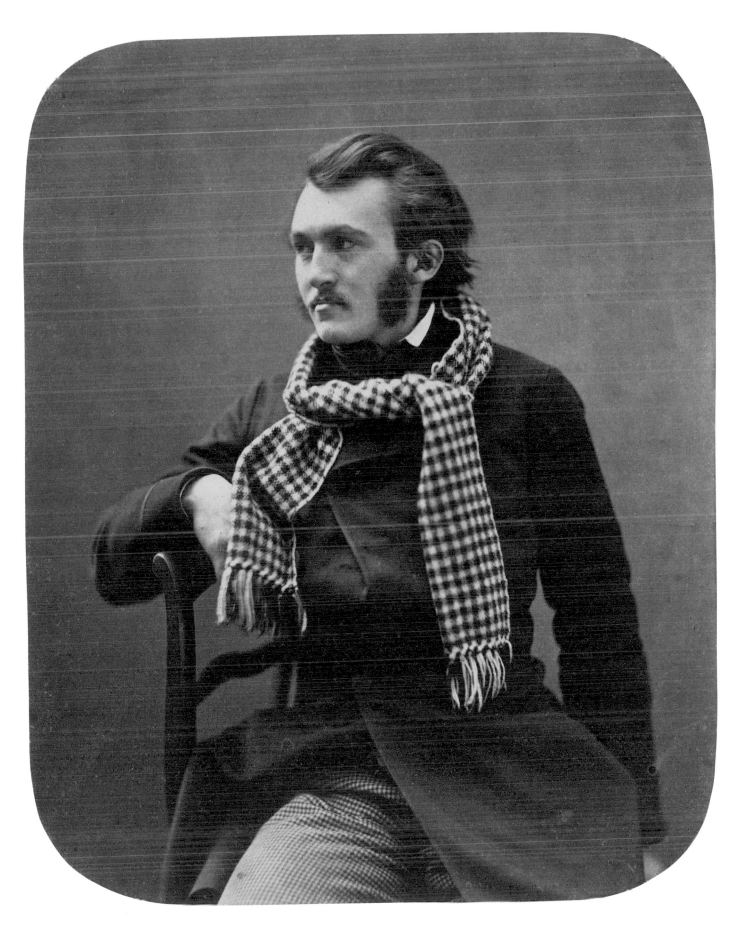

Gustave Doré 1856-58

Aimé Millet
1856–58
Salt print
8 7/8 x 6 3/16 in.
84.xm.436.6

The reverse side of this print is inscribed in Nadar's hand with the name *Mille,* an incomplete transcription, it is believed, of the name Millet, and the sitter is thought to be the sculptor Aimé Millet (1819–1891). He would have been about thirty-seven at this time and poised on the brink of his first great success. Millet studied drawing with his father, a miniature painter, then trained with Viollet-le-Duc, entered the École des Arts décoratifs, and finally in 1842, the École des Beaux-Arts, where he became a pupil of the sculptor David d'Angers. His principal métier was sculpture, but he attracted notice in the salon of 1849 for his drawings after old masters, particularly his delicate rendition of da Vinci's *Mona Lisa.* Ingres admired the drawing, and by photographing it, Nadar's friend Gustave Le Gray made it well known.[95]

Millet was a prolific sculptor, executing numerous works bought by the government, including statues for the Opéra, the Institut de France, and for the facades of the Hôtel de Ville and the additions to the Louvre made by Napoléon III, who also bought Millet's statue of Vercingétorix for himself. Three of his sculptures are tangible manifestations of his links to Nadar and his circle: his busts of George Sand and Dr. Petroz, and the figure of a youth removing petals from a rose that he made for the tomb of Henri Mürger in 1862. Among Millet's artist friends were Barye, Daubigny, and Courbet, all of whom sat for Nadar.

Nadar has placed Millet in a dynamic pose, his body turned away from the camera to the right, his head twisted back over his shoulder to the left, imbuing his slight figure with force and energy that accord with contemporary descriptions of him.[96] Both the set of his mouth and his forceful gaze indicate strength of purpose tempered by benevolence. As often in Nadar's portraits, the white of the sitter's collar sets off the head from the somber tones of the clothing, in this case a loose-fitting corduroy jacket. The collar's white is echoed at the cuff, but the sculptor's hands are not visible.

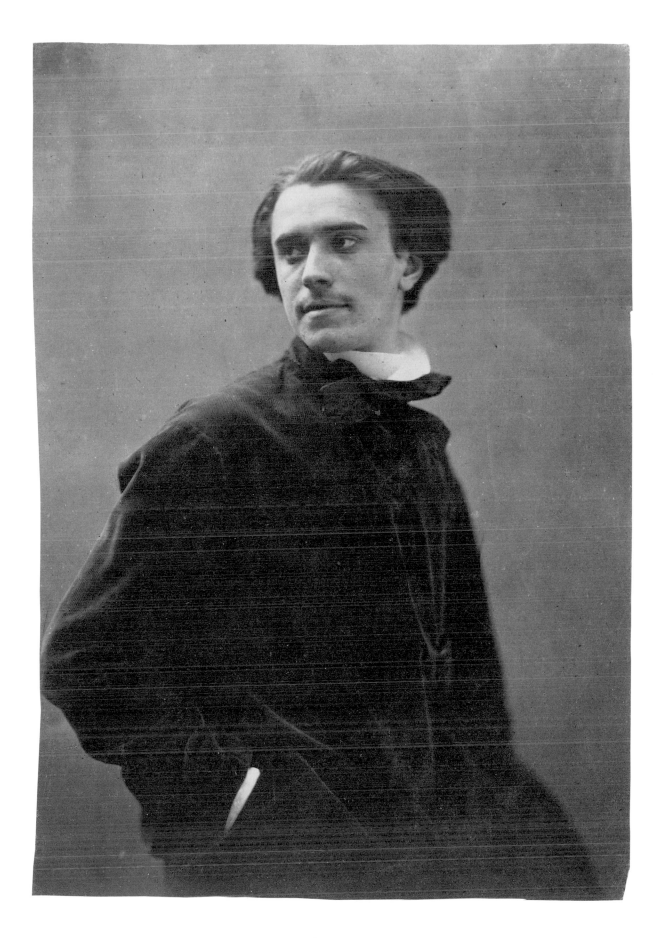

Aimé Millet 1856–58

Nadar and
Adrien Tournachon
(French, 1825–1903)
Adrien Tournachon
1854/55
Gelatin coated
salt print
9 1/2 x 7 1/8 in.
Gilman Paper
Company Collection,
New York

Note: Exhibited in
Los Angeles and Baltimore.

Adrien Tournachon was five years younger than his brother Nadar (Félix Tournachon), and from his school days forward he lived in his older brother's shadow. Their relationship was consistently troubled despite Nadar's attempts to find Adrien a vocation, to financially support Adrien's enterprises, and to look after his well being. Throughout their lives the younger brother was envious of the older brother's vitality, friendships, and renown. When Adrien's career as a portrait painter faltered in 1853, Nadar, who was then still a caricaturist and journalist and not yet a photographer, paid for Adrien to learn the art from Gustave Le Gray. With the aid of a backer, Nadar set Adrien up in a photographic portrait studio in the boulevard des Capucines, with the understanding that Nadar would play some part in its operation.[97] Nadar also took lessons in photography at this time. For a brief period in 1854 and 1855 they worked together as photographers in loose collaboration in Adrien's studio. As both were novice photographers without fully developed individual styles, and as they often worked together, authorship of a given work, unless signed, cannot easily be distinguished.[98] Their joint productions were typically made in direct, unmodulated sunlight with the sitters placed close to a wall or canvas backdrop. This resulted in strong cast shadows on the wall behind the subject, anchoring the person in a distinct if unarticulated space. Later portraiture by both would be less light spattered than this image and less apt to distract from the face of the sitter.

This eccentrically framed portrait of Adrien in a wide-brimmed straw hat is the most striking of their works from the period. The fully lit area around his mouth is isolated by the shadow of his hat brim. The sensuality of his lips is heightened by the slight parting necessary to hold the cigarette that angles outward from his mouth and by the positioning of his little finger. It and its long fellows caress his unshaven jaw. From their cover of protective shadow his eyes mockingly seduce the camera. His rakish and unsettling presence reflects the psychological tension that characterized the relations between the two brothers. After the separation of their photographic enterprises when Adrien persisted in using the pseudonym "Nadar" that Félix had invented for himself and made famous, Nadar would find it necessary to sue to force him to desist. Adrien's dependency on Félix would unhappily continue until psychological deterioration forced him into the mental institution where he spent the last ten years of his life.

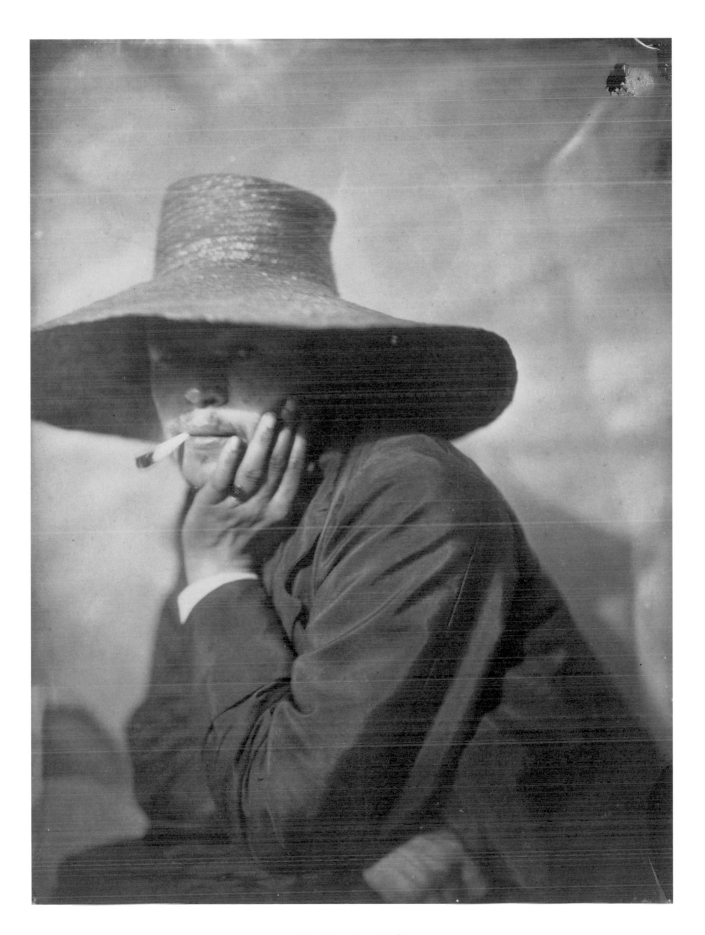

Adrien Tournachon 1854/55

Théodore Rousseau
1855–59
Salt print
10 1/8 x 8 in.
84.xm.436.186

The imperturbable painter Théodore Rousseau (1812–1867) found his vocation early and from the outset, about 1830, his sole interest was in landscape, directly and realistically observed, on the model of Constable and the seventeenth-century Dutch landscape painters, rather than on the ideal landscape of Poussin. His attitude toward nature was one of priestly reverence, and his observational powers were acute.[99] His refusal to embellish his sometimes melancholy landscapes with references to classical mythology such as temples, dryads, nymphs, and the like, meant that from 1835 until 1841 everything he submitted to the official salons was denied entry, thus depriving him of exposure and income. Disgusted by this aesthetic discrimination, but absolutely confident in his art, Rousseau withheld work from 1841 until after the revolution of 1848 when the salons were reorganized. He moved at this time to the hamlet of Barbizon on the edge of the ancient royal forest of Fontainebleau, where he had painted during shorter, earlier stays. As Gautier pointed out, he scrupulously painted what he saw and his works are acutely sensitive to nuances of light and shadow, particularly at dawn and dusk. His paintings, with those of his friends Diaz and J.-F. Millet, are the principal glories of the Barbizon school. Life in the forest was not, however, idyllic, as his finances were intermittently troublesome and he had formed a permanent liaison with an unfortunate woman whose mental condition steadily worsened.

Rousseau and Nadar do not seem to have known each other well, although Nadar photographed many of the people they knew in common. They probably met in the 1840s before the painter moved to Barbizon or on one of Rousseau's winter forays to Paris. In his review of the salon of 1853 Nadar noted that Rousseau's work had long exhausted praise.[100] The pose Rousseau has assumed is as upright as one of the oak trees whose portraits he painted. He was known to be solitary in nature and obsessive in reworking his canvases, and this reserve and intensity show in his buttoned-up portrait. Another pose from the same sitting shows him no more relaxed, even though he faces the camera more directly and his coat is open.[101] He was perhaps too serious to have been much engaged by the charm of Nadar's conversation, content to devour the viewer with his steadfast gaze. It may be that the photograph was made to mark the triumphant vindication of Rousseau's vision when a room was devoted to his painting at the Exposition of 1855.

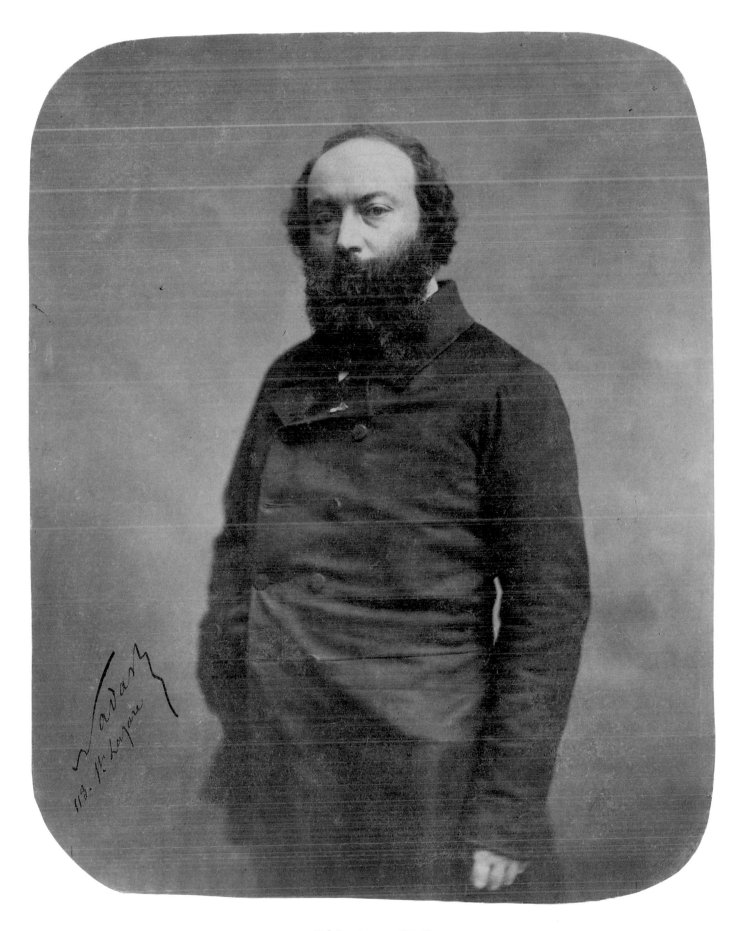

Théodore Rousseau 1855–59

94

Francisco, Maréchal Serrano

Negative of April 1857
Salt print, circa 1860
9 1/4 x 7 1/4 in.
84.XM.436.276

In the complex and turbulent dynastic struggles and civil wars in nineteenth-century Spain, Maréchal Francisco Serrano y Dominguez (1810–1885) played a consistently important role. A general's son, he entered the army at age twelve as a cadet. His attractive appearance, elegance, affability, and incontestable bravery enabled his success as a soldier, diplomat, and statesman. Over time he held a variety of important military and civil posts, including minister of war, minister of foreign affairs, viceroy of Cuba, president of the council of ministers, commander in chief of the army, and regent. He was awarded a dukedom. Serrano's life, however, was not simply a series of triumphs—he was once sent into exile in the Canary Islands, at least twice voluntarily sought refuge in France, and was briefly imprisoned. In the 1860s he was a proponent of such democratic and liberal measures as universal suffrage and freedom of religion and the press, but for a brief time in the early 1870s he was effectively the dictator of Spain.

When Serrano sat for Nadar he was forty-six and the Spanish ambassador to France, a post he held only for a year. He is more elaborately turned out than any other sitter to appear before Nadar's camera, bedecked with the medals—including the cross of

San Fernando—that are testaments to his military prowess. His diplomatic uniform is heavily embroidered in gold. His carriage is erect, his hat held in the crook of his right arm, and his left thumb hooked through the hilt of his ceremonial sword. He seems thoroughly accustomed to holding himself in this formal posture, even if he is unfamiliar with the photographic process, which may be inferred by the way that he looks appraisingly at Nadar and the camera. As there is no evidence that he was much interested in the arts it is baffling how he came to choose Nadar, over more fashionable photographers like Disdéri, to make his portrait. Because there is a photograph by Nadar of Serrano's successor, Narvaez, also in full formal diplomatic regalia, it seems that the two photographs may have been made to commemorate the changing of the Spanish ambassadorial guard in September 1857.[105] Despite his illustrious career Serrano is not much remembered today, even in Spain, but in happy coincidence with his splendid appearance, Madrid's equivalent of Fifth Avenue or Rodeo Drive, the Calle Serrano, is named after him.

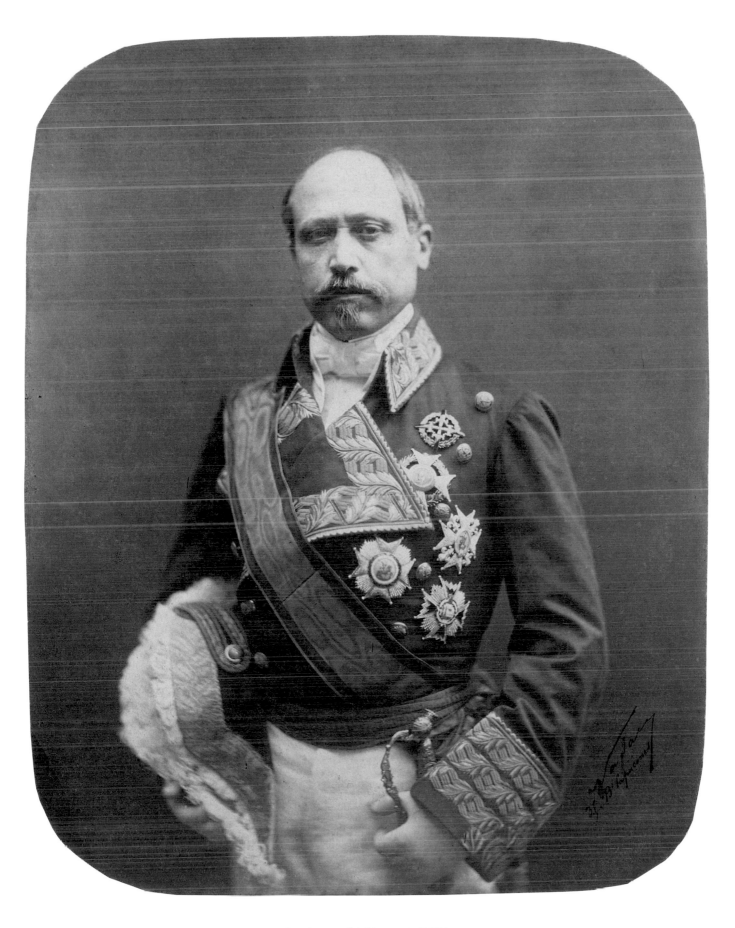

Francisco, Maréchal Serrano April 1857

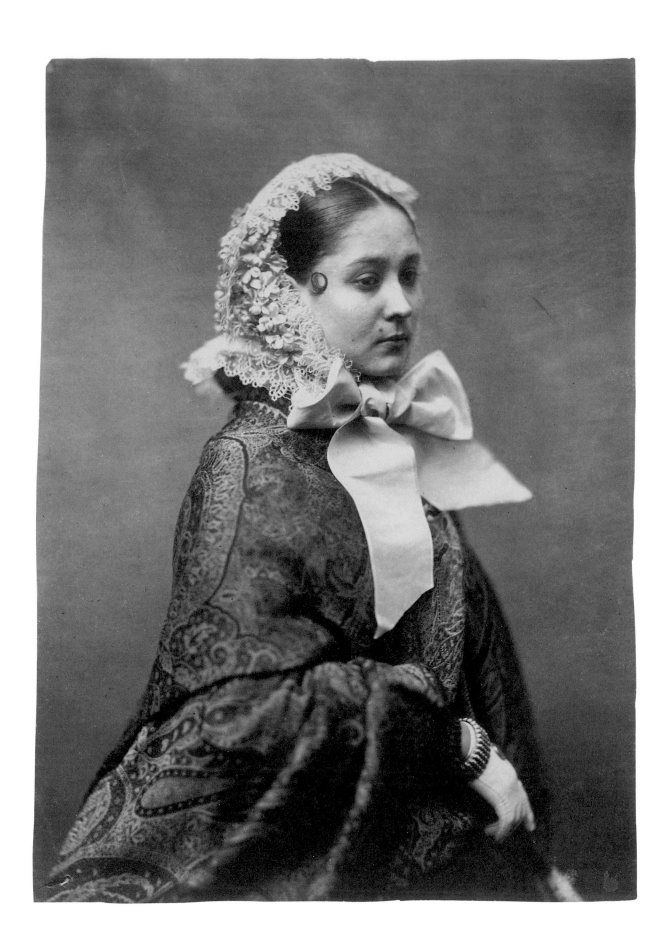

Finette 1858/59

Finette

1858/59

Salt print

8 3/4 x 6 1/4 in.

84.XM.436.496

Although Finette agreed to be photo-graphed, she gave little of herself to the camera save the grace of her bearing and her carefully contrived appearance. Her gaze is directed downward, her expression tinged with sadness. The lace that circles and covers her head is entwined with artificial flowers and is neatly arranged to form a ruff where it falls over the edge of the stand-up collar of her woven, lace-patterned cape. The bold bow at her throat directs attention to her face while contrasting with the delicacy of the lace and the swirling design of her wrap. The spit curl at her temple, her makeup, and the cosmetic beauty mark above her lip indicate that she could not have been thought respectable in the Paris of the 1850s. A bracelet circles the wrist of her ele-gantly drooping, kid-gloved hand.

Because she was a dancer at the Bal Mabille, an elaborate if disreputable music hall and garden, Finette was a woman accus-tomed to being admired. As a performer and a *cocotte* she was quite aware of how she comported herself. Her hands in Nadar's portrait are held in similar fashion to one of the two contemporaneous etchings made of her in 1859 by the American painter James McNeill Whistler (1834–1903), whose mis-tress she briefly was during his student days in Paris.[106] Since Nadar presents Finette as essentially modest and seemingly decorous it can perhaps be assumed that her portrait was made at an admirer's behest rather than to publicize her career. It is tempting to think that Whistler may have commissioned it as a souvenir of their affair, but regrettably, although they had friends in common, there is no conclusive evidence that Nadar met Whistler until 1862. When the photographer went to London to publicize his ballooning exploits, Baudelaire wrote to Whistler about Nadar and urged Whistler to show his "mar-velous" etchings to Nadar.[107] At about this time "Madame" Finette was dancing the can-can in London.

As a dance-hall performer, Finette was an atypical subject for Nadar's camera in the late 1850s, but as the mistress of a fledgling artist she would have been of a type familiar and congenial to him from his Bohemian days in the 1840s. What is curious about the way she appears in his photograph is that psychologically she neither gives herself whole-heartedly to the camera nor stands aloof from it, occupying a place as ambiguous as her rela-tion to society.

98 **Leopold,
Count of Syracuse**

circa 1858
Salt print
7 15/16 x 6 1/8 in.
84.XM.436.27

As he was of royal blood, Leopold, Count of Syracuse (1813–1860) was an atypical sitter for the antimonarchical Nadar, and how he found his way to Nadar's studio is something of a mystery.[108] A younger brother of Ferdinand II, King of the Two Sicilies, the Bourbon kingdom that united the island of Sicily and the southern area of Italy and had its capital at Naples, Leopold was a political liberal in a family and kingdom noted for conservatism. In 1830, early in his brother's reign, he was lieutenant general of Sicily, responsible for the administration of that island. His liberal opinions brought him local popularity, causing his brother to fear that Leopold had aspirations to rule independently. He was recalled to Naples in 1835. Married to a prudish princess, whom he apparently disliked, he settled into a life of earthly pleasures, political dissent, lavish generosity, and patronage of the arts. A visiting Englishman described him in 1847 thus: "for a king's brother, a very clear-headed, well-informed man."[109] Had his advice about signing the alliance offered by Victor Emmanuel of Savoy been heeded by his family in 1860, their kingdom might not have been swallowed up in the unification of Italy and their dynasty terminated.

However pleasure seeking, Leopold was a talented and ambitious amateur sculptor whose wealth and position made it possible for him to erect monumental public sculpture of his own creation in Naples. His activities as an artist and patron may have led him into artistic circles in Paris, which he occasionally visited, and thus to Nadar. An introduction of the prince to the photographer may have been made by another of Nadar's sitters, the pianist Thalberg, who had performed at a nighttime party given by Leopold in the torchlit amphitheater of Pompeii.

Perhaps as an allusion to Leopold's avocation as sculptor or as a reference to Renaissance princely portraiture, Nadar arranged a great swath of velvet over his sitter's shoulder, effectively shielding his corpulence.[110] Beneath this sweep of material the count appears to be wearing only a simple shirt with a banded edge, a surprisingly unassuming costume for one of his rank. Leopold's untrimmed beard was a token of his political opinions, the creases under his eyes of his somewhat dissolute habits. Visage, drapery, and lighting together produce an effect strongly reminiscent of paintings by Titian. The sad-eyed and amiable Syracuse would die a year or so later at forty-seven.

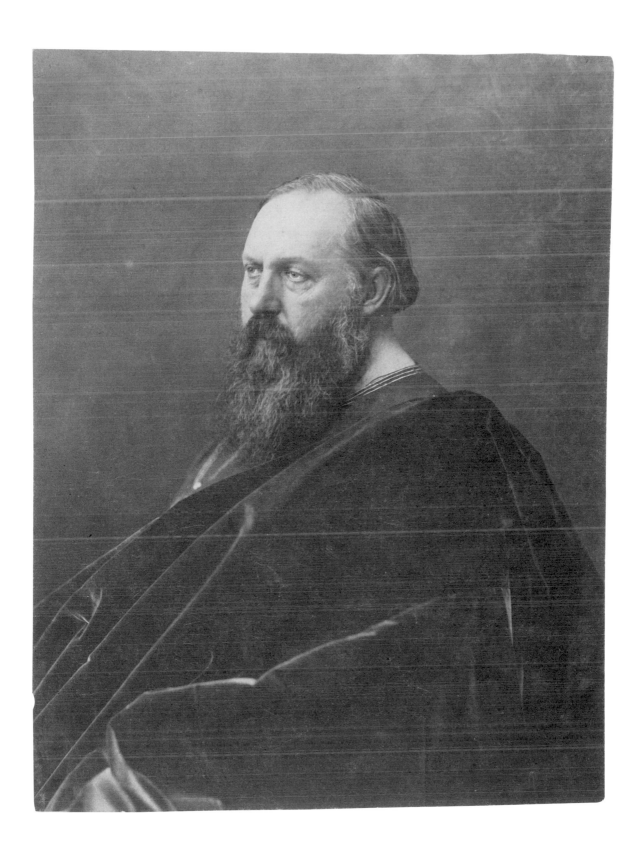

Leopold, Count of Syracuse circa 1858

100 *Nadar* and
Adrien Tournachon
(French, 1825–1903)
Pierrot Listening
1854/55
Gelatin-coated
salt print
11 3/4 x 8 1/2 in.
Bibliothèque
Nationale de France,
Paris, Département
des Estampes et de
la Photographie
Est. Eo. 99b petit
fol., t.1

*Note: Exhibited only
in Los Angeles.*

The mime Charles Deburau (1829–1873) inherited his vocation, character, costume, and perhaps even this pose from his father, Baptiste Deburau—a brilliant mime from a family of roving circus performers—and from the Italian commedia dell'arte. Here he plays a raptly attentive Pierrot. The Pierrot character was originally a stereotypically buffoonish servant whose pranks, greed, and gluttony were rewarded with copious pratfalls and punishments. In the hands of the Deburaus, father and son, Pierrot evolved into a wily trickster, who despite reversals often triumphed over his adversaries by wit and perseverance.[111] The balletic grace and precision of gesture displayed here are an indication of the Parisian Pierrot—still mischievous in nature, but also occasionally poignant. Charles Deburau's skill, like that of his father and of the twentieth-century actor Charlie Chaplin (particularly in his silent films), was his ability to convey a wide gamut of emotions without speaking a word, moving an audience to laughter or tears. It is, of course, ironic to portray a mime listening for a sound unheard by the mute, his audience in the theater, or the viewer of the photograph.

When Nadar was twenty in 1840 and first seeking to become a man of note in Bohemian Paris, with next to no money he staged a gala soirée with programs advertising, among many attractions, the presence of the elder Deburau, who was in fact impersonated by one of Nadar's friends.[112] By making a narrative series of photographs of Pierrot, from which this image comes, he again hoped to capitalize on the Deburau image. The set was intended to advertise the photographic studio that Nadar had recently enabled his younger brother Adrien to establish; but the younger Deburau was Nadar's friend, not Adrien's, and the new large-format camera with which the images were made was purchased with part of the dowry of Nadar's wife, Ernestine. Nevertheless, when the series of photographs was exhibited at the Exposition Universelle of 1855, where they won a gold medal, they bore Adrien's name, perhaps because he had kept the negatives when he and Nadar had definitively split their photographic businesses in January 1855.

The young Deburau's career was advanced in the 1850s by the singer Rosine Stoltz (see p. 121), who was enamored of him, but in the following years he was much burdened by debt and often forced to tour the provinces and abroad in order to raise enough money to maintain a theater for his troupe in Paris.

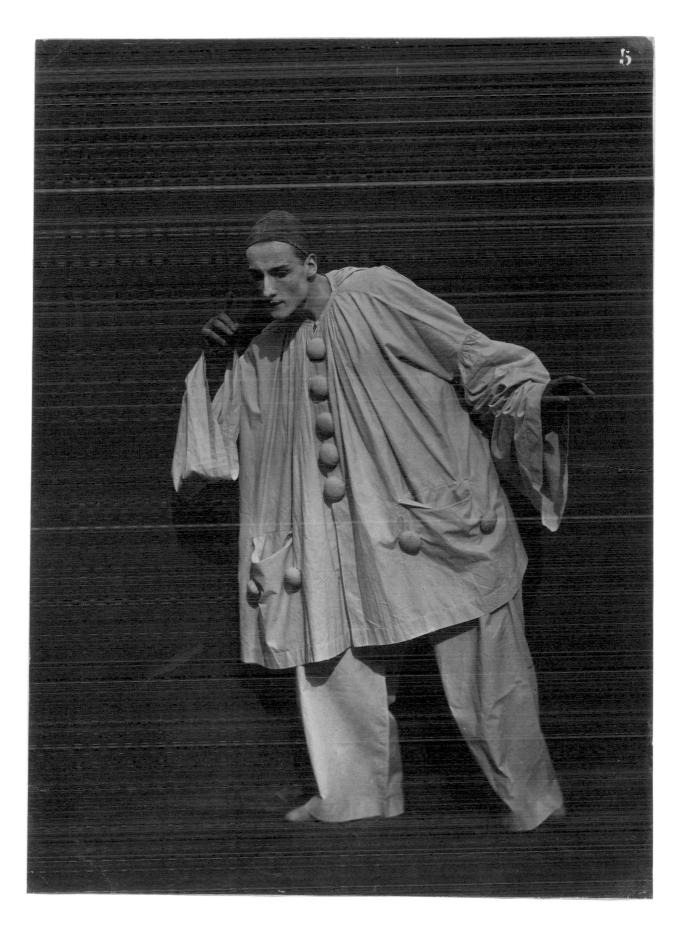

Pierrot Listening 1854/55

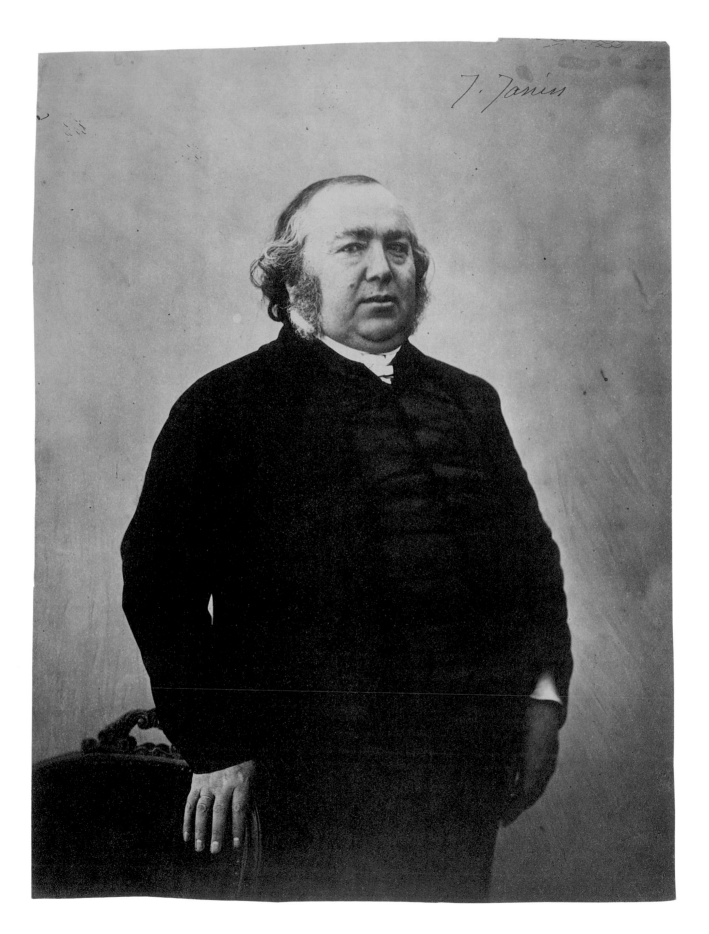

J. Janin

Jules Janin 1853/54

Nadar and
Adrien Tournachon
(French, 1825–1903)
Jules Janin
1853/54
Salt print
9 5/8 x 7 1/4 in.
84.XM.436.29

The theater critic, novelist, and literary historian Jules Janin (1804–1874) was another of the amazingly prolific French writers of the mid-nineteenth century. Initially a political commentator, he shortly turned to theater criticism. His reviews mixed actual attention to the play at hand, of which there were a plethora, with fantasy and dollops of his personal life. It has been calculated that he produced 2,240 reviews, chiefly for the newspaper *Les Débats*, as well as prefaces, introductions, appreciations, and fiction. Often referred to as the prince of critics, his prose style seems to have resembled a thin, effervescent wine that does not travel well and is of inconsistent quality from year to year, or in his case, week to week. In conversation, he attributed his success over forty years to his having changed his mind every fifteen days, thus continuing to surprise the attentive public of his weekly theatrical reviews.[113]
As he was often acerbic, he necessarily made enemies and was at least once sued for defamation. He was perhaps excessively praised by his contemporaries but has been all but forgotten by posterity. As a prominent literary figure he was an inevitable choice for Nadar to caricature. There are at least two sketches of him by Nadar in existence, one of which shows only the back of his head and his ragged haircut (see fig. 1).[114]

Authorship of this portrait is slightly problematic. It seems to have been made during the brief period that Nadar and his brother Adrien worked together in the latter's studio in the boulevard des Capucines. There are three images of Janin wearing these clothes and all appear to have been made at the same sitting.[115] In the first image, now in the collection of the Bibliothèque Nationale de France, Janin stands to the left of the chair and the picture is signed by Adrien as *Nadar jeune*. In this, the second photograph, Janin closely abuts the chair, now on the right, and the print is inscribed in Nadar's handwriting with Janin's name. In a third, also in the B. N., there is no chair, the back cloth is less brightly lit, and the print is signed by Nadar. The three prints suggest a sequence of events in which Janin posed first for Adrien, then for both Adrien and Nadar, and then finally for Nadar alone. As the series progresses Janin's silhouette becomes increasingly monolithic and the image more like Nadar's sophisticated portraiture of the next few years. In addition Janin's expression becomes progressively less friendly, perhaps due to the fact that he and Nadar had quarreled or perhaps because his gout was troubling him.[116] This is likely the middle picture in the series and made by the brothers in collaboration.

103

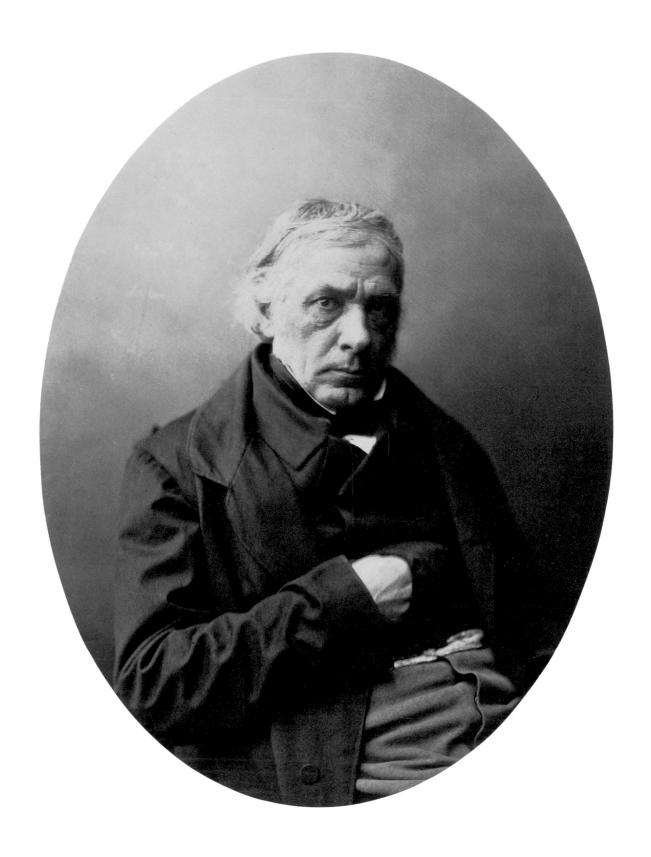

Victor Cousin 1854–59

Victor Cousin

1854–59
Albumen print
circa 1860s
7 7/8 x 6 in.
84.XM.343.3

A precocious student who became a popular, influential professor and lecturer and then a reforming government minister, the distinguished philosopher Victor Cousin (1792–1867) must be considered one of the most eminent of Nadar's sitters. When Cousin first started teaching in the mid-1810s he revivified French philosophy, then in a period of desuetude, by emphasizing first the work of Locke and the Scottish school, and then that of Kant and his German followers. His own philosophy is usually described as eclectic but methodical, uniting elements of sensualism, idealism, skepticism, and mysticism into a "juste milieu."[117] Cousin's best-known book is *Du vrai, du beau, et du bien* (On the true, the beautiful, and the good). His brilliant teaching career was occasionally dislocated by political upheavals in the 1820s, but the philosopher's life was radically changed by the accession of Louis-Philippe in 1830, when Cousin became Minister of Public Instruction and a peer of France. He then carried out an ambitious restructuring of the system of primary and secondary education, based primarily on German models. Cousin's public career effectively ended with the fall of the monarchy in 1848. Ironically, in view of his plebeian origins, in the latter part of his life he wrote extensively on the bluestocking noblewomen of the seventeenth century.

The man who looks out at us from Nadar's photograph is evidently intent on being seen as serious, with his firmly set mouth and nearly baleful eye, gravely suspicious of the process that will fix his image for posterity, although he will survive the sitting to pose again for Nadar.[118] While his right eye seemingly bores into the camera, his left is all but lost in deepest shadow. Cousin is well into his sixties here and, as is often the case with elderly bachelors, looks somewhat disheveled, with wrinkled clothing and some patterned fabric sticking out between vest and trousers. The cord of his monocle is barely visible against his vest, its lens hidden behind the hand that he Napoleonically tucked into his vest. Nadar has tried, by retouching the negative, to simplify his sitter's silhouette by eliminating the back of the chair on which he sits, but its traces remain, interrupting the otherwise smooth line of the right shoulder. The oval format intensifies the force of the sitter by causing his form to swell to fill the space. As this is an albumen print of the 1860s made from a negative of the 1850s, which would have originally been rendered as a salt print, it is possible that this print was made to commemorate Cousin's death in 1867.

105

106

Adolphe Crémieux

December 1856

Salt print

7 15/$_{16}$ x 6 1/$_{8}$ in.

84.XM.436.397

Madame Crémieux

December 1856

Salt print

8 3/$_{4}$ x 6 1/$_{4}$ in.

84.XM.436.32

It was a pleasure for Nadar to photograph the lawyer and politician Isaac-Moïse Crémieux (1796–1880), known as Adolphe, and his wife, Madame Crémieux (died 1880); he very much admired the man, whose political views often coincided with his own.[119] Their paths had crossed before. In the 1840s Crémieux had often defended the liberal press, including *le Charivari* and *la Caricature,* newspapers for which Nadar worked.

Crémieux's career as a lawyer began in Nîmes in 1817, but by 1830, possessed of a wife, a phenomenal memory, a fortune, and a growing reputation as a distinguished jurist, he was practicing law in Paris. He was largely responsible for establishing the civil rights of Jews under French law and actively sought to ameliorate their position in the Muslim states. He was brilliant, incontestably honest, and a consistent advocate for liberal causes — tactfully in the *Chambre des députés,* to which he was elected in 1842, and forcefully in his law practice. Oddly, he was also the lawyer for the then-exiled imperial (Bonaparte) family. When Louis-Philippe abdicated during the revolution of 1848, Crémieux played a role in speeding the monarch's departure and assuring that other members of the Bourbon family were denied the throne.[120] As a minister of justice in the government that followed, he liberated political prisoners and fostered reform, only to be briefly imprisoned himself after Napoléon III's coup d'etat three years later.

Temporarily, he abandoned politics for family life, practicing law, and indulging his highly cultivated taste for the arts. A contemporary later said that one attended his parties not so much for the important artists who were there and the best music in Paris, but for the pleasure of hearing him speak. Crémieux reentered the *Chambre des députés* at the end of the 1860s. He voted against the war with Prussia in 1870 that caused the collapse of the Second Empire and the fall of Napoléon III, but which led indirectly to Crémieux again becoming, briefly, a reforming minister of justice. He was soon elected a permanent senator, but as he was now seventy-five his political career gradually but gracefully declined.

Crémieux was sixty when he sat for Nadar in December 1856, and as an opponent of Napoléon III, like Nadar, temporarily inactive in politics. Nadar began the sitting, the only one that he ever described in detail, by talking and laughing with Crémieux while placing him in the best light and adjusting the lens. His contemporaries thought the sitter peculiar in both appearance and manner; Madame Crémieux disagreed and insisted that Nadar concede that her husband was handsome.[121] At least in retrospect the photographer agreed, finding the man handsome in the tenderness he inspired (and merited), but more truly, if unconventionally, beautiful because of his "superior intelligence, infinite goodness, perpetual forbearance, love of justice, and above all the inalterable serenity of his pure conscience."

Of Madame Crémieux we know much less. Née Silny, she was a native of Metz, and married Crémieux in 1824. Her personal qualities were such that in 1869 she was described as being "of the greatest distinction."[122] Nadar also admired her and the unclouded marriage she and her husband

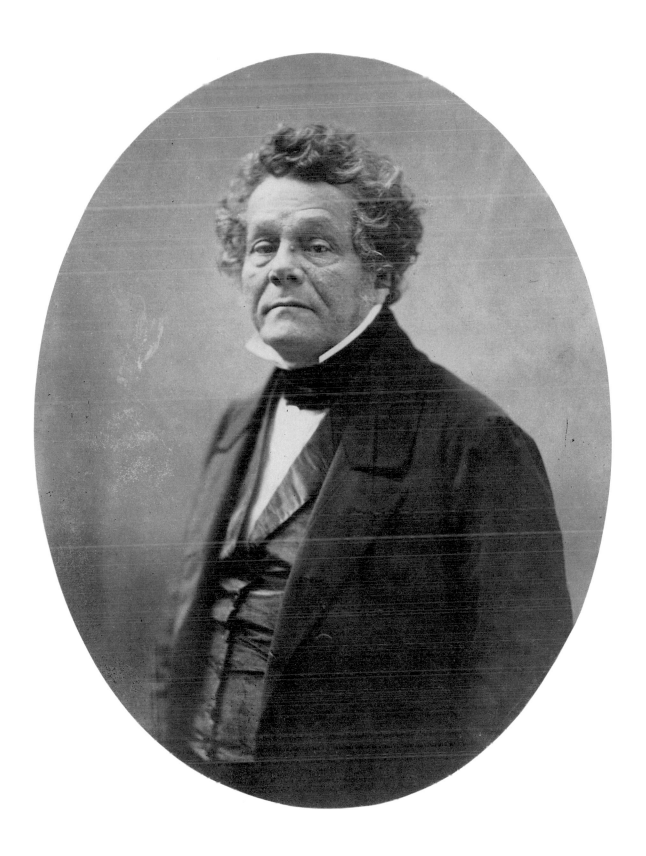

Adolphe Crémieux December 1856

Madame Crémieux December 1856

shared, a union that lasted for more than fifty years and ended with their deaths, a month apart from each other, in 1880. Nadar attended Crémieux's funeral, which prompted his recollection of their sitting more than twenty years earlier. Both wore quietly expensive clothes in which to be photographed, but their presentations of themselves otherwise differ. She seems demure, if not slightly sad, her eyes lovingly directed toward her husband, who no doubt stood nearby as she posed, watching her before the camera as she, misty-eyed with admiration, had watched him. A faint smile plays about her lips. He, a man accustomed to public appearances, looks right at the camera in contrast to his wife's attractive, innate modesty. Her portrait is domestic where his is civic. These portraits, of what we would call

a distinguished, crusading civil rights lawyer and his adoring wife, do not form a matched pair because of their difference in format. The oval print of Crémieux is of the kind that Nadar offered for sale in his studio, an edition print, while that of her is a proof print.[123] A finished print of Madame Crémieux that Nadar supplied to the couple might have been similarly ovoid, although the fact that she has been photographed from a greater distance than he causes their heads to be unequal in size.[124] In addition, Nadar seems to have placed the camera slightly lower when photographing Monsieur Crémieux, giving him added stature. These two pictures are exceptional in part because we know more about the circumstances of their making than any other of Nadar's portraits.

110 **Auguste Luchet**
1855–59
Salt print
8 1/2 x 6 1/4 in.
84.XM.436.33

The writer Auguste Luchet (1806–1872) regards the camera directly but distrustfully. His life had been difficult and his character and appearance were noted for their outward harshness. After early stints as a salesman, lawyer's clerk, and employee of merchants, he turned to journalism and writing plays and novels. During the reign of Louis Philippe he forcefully expressed his vehemently republican political beliefs in newspaper articles, among them an apologia for a man who had attempted to assassinate the king. His ferocity in attacking the great men of the day in a novel of 1841 landed him in court and, having been found guilty, the choice between two years of prison or exile. He chose the latter and after five years on the island of Jersey returned to France in 1847. After the revolution of 1848 that ended the monarchy he was briefly a government official and then joined and remained on the staff of a newspaper. In addition to critical commentary and plays he wrote a memoir of his exile, and as part of a guide to the Exposition of 1867, he penned a discussion of the great kitchens and wine cellars of Paris.[125]

Luchet was portrayed twice by Nadar; first in 1851 when Nadar made him the subject of a captioned caricature and second when he posed for the camera. Despite his rough-hewn appearance, Luchet had in conversation a delicacy of expression, as well as an honest and generous heart. His political opinions aligned with those of Nadar, and the two men could be supposed to have much in common. It is thus somewhat surprising that he stares suspiciously at us, and that he seems awkwardly constrained in his pose. His right elbow rests on the back of the chair in which he sits and he has had to undo two of the buttons high up on his vest in order to insert his hand. He is well dressed, in a velvet-collared jacket with fabric-covered buttons, matching vest and trousers, and polka-dotted cravat. His hair may be coarse and unruly, but his clothes are evidence of the prosperous respectability he had attained by the time Nadar photographed him. The overall effect of the portrait is intimate but far from flattering.

The print has been somewhat trimmed at top and bottom from its original size.

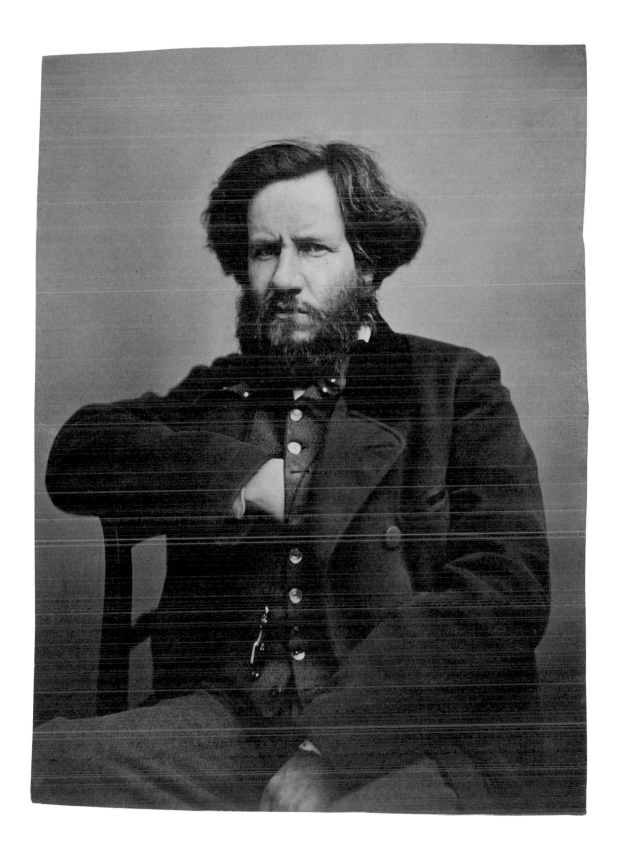

Auguste Luchet 1855–59

Self-Portrait in American Indian Costume

1863
Salt print
8 $^9/_{16}$ x 5 $^1/_{16}$ in.
Gilman Paper
Company Collection,
New York

Second Empire Paris has been consistently described as a frivolous and continual whirl of social activity, a principal feature of which were costume parties and balls. They ranged from grand spectacles like those given by the imperial family in their palaces to simpler entertainments staged in dance halls and restaurants. The costumes worn to these affairs were often elaborate, limited only by the purses or imaginations of their wearers. The Countess of Castiglione, a mistress of Napoléon III, sumptuously garlanded with flowers and rubies, brazenly impersonated the Queen of Hearts at the Tuilleries, while the artist Gustave Doré, decked in a wide variety of plants and with insects glued to his nose, appeared as "the countryside after the rain."[126]

For an unknown party, Nadar wore an apparently genuine beaded, feathered, furred, and fringed Plains Indian outfit, but he incongruously topped it off with a wig in the style of Louis XIV. (He later would pose George Sand swathed in velvet and wearing the same wig, which gave her a mild resemblance to that monarch.) In another photograph of this costume the pose is similar but he added a necklace of oversize beads, making it seem as if he were using the camera as a mirror in order to decide the details of what he would wear.[127] Although Nadar made many self-portraits these are the only two in which he appears in fancy dress. This assumption of another identity anticipates Andy Warhol's Polaroid self-portraits in drag but differs from them in that these were made to mark a particular, now forgotten, occasion.

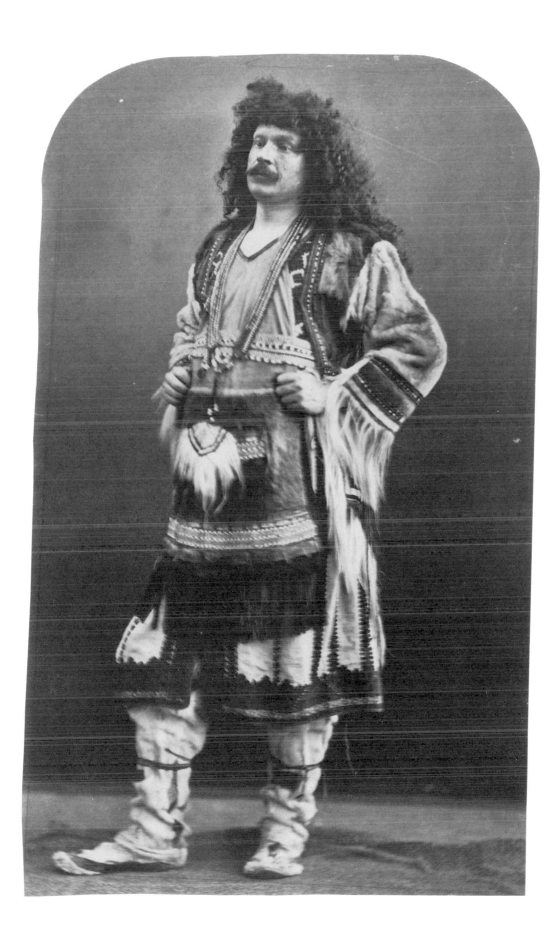

Self-Portrait in American Indian Costume 1863

114 **Augustin-Eugène Scribe**
1856–59
Salt print
10 x 8¼ in.
84.XM.262.2

Opposing familial pressure that he become a lawyer, Eugène Scribe (1791–1861) persevered in writing plays despite the failures of his first thirteen between 1810 and 1815—a play being considered a success if it ran for forty performances.[128] Critical and popular acclaim, and ultimately great wealth, rewarded his tenacious productivity in writing over 230 plays and librettos. These works varied from early plays like *The Bear and the Pasha* (*L'Ours et le pacha*), a farce with popular songs, to tragedies like *Adrienne Lecouvreur,* in which the heroine dies from inhaling the scent of poisoned flowers, to librettos for operas, both comic and tragic, by Meyerbeer, Halévy, Donizetti, Rossini, and, frequently, Auber.[129] The open secret of his success was his systematic collaboration with a team of coworkers who supplied stories, dialogue, and (when needed) jokes, which he synthesized into well-made plays. His historical dramas hinged on the fictionalized personal motivations of individual characters, rather than social, philosophical, or intellectual currents as causative factors of important political events. Even so, plot weighed more than character in his work. The formal symmetries of his plays, their artificial situations, their sensationalism, and their tidy resolutions were immensely influential. The realism of Ibsen that followed was in direct reaction against the theater of Scribe. His work is now seldom performed, save for a few of the operas for which he wrote the librettos.

Scribe is more conventionally posed than most of Nadar's sitters from the rue Saint Lazare period. The successful playwright, in his mid-sixties, wears formal, elegant, and expensive daytime clothing. Scribe's studs and cufflinks are elaborate, his watch chain finely worked; his lapel sports a decoration, and his necktie is moiré silk. There is neither playfulness in the sitter's costume, as in some Nadar portraits, nor is there much liveliness of expression. The line of Scribe's mouth is so uncommonly straight as to give little idea of temperament. The sitter's left eye is mild and even, but his right eye arrestingly burns out from deep shadow, providing evidence of the anxiety that caused the playwright to gnaw on his handkerchief when a rehearsal was going badly.[130] Scribe leans against a table covered with a heavy, fringed fabric and surmounted by two casually placed books, which could be taken as overt symbols of Scribe's vocation except that Nadar used such attributes nowhere else in his photographs. Judging from the bland general look of the portrait it is possible to conclude that the interaction between the playwright and the photographer was amicable but minimal. Nadar may have thought Scribe too self-contained a sitter to have revealed much of himself to the camera, but found the image worthy of his signature.

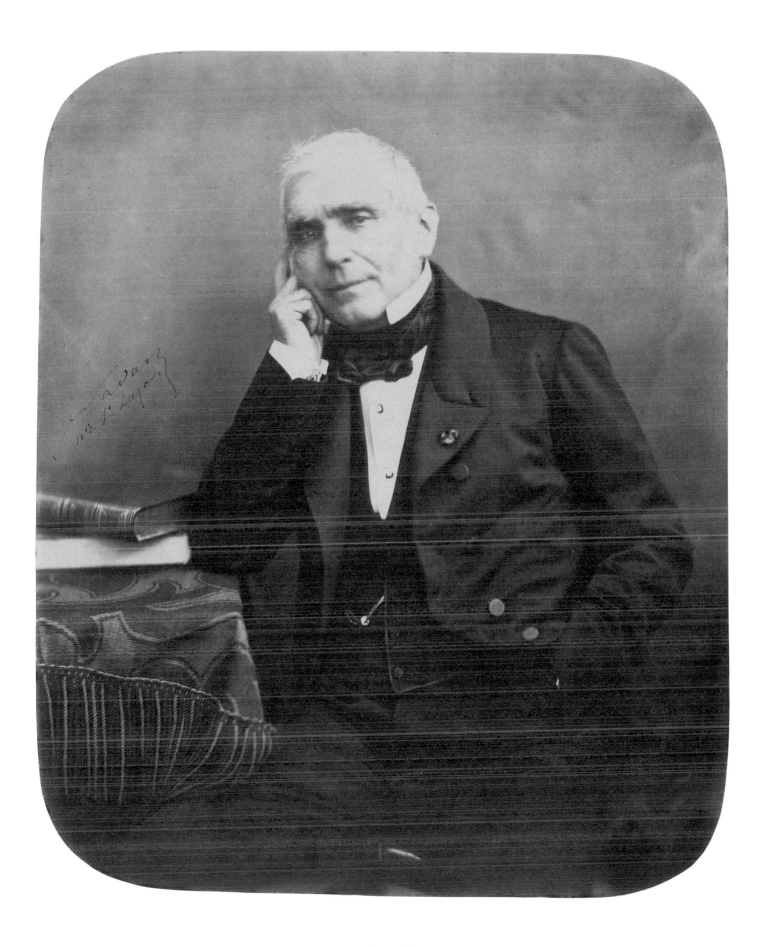

Augustin-Eugène Scribe 1856–59

116 **Sarah Bernhardt
(Rosine Bernard)**

Negative circa 1864
Gelatin silver print
by Paul Nadar,
circa 1924
8 5/16 x 6 3/8 in.
84.XM.436.494

Sarah Bernhardt (1844–1923) was about twenty when she posed for Nadar and had barely begun her long and phenomenally successful career. Nadar's photograph of the extraordinary actress was probably the first of the innumerable images that would be made of her by painters, photographers, sculptors, and graphic artists.[131] The young woman with the lissome shoulders and the golden voice would become an incomparable and indomitable actress, famous first in France and then throughout the world, starring as the heroine in a wide variety of plays, from classic tragedies like Racine's *Phèdre* to new plays such as Sardou's *La Tosca,* and *Théodora,* which was written expressly for her. From the 1880s she toured continually in revivals of her greatest triumphs, even after the amputation of one leg in 1915 when she was seventy-one. She had a genius for self-promotion, keeping a white satin-lined coffin in her bedroom, more for the sake of its shock value than as an acknowledgment of mortality. Her celebrity, the enormous attention she attracted everywhere she went, was not unlike a phenomenon of late twentieth-century media-generated publicity. A gifted amateur sculptor, she also wrote two novels, two plays, and her memoirs.

She spent prodigious sums of money, living lavishly, and died famous for the astonishing performances she had once given and for the beauty, grace, and charm that had once been hers.

At a time when Nadar was preoccupied with ballooning and willing to leave most of the portrait work to studio assistants, Bernhardt's dawning aura drew him back to the studio to make touching images of her delicate face. He wrapped her round with a great sweep of velvet that bared one shoulder but showed no more of her slender body, centering all attention on her head, which is seen nearly in profile. Save for the determined set of her lips, the intensity she brought to acting and living is for the moment concealed.

The truncated column at the left was a studio prop of the kind that was to increasingly figure in Nadar's studio output when it was no longer under his direct supervision, making its productions more conventional. To further her career Bernhardt, costumed for her latest triumph, would repeatedly sit for many other photographers including Paul Nadar (1856–1939), who made this print from his father's negative.[132]

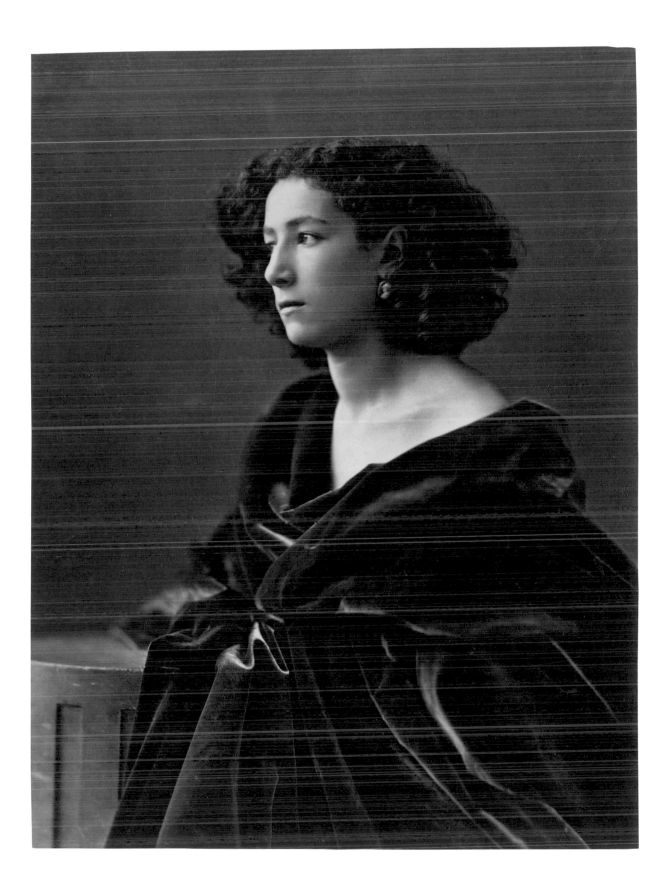

Sarah Bernhardt 1864

Émile Augier

118

1857

Salt print

9 5/16 x 7 3/8

84.xm.262.3

The author of twenty-nine plays, Guillaume-Victor-Émile Augier (1820–1889) was one of the principal French playwrights of the nineteenth century, although he is now less well known than his contemporaries Labiche, Sardou, and Feydeau. Born into a family of writers including his father, who wrote romantic novels when not practicing law, Augier himself studied law while writing plays. His first to be produced was *La Cigué,* a classical fantasy in verse. Subsequent plays, of the 1850s and 1860s, not in verse, were sometimes written in collaboration with others, and were set in the present day. These comedies of manners and character upheld the moral code of the period "by examining what happens when it [the code] is breached by complacency, philistinism, corruption, vulgarity, ostentatiousness, and social climbing."[133] Augier's satires of bourgeois society under siege were consistently successful, appreciated by audiences drawn from the same social strata as the characters onstage. Last-act resolutions, via marriage rather than a *deus ex machina,* of the problems posed in these well-formed plays, handily reinforced the audience's conservative republican values regarding financial propriety and the sanctity of the family.[134]

Augier and Nadar had known each other from at least the point when both worked on the newspaper *Le Spectateur républican* in the 1840s. Augier is the subject of an undated Nadar caricature made at about the same time and from nearly the same angle as the 1857 photograph (see fig. 4). The portrait emphasizes and the caricature exaggerates the shape of Augier's most salient feature, his prominent nose.[135] The profiles in each are a rare, direct crossover into photography from Nadar's continuing career as a caricaturist. In another pose from the same sitting Augier's head is more turned to the camera and the nose no longer silhouetted, so the second image is only a collateral relation of the caricature.[136] Profile views are rare in Nadar's photographs, probably because they make it impossible to capture the expression of the sitter's eyes and lessen the interaction of subject and photographer. The result is a more formal portrait than Nadar usually sought. Augier presents a wholly dignified, if distant, appearance for the camera, impeccably dressed and clearly prosperous. Evidently he was a bon vivant and something of a lady-killer: The Goncourt brothers later wickedly described the little curls around Augier's balding head as entangling the loves of many women of the theater.[137]

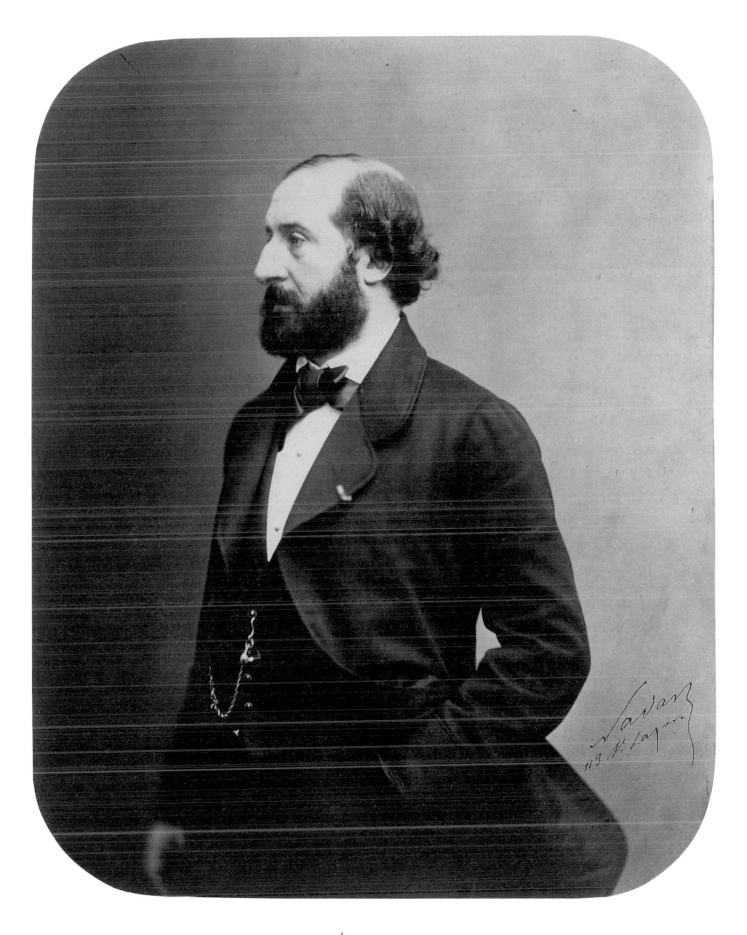

Émile Augier 1857

Up until the night of May 1, 1847 the singer Rosine Stoltz (1815–1902) had dominated the stage of the Paris Opéra for nine years in leading roles in works by Rossini, Berlioz, Donizetti and other composers like Halévy and Auber, whose names are now little known. That evening, during a performance of Rossini's *Robert Bruce,* when her voice faltered and momentary silence was followed by hisses, jeers, and thrown objects, she became enraged, and after somehow finishing the performance, she announced that she would no longer sing on that stage.[138] This effectively finished her mainstream career although she continued to appear in the provinces and abroad. Her success had been due to her ravishing if impure voice, varyingly described as that of a mezzo-soprano or a contralto,[139] and the complacent management of the Paris opera, which had given her extraordinary authority to do as she wished.

She began as the daughter of a Paris concierge. Her convent and conservatory education was sponsored by a royal patron, the Duchesse de Berri, and after concertizing in Paris her first successes came in Belgium and Holland. Her Paris career then followed. Recently described as the Maria Callas of her time, the mercurial and fiery Stoltz later became a baroness, and in 1870 she published a book of spiritualist sayings received, presumably in a trance, from Marie Antoinette, or so she said.[140]

At about the time when Stoltz sat to Nadar she had returned to the Paris Opéra for a single performance of her greatest triumph, as Léonore in Donizetti's *La Favorite,* in which she played the title role. Donizetti wrote the part, that of a medieval Spanish king's mistress who falls in love with tragic consequences, with the strengths of her voice in mind. In Nadar's photograph she seems more like a flamenco dancer, with her lace mantilla, spit curl, and shawl wrapped about her shoulders, as if ready in both appearance and temperament to play Carmen in Bizet's not-yet-written opera. At times Stoltz encouraged people to think she was Spanish in origin, which may have enhanced her allure at a time when the glamorous (and Spanish) Eugénie was Empress of France. Seductive at forty, she is perhaps the only sitter of Nadar to seem to be actively flirting with the camera—and perhaps the photographer as well.

120 **Rosine Stoltz**
1856–58
Salt print
9 $\frac{1}{8}$ x 6 $\frac{1}{4}$ in.
Musée d'Orsay, Paris
Pho. 1991–2 (57)

Note: Exhibited only in Los Angeles.

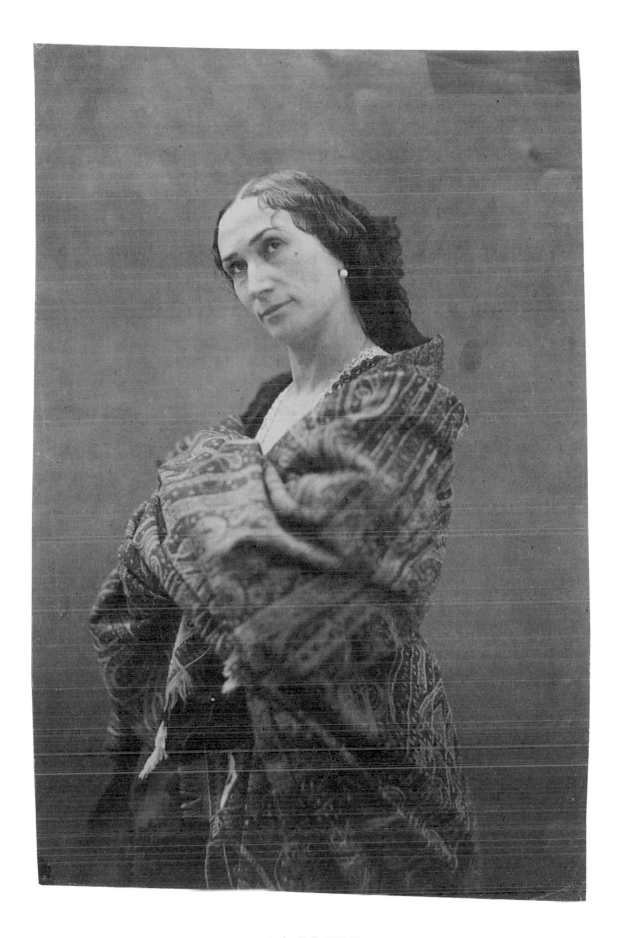

Rosine Stoltz 1856-58

Jules de Prémaray
1857
Salt print
9¹/₄ x 6¹/₁₆ in.
84.XM.436.264

Jules Martial Regnault (1819–1868), called de Prémaray, sat for Nadar in 1857. The two men had known each other since the early 1840s. In a December 1858 letter to Nadar, de Prémaray reminisced about the days of their first acquaintance, when Nadar's invariable good humor was "like music to cheer up their chums" (despite the misery of impoverishment).[141] As a youth de Prémaray worked briefly in business; at eighteen he started to write for the theater, but with so little initial success that he was forced to take menial jobs to survive. After some of de Prémaray's plays were produced in the 1840s he found more permanent employment as a political commentator and editor for the newspaper *La Patrie*.[142] The comedies and dramas that he wrote in the 1850s, sometimes in collaboration with others, were better received, and his experience in the theater turned him into an astute, fair, severe, but not bitter, drama critic. On the verso of his photographs Nadar customarily wrote the professions of his sitters and he designated de Prémaray as a theater columnist rather than as a playwright. By 1859 the critic's precarious health forced him to give up all kinds of writing and he died in 1868 at age forty-nine.

Before his sitting in 1857, de Prémaray wrote to Nadar to ask what clothes he should wear, confirming, as Françoise Heilbrun has pointed out, the importance Nadar placed on clothes in his portraits. (Or perhaps the letter indicates that de Prémaray's theatrical background led him to equate being photographed with being onstage, for which he would need a costume.) Whether the velvet smock in which de Prémaray is pictured belonged to him or to Nadar cannot be told for certain, but it seems large for the writer's frail figure, and the sleeves appear to have been turned back at the wrists, creating deep satin cuffs. His eyeglasses are hooked over one of the buttons that run down the garment's front. The deep circles under his eyes may be symptoms of the severe illness that necessitated a three-year course of hydrotherapeutic treatments starting two years later.

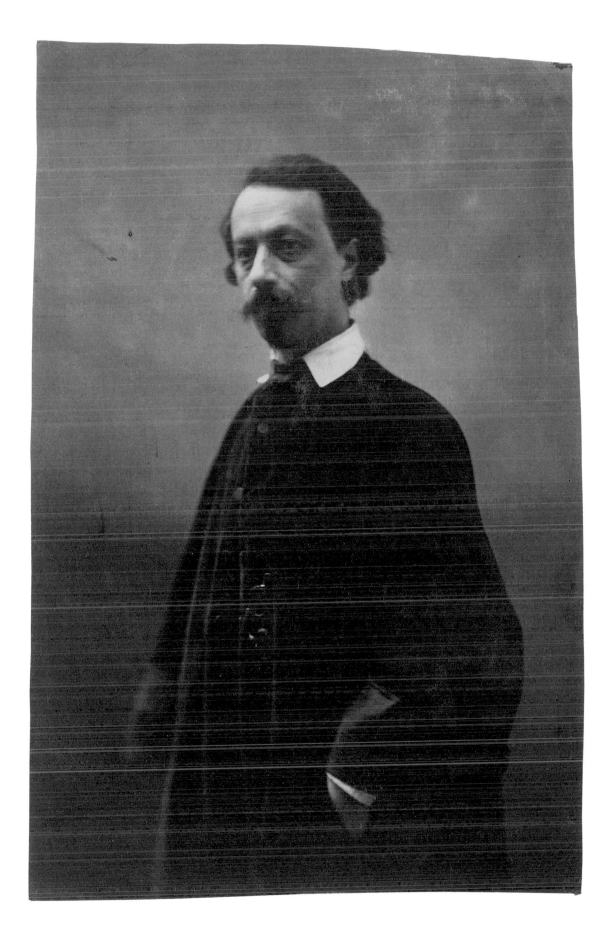

Jules de Prémaray 1857

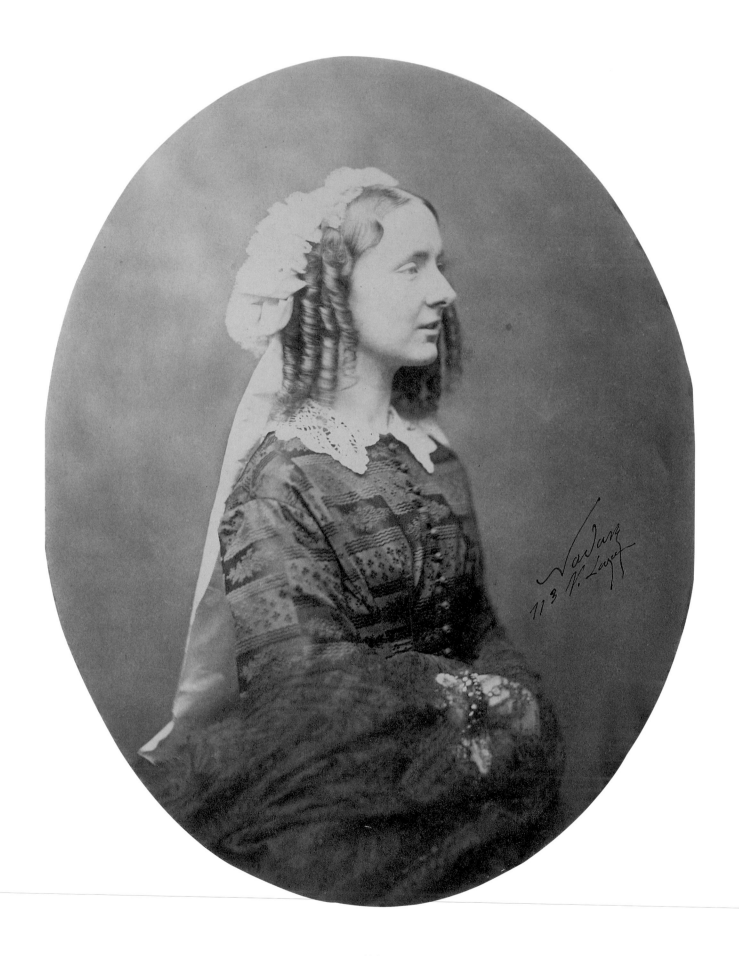

Mme E. M. Labiche 1855–59

Mme E. M. Labiche

1855–59

Salt print

8 13/16 x 6 3/4 in.

84.XM.436.41

Independent of the life of her husband, the prolific playwright Eugène Labiche (1815–1888), little is known of the life of Madame Labiche, save that her maiden name was Adèle Hubert, that she and Labiche were married in 1841 or 1842, and that they had a son, André.[143] Sometimes described as an heiress, she came from a respectable and stuffy family that found his profession disreputable and the theatrical milieu immoral.[144] In the introduction to the 1878 collection of his complete plays, which he dedicated to his wife, Labiche recalled that the Hubert family insisted as a condition of his marriage to their daughter that he write no more plays. A year later his wife, seeing how miserable he was, released him from the prohibition. The dozens of frothy comedies that followed were his best and commercially most successful, including *The Italian Straw Hat*, which is still performed. His principal subjects were the foibles, pretensions, and predicaments of the bourgeois society from which both he and his wife had come.[145] After 1877 he gave up writing permanently and the couple went to live on their country estate, where he enjoyed playing the role of country squire.

Nadar wrote in *Quand j'étais photographe*, in his essay on his clients, that when married couples came to see the trial proofs of the photographs that had been made of them the day before, nine times out of ten the wife became wholly absorbed in her husband's portrait, as also was he. Husbands generally seemed less interested in the images of their wives.[146] Perhaps the Labiches were among the ten percent of whom this was not true, as Labiche was personally modest.

Madame Labiche is luxuriously dressed for her portrait and her hair carefully arranged in the ringlets that were more fashionable in the 1840s than in the 1850s. Contrary to Nadar's usual practice, she is brightly illuminated, making the pattern of her silken dress evident. Gathered around her waist and over her braceleted wrist and gloved hands is a fine and filmy lace shawl. Around her neck is a crocheted collar, and on the back of her head she wears a ruffled day cap with wide trailing streamers. It is perhaps to better show this complicated headgear that Nadar asked her to turn to one side, creating a profile view that emphasizes her long, straight nose. Her lips are slightly parted in a suggestion of a smile, indicative of her sweetness of character. She looks quite the respectable and well-brought-up woman that she was.

126 **Jean-François-Philibert Berthelier**

1856–59

Salt print

9¹/₂ x 7⁷/₁₆ in.

84.xm.436.49

When the singer and actor Jean-François-Philibert Berthelier (1830–1888) arrived in Paris in 1850, his theatrical experience had been varied but slight. He had first stepped on stage at age eleven during a school prize-giving ceremony. While working as a traveling salesman he had sung comic ditties after dinner to amuse other hotel guests, and he had appeared in one role at a theater in Poitiers. Having been rejected for formal training at the Paris Conservatory, he sought employment and experience in the flourishing café-concerts (cabarets) of the period. His voice was strong and clear, his delivery original and adroit. Taken up by the composer Offenbach, Berthelier was soon successfully shuttling between three theaters—the Bouffes Parisiens, the Palais Royal, and the Opéra Comique—in a succession of as many as three light-hearted singing roles a year.[147] These gave him an extended repertory of comic songs and made him famous, and, ultimately, rich.

When Berthelier sat for Nadar he wore a costume[148] and perhaps a wig, presumably from the play in which he was currently appearing. Tasseled cap on head and brimmed hat in hand, his pose is diffident. As Maria Morris Hambourg has pointed out the oval form of the print is echoed within by the shapes of the cap and head and the shoulders.[149] Strongly lit, from above and the left, with a slightly goofy expression, he wistfully gazes away from the camera as if at some offstage object of his affection. It is likely that he re-creates here a moment from one of the operettas in which he appeared, so the portrait becomes as much one of an actor playing a role as of the man himself. This dual aspect of the image is perhaps unavoidable in portraits of actors but runs counter to Nadar's desire to capture the essence of his sitters.

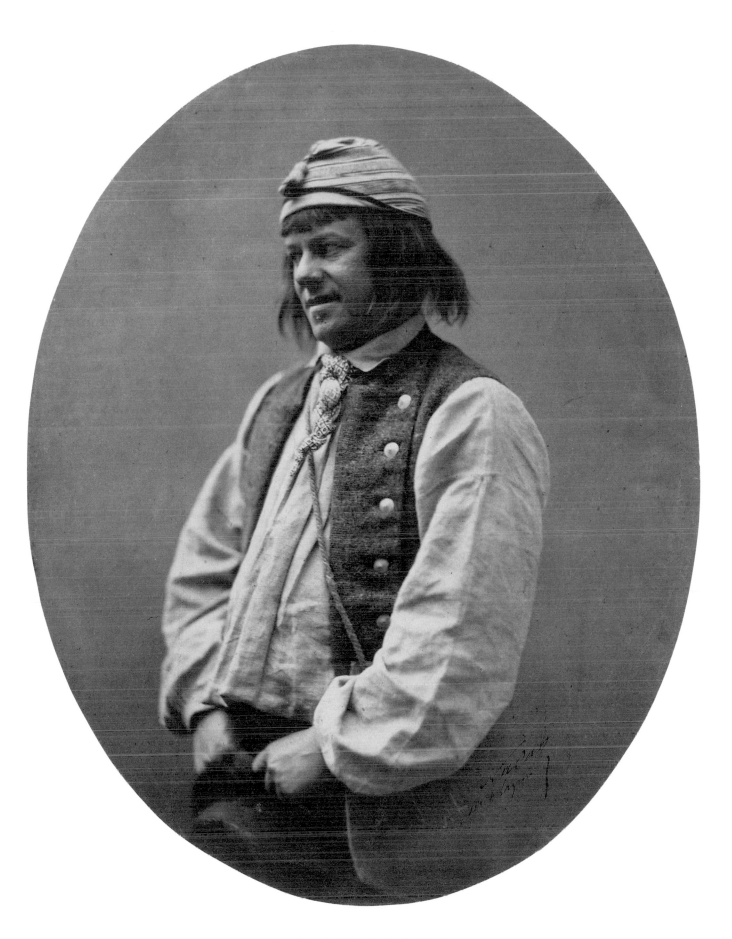

Jean-François-Philibert Berthelier 1856–59

128 **Self-Portrait**

circa 1855

Salt print

8 1/16 x 6 11/16 in.

84.XM.436.2

Of the photographer's self-portraits this is the most superficially attractive and, because of its intimacy, the most engaging. Nadar looks over toward the camera as if to another person, as if he had been pondering some matter and only glanced outward and upward when spoken to. It differs from his other studies of himself in several respects. He is more formally dressed, although the soft, unstructured jacket that looks almost black may well be red, the color he habitually wore.[150] His little round collar, which seems to be starched, and his neatly knotted tie are of more conservative cut than usual. Also, in only this instance among the self-portraits, and unlike nearly all his pictures of other people, his hands are conspicuous. Two of his left fingers tensely angle up over the support on which his right elbow rests. The fingers of his right hand, which is sharply bent back at the wrist, are curled against his cheek echoing the shape made by his hair. What is oddest is that a

man who was five feet ten appears much shorter and more compact, tightly held in. The impression he gives is of contained intensity, which is wholly appropriate in light of his frenetic productivity.

Of the many self-portraits of a man who continually reinvented himself, this alone is signed and bears the address of his studio, indicating that he intended to use it to promote himself as a photographer. As a conscious propagator of the fame of others and a believer in the Romantic artist as a heroic figure, he was anxious to cast himself as a forceful figure, but he was astute enough to know that he must also seem thoughtful and approachable. The photograph, a canny combination of intentions, may have hung at the entrance to the rue Saint-Lazare studio, but it may also have been intended for display in one of the public exhibitions to which Nadar sent work, like those of the Société Française de Photographie.

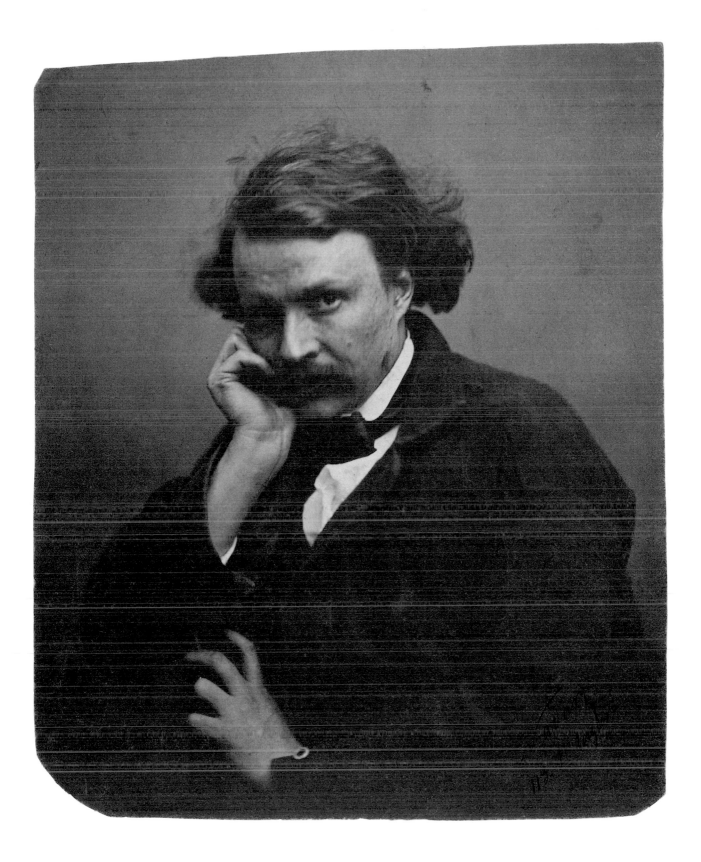

Self-Portrait circa 1855

"Andy Warhol

THIS PHOTOGRAPH
MAY NOT BE-- ETC.

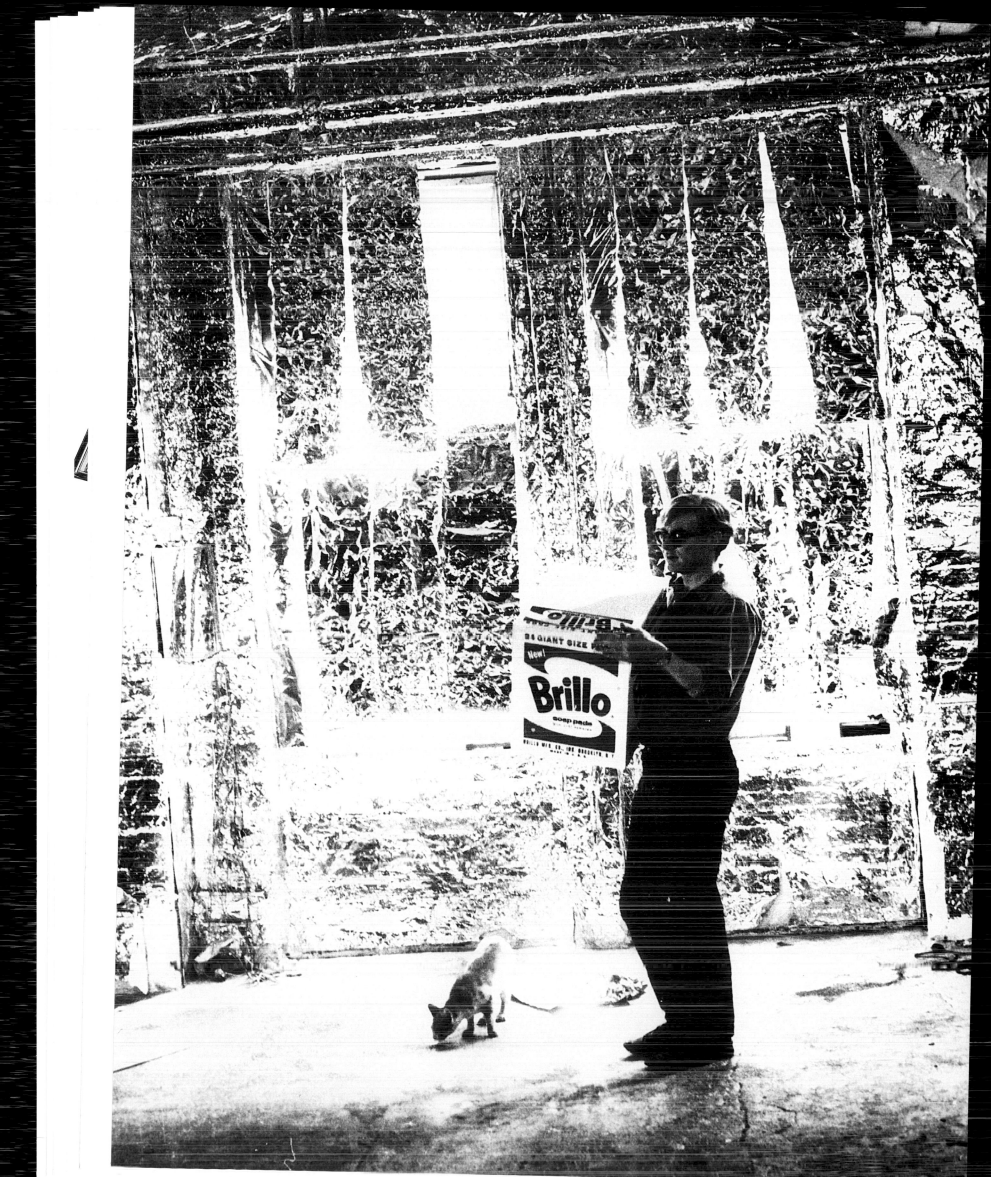

144

FIGURE 12
Andy Warhol, "The Last Supper"
(Detail of Ceramic Sculpture),
1985. Polaroid Polacolor
ER print, 4¹/₄ x 3³/₈ in.
The Andy Warhol Foundation
for the Visual Arts, New York,
FA 09.01128.

While he continued to photograph and paint society personalities, people on the street, including those who lived there, were of more and more interest to Warhol's camera. In his *Diaries* he expressed a desire to be like Weegee, who spent his nights in the 1940s following a police radio to crime scenes, or to emulate his contemporary Bill Cunningham, who spent his days prowling Manhattan with camera and bicycle in search of the latest street-fashion trends. Warhol considered carrying photo-releases with him, talked about a series on 42nd Street, and reported the hazards of his own street photography—like having a homeless man scream that he would take Warhol's picture while refusing to be photographed himself, or having a street ventriloquist's dummy recognize him when he was trying to photograph the crowd. His fame made street photography difficult; he often found himself signing autographs rather than getting spontaneous pictures of New York pedestrians.

Decades of medical problems had driven him from specialists to natural remedies to the use of crystals—anything to avoid hospital visits and further operations. In February 1987, at age 58, Warhol could no longer postpone gallbladder surgery. The operation was uneventful, but he died the following day from unexpected complications in the recovery process. Only weeks before, he had been to Milan to see an installation at the Palazzo delle Stelline of paintings from what would be one of his final major series, "The Last Supper." In preparing these enormous canvases—some as large as thirty-five feet wide—Warhol used color and line reproductions of Leonardo da Vinci's well-known fifteenth-century fresco *The Last Supper* (1495–97/98, in the Refectory of Santa Maria delle Grazie, Milan), rephotographing some of these mediocre translations so that he could look at the composition as a negative image. In the process of deciding how to portray Christ and the apostles, Warhol, a practicing Byzantine Catholic, also studied cheap three-dimensional replicas after Leonardo for another interpretation of this famous event and its complex composition. These ceramic representations of biblical characters, though inanimate, became Andy's photographic subjects and thereby assumed new life [FIGURE 12]. His Polaroid camera recorded individual faces and poses as well as small still lifes taken from the table's contents. Warhol's application of instant color photography to these iconic personages was, appropriately, a further popularization of the Renaissance painting that had, through mass reproduction, made modern celebrities of ancient religious figures. His finished canvases on the subject insured his connection with Leonardo and the famous faces at the table.

Warhol Catalogue

NOTE TO THE READER

Unless otherwise noted, the photographs in this
catalogue belong to the J. Paul Getty Museum.
The Getty pictures are indicated by an accession
number, the first two digits of which reflect the
year of acquisition. Dimensions indicate the sheet
size unless otherwise noted.

154 **Self-Portrait with Gerard Malanga and Philip Fagan**
circa 1963
Gelatin silver print,
photobooth strip
7 3/4 x 1 1/2 in.
The Andy Warhol
Museum, Pittsburgh
FM 01.00007

Gerard Malanga (born 1943), seen here in profile in the foreground, was Warhol's assistant from 1963 to 1970, during which time he silkscreened Andy's images onto canvas, worked as a cameraman on his films, performed in multimedia productions, and edited the magazine *Interview* they founded together in 1969. Warhol and Malanga, then an aspiring poet and photographer, put together the book *Screen Tests/A Diary* (1967), a volume composed of Malanga's poems and a collection of stills from fifty-four of Warhol's three-minute portrait films. The two had begun making screen tests of friends and visitors at their Factory studio space about the same time that they started frequenting photobooths, like the one Malanga preferred in the Playland arcade on Seventh Avenue. On the day these pictures were made, Philip Fagan, a dancer who Warhol was romantically involved with at the time, accompanied Malanga and Warhol. The three took turns posing in the lower foreground and produced at least seven four-frame sequences of their triple portraits.

After leaving the Factory, Malanga followed *Screen Tests/A Diary* with a second volume of poems, *Chic Death* (1971), inspired by Warhol's 1963–64 painting series entitled "Death and Disaster." It contains several pieces dedicated to Andy, including this biographical sketch:

Photos of an Artist as a Young Man

for Andy Warhol

He lies on bed—white walls
behind him:
furniture scarce.
Illustration of shoe
horn hangs on wall behind
and above him. He has
dark hair. He holds Siamese
cat in arms. It's 1959.

"I grew up in Pittsburgh
after the war: ate soft
boiled eggs every day for two years:
attended Carnegie Tech;
went to New York: lived
with ten dancers on the upper West Side;
free lanced in shoe illustration
with I. Miller Shoe."

Beyond the slow introduction
to refinement, the development of character,
it's not easy to breathe. He is
the invisible and unimaginable journey
through colors silk-screened on canvas
what he or the boy may have seen
years before, standing there
in the field, young, innocent, speechless.

GERARD MALANGA, *Chic Death* [27]

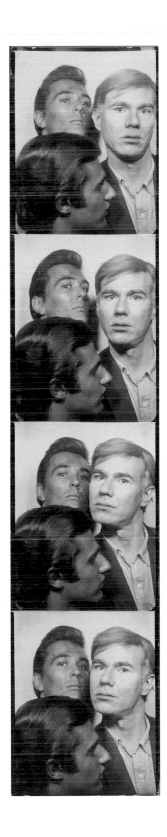

Self-Portrait with Gerard Malanga and Philip Fagan circa 1963

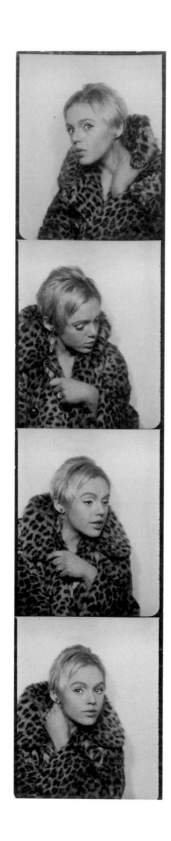

Edie Sedgwick 1965

Edie Sedgwick

1965

Gelatin silver print,
photobooth strip
7³/4 x 1¹/2 in.
The Andy Warhol
Foundation for
the Visual Arts,
New York
FM04.00119

In 1985, Warhol talked to his *Diaries* about going to a sixties party at the nightclub Palladium:

Every girl who said hello was an 'Edie.' And somehow they never get the hair right—Edie's was straight back and dyed like a boy and really white, but they usually give themselves bangs or something. Everybody gets the Edie look wrong and I don't know why.[28]

That look—the feminine interpretation of the Warhol look adopted by the twenty-two-year-old Edith Minturn Sedgwick—and Sedgwick's brief, volatile relationship with the artist made her New York's Girl of the Year in 1965.

Tom Wolfe, astute chronicler of the sixties, explained the phenomenon this way:

The Girl of the Year is a symbolic figure the press has looked for annually in New York since World War I because of the breakdown of conventional High Society. The old establishment still holds forth. . . . But alongside it, all the while, there has existed a large and more dazzling society, Cafe Society it was called in the twenties and thirties, made up of people whose status rests not on property and ancestry but on various brilliant ephemera, show business, advertising, public relations, the arts, journalism or simply new money of various sorts, people with a great deal of ambition who have congregated in New York to satisfy it and who look for styles to symbolize it.[29]

While the press christened Edie Girl of the Year, Warhol eagerly made her his new Superstar. Born in 1943, she came to New York from Cambridge, Massachusetts, where she had been a private art student. Her family, of old

New England descent, was in California, where she had been raised (when not hospitalized for psychiatric care) on a three-thousand-acre ranch near Santa Barbara. Two of her seven siblings, brothers Francis and Robert, had died violently in 1964–65. A wealthy grandmother lived on Park Avenue, and in 1964 Sedgwick moved in with her and pursued acting and modeling prospects. Edie and Andy met at a party, and he suggested that there might be a part for her in one of his movies. One visit led to parts in thirteen Factory films of 1965, including a series of mostly unscripted films documenting Edie's "normal" life, originally called *The Poor Little Rich Girl Saga*. She also starred in *Lupe*, loosely based, as were several of Warhol's other films, on a Hollywood scandal. Ironically, her character, Lupe Velez, had killed herself in 1944 with an overdose of sleeping pills—as would Edie in 1971.

In addition to performing for Warhol's movie camera, Edie frequently accompanied him to parties and opening nights. She spent hours each day selecting clothes and applying makeup. The celebrity of this High-Society daughter turned Cafe-Society darling derived as much from her daring style and beauty as from her underground film roles. When she and Warhol attended the opening of his first one-man museum show at the University of Pennsylvania's Institute of Contemporary Art, the large crowd surged around them as they stood on a staircase above security officers. Edie and Andy signed souvenirs, then escaped with their entourage through a newly made hole in the museum's ceiling.

157

Brigid Berlin 1971

Brigid Berlin

1971
Polaroid Polacolor
108 print
4¹/₄ x 3¹/₈ in.
The Andy Warhol
Foundation for
the Visual Arts,
New York
F144.00018

I wake up and call B.
B is anybody who helps me kill time.
B is anybody and I'm nobody. B and I.
I need B because I can't be alone.[30]
ANDY WARHOL, 1975

Warhol dedicated his 1975 book, *The Philosophy of Andy Warhol,* to four colleagues, including "beautiful Brigid Polk, for being on the other end." Brigid "Polk" Berlin (born 1939) was on the other end for more than twenty-five years. She got to know Warhol in the mid-1960s and became a fixture at 231 East 47th Street, the first of the artist's studio spaces to become known as the Factory. Berlin, who suffered from weight and drug problems (apparently she acquired the nickname Polk ["poke"] from her intravenous use of speed), was not a Factory Superstar, a regular party date, or a business manager for Warhol, but she was, over several decades, a friend, a highly important muse, and probably the most loyal of his Factory "family."

Brigid's father, Richard Berlin, went to work for the Hearst Corporation as an advertising salesman right after World War I and steadily ascended the corporate ranks: he was the executive vice president of the magazine division by 1930, president of the corporation in the early 1940s, and, upon Mr. Hearst's death in 1951, became chief executive officer. He and his wife, former debutante Muriel "Honey" Johnson, raised four children, of whom Brigid was the oldest, in their Fifth Avenue home, where they gave parties for presidents and royalty. Brigid attended boarding schools, and, instead of college, a finishing school. At twenty-one she came into an inheritance from a family friend,

married a window decorator (for seven months), rented vacation homes, hired private planes, and entertained extravagantly until the money ran out.

Brigid was making her own art (involving batik dyeing), indulging an amphetamine habit, and living in modest circumstances when she began spending time at the East 47th Street Factory. In addition to being a gifted artist (and one who shared Warhol's enthusiasm for the Polaroid medium), she was a funny, gregarious, uninhibited companion who amused Warhol both at the office and on the phone. Their phone conversations would run to three hours and would sometimes be taped by both parties, creating the typically Warholian question, "Whose tape was the original of this performance piece?"

Warhol may have been most fascinated with Brigid's privileged childhood (she told him she first saw *The Wizard of Oz* in the screening room at Hearst's San Simeon estate) and her close association with a publishing empire that included eight newspapers, four radio stations, three TV stations, and a book company. Warhol had wanted to produce films with Hollywood and attempted to create his own alternative studio and superstars. Discouraged with the prospects for that business, he started a magazine intended to be a monthly film journal, *Interview,* in 1969. According to Brigid, "Andy always said he started *Interview* for me. Because of Daddy. He wanted to have his own Hearst empire."[31]

Lita Hornick

1966

Gelatin silver print, photobooth strip

8 x 1¹/₂ in.

The Andy Warhol Museum, Pittsburgh

FM04.00013

Lita Hornick (born 1927) would become known as the "Kulchur Queen," a literary critic whose writing included the essay "Why I Love Gay Men" (in *Great Queens Who Loved Poetry,* 1993). In 1966 she was already the force behind Kulchur Press and a supporter of poets, including Warhol's assistant Gerard Malanga, who convinced her to publish a book combining his poems with stills from Warhol's large series of black-and-white "Screen Tests."[32] Hornick not only agreed to fund this book of fifty-four poems and portraits of underground poets, musicians, and Superstars (*Screen Tests/A Diary,* 1967), but she also commissioned a painted portrait from her new acquaintance, Andy Warhol.

In 1964 the artist Alex Katz painted Hornick's portrait. When Hornick interviewed Katz later about how he approached portraiture, particularly this commission, he told her that, as always, "he dealt only with appearance and surface, without any psychological penetration."[33] He created a large, bust-length image of Hornick in pearls and "a low cut black Trigere cocktail dress with rhinestone straps and much exposed cleavage."[34] Although Katz claimed to be interested only in recording her physical appearance at the time, albeit in reduced form, he offered that his subjects did sometimes become symbols, in her case that of the "glamorous woman" (which, Hornick says, "was not wholly inappropriate" in 1964).[35] Katz told this wealthy wife of a Fifth Avenue retailer (Morton Hornick owned a curtain company) that he had not tried to see through her makeup, but rather had "let good taste go and went for style."[36]

Two years later, Warhol shunned both psychological probing and personal style, choosing instead a Times Square photobooth for the instantaneous creation of a new Hornick portrait. In fact, Warhol didn't even accompany his sitter to pose for the automatic camera. Malanga went with Hornick and, possibly, gave her some direction as she arranged herself, before light and dark backgrounds, smiling and serious, in profile and confronting the lens, with and without pearls, in a sophisticated turban and in a more matronly headband, in this smallest and cheapest of portrait studios. At least thirty strips of four frames each were created by Hornick, Malanga, and Andy's surrogate camera.

He chose one of the turbaned, 1940s-style poses, which Hornick would later describe as "regal," to be enlarged in silkscreen and repeated on eight canvases in as many different combinations and shades of his favorite high-key yellows, reds, greens, and blues. In *Lita Curtain Star,* the finished eight-panel piece that now belongs to the Museum of Modern Art (New York), Hornick's face and accessories are duplicated in black outline following the photographic image, with her pearls, striped sweater, turban, face, and eyes changing color and emphasis from one "frame" to the next. She understood that the final painting, like the photobooth studies she helped to compose, both "glamorizes and satirizes" her.[37] The Hornicks, collectors and admirers of Pop Art, apparently had been prepared for that possibility; they reportedly were the first to ask for a portrait that "looks like Marilyn Monroe's."[38]

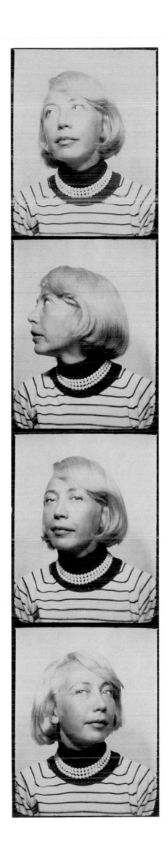

Lita Hornick 1966

Taylor Mead 1969

Taylor Mead

1969

Polaroid Polacolor

108 print

4¹/₄ x 3³/₈ in.

The Andy Warhol

Museum, Pittsburgh

F024.003

Andy Warhol considered Taylor Mead (born December 31, year unknown) a star when they met through curator Henry Geldzahler in 1963. Geldzahler was an admirer of Mead's poetry, but Warhol was probably more aware of his various roles in acclaimed underground films, such as Ron Rice's *The Flower Thief* (1960) and *The Queen of Sheba Meets the Atom Man* (1963), and Adolfas Mekas's *Hallelujah the Hills* (1962). By the time of their meeting, Mead had not only debuted as a comic film actor, published two volumes of his diaristic notebooks (*Excerpts from the Anonymous Diary of a New York Youth,* 1961 and 1962), and hitchhiked across the country several times, but he had been arrested numerous times, once for being homosexual. His roots were in an upper-class, politically connected Midwestern family.

Having spent time in San Francisco and Venice, California, and absorbed the writings of restless Beat authors Jack Kerouac and Allen Ginsberg, Mead was reading his own poetry in Village coffee shops and working on his third volume of notebooks ("written . . . from the perspective of stardom") when he agreed to join Warhol and friends Gerard Malanga and Wynn Chamberlain on a road trip to Los Angeles.³⁹ The purpose of the trip was to attend the opening of Warhol's second one-man painting show at Irving Blum's Ferus Gallery. Warhol was afraid of flying at that point and didn't drive, so Mead and Chamberlain were enlisted to make this journey through Pop highway culture possible. In Los Angeles, the foursome attended the Marcel Duchamp retrospective at the Pasadena Art Museum and made a movie with Warhol's new 16 mm Bolex

camera. Mead played the unlikely role of Tarzan in this early experiment called *Tarzan and Jane Regained . . . Sort of,* which also featured Dennis Hopper. In 1967 Warhol cast Mead in one of the Factory's commercially distributed films, *Lonesome Cowboys,* a gay rendition of the Western genre.

Mead appeared in other Warhol films, such as *Couch* (1964) and *Nude Restaurant* (1967), and in the photobooth "sequences" being accumulated by Warhol. He took full advantage of the few minutes and four frames allowed in each photobooth "shoot"; in more than fifteen of these sessions he is seen in a white t-shirt clowning with an umbrella, stretching his shirt to imitate the veiled, praying virgin, and coquettishly showing off his chest. The photobooth pictures probably date to the mid-sixties. However, in 1969, the year of this Polaroid portrait, Mead's appearance and behavior have not changed. Warhol biographer Bob Colacello described him around 1970 as someone who "looked like a Bowery bum and talked like a Village waif."⁴⁰ Here the introverted "waif" seems to lunge at the camera, as if surprising the photographer from a nearby hiding place. The impish, bare-chested Mead appears as a provoked gremlin superimposed (by way of a double exposure) on top of an anonymous male nude. Although this combination of forms was probably contrived photographically for purely aesthetic reasons, Mead's fierce but farcical expression may have been laid over the male body as a kind of demonic mask intended to frighten off the police or other authorities trying to limit individual, particularly homosexual, rights.

**Leo and Antoinette
Castelli**

1978
Gelatin silver print
10 x 8 in.
The Andy Warhol
Foundation for
the Visual Arts,
New York
FL06.00019

Many critics cite a 1962 exhibition at the
Sidney Janis Gallery called *The New Realists,*
which included the work of Warhol, as the
beginning of Pop Art. Others, however, credit
the one-man shows of Jasper Johns and Robert
Rauschenberg that Leo Castelli held in 1958
with bringing in the Pop Era. By the mid-1960s,
Castelli (born 1907) had also taken on Roy
Lichtenstein, James Rosenquist, and Andy
Warhol, assembling the most important group
of American post-war artists working in the
Pop style.

The man who would create the market,
both in the United States and Europe, for this
radical art of the sixties was born in Trieste, Italy,
and trained as a lawyer in Milan. He worked at
banking and insurance in Italy, France, and
Romania, and in 1933 he married a Romanian,
Ileana Shapira. His wife's wealth allowed them
to investigate the gallery business in Paris in
1939, and later, after emigrating to New York,
to open a second business on a floor of
the family home. Their first show in 1957
consisted of a group of established Americans
and Europeans, such as Jackson Pollock,
Marsden Hartley, David Smith, Fernand Léger,
Willem DeKooning, and Francis Picabia, but
in the first months of their second year the
new talents of Johns and Rauschenberg were
prominently displayed.

By the late 1970s, the Castellis had divorced,
Ileana had her own gallery on West Broadway,
Leo had opened two Soho spaces, and Leo's
second wife, Antoinette (1928–1987), was
running another aspect of his art business,
Castelli Graphics. Leo Castelli has been vari-
ously described as both "the Pope of Pop"
and "a modern Medici," suggesting someone
who had a benign, generous nature in concert
with a scheming, unscrupulous business
sense. Warhol had known and worked with
the Castellis for many years when he made
this picture in 1978. Five years earlier, he had
created a silkscreen painting of Leo, which
the sitter appreciatively called "savage, quite
savage."[46] But his intention here is not so
much to create a portrait as it is to document
the relationship of two art world powers. He
captures them at one of the many art world
gatherings they shared with their most famous
Pop artist, possibly a cocktail party at the home
of Thomas Armstrong, director of the Whitney
Museum, that was also attended by Johns, the
dancer Merce Cunningham, and the art critic
Hilton Kramer. That day, Warhol records, had
begun with him watching his friend Calvin Klein
on a TV talk show, continued with a visit to one
of his own shows at the Blum-Helman Gallery
(where he discovered that one of the *Soup Can*
paintings was a fake), and ended, after the
Armstrong party, at the home of the designer
Halston, discussing with friends that day's
New York Times article about them.

Leo and Antoinette Castelli 1978

**Keith Haring
and Juan Dubose**

1983
Polaroid Polacolor
ER print
4¹/₄ x 3³/₈ in.
98.XM.168.7

The early 1980s saw the emergence of artists whose work originated in or was inspired by graffiti, stylized words and pictures spray-painted by rebellious teenagers on the walls of urban America. These young artists, such as Futura 2000, Kenny Scharf, Jean-Michel Basquiat, and Keith Haring (1958–1990), worked on the street and in subways as well as on gallery walls and canvases. Warhol made Haring's acquaintance in 1982, when the twenty-four-year-old was having his first major one-man show at the Shafrazi gallery, a venue overseen by Tony Shafrazi, who had played a controversial role in the New York art scene since the early 1970s.

Haring grew up in a small Pennsylvania town and described his childhood as one prescribed by his parents and television. However, his sheltered existence did not prevent him from having his first LSD experience at fifteen and taking other "trips" in the fields around Kutztown. He attended art school in Pittsburgh before moving to New York City in 1978, where he took classes at the School of Visual Arts. Haring met Scharf and Basquiat at this time and read Beat-movement novelist William Burroughs. This education and exposure no doubt had an impact, but Haring attributed his reductive graphic style, which Warhol would praise as "cartoonist," to the hallucinatory power of drugs, telling Timothy Leary, "The drawing I did during the first trip became the seed for 'all' of the work that followed and that now has developed into an entire 'aesthetic' view of the world (and system of working)." [50]

His reputation as a graffiti artist came primarily from the "cookie-cutter" line drawings of babies, dogs, and dancing figures in white chalk that he created on black paper found in the subway. This work started in 1981, when he was also painting on cheap found objects of metal, plastic, or other surfaces that would sustain his decorations. With Shafrazi's help, Haring achieved nearly overnight success in the teeming art market of the 1980s. In 1983 he had his second show at the gallery. More significantly, he was represented that same year in the Whitney and the São Paulo biennials. His fame led to more mural and sculpture commissions, solo shows, and the opportunity to open Pop Shops to sell his work in New York and Tokyo. He used this increasing celebrity to draw attention to the horrifying spread of AIDS, a disease that caused his own death in 1990 at age thirty-one.

Warhol's Polaroids of Haring and his partner Juan Dubose, who died in 1989, were made in preparation for several 40 x 40-inch painted portraits, one of them done in black and white. The strong shadows created by studio lighting and the camera's flash are even more emphatic in Warhol's canvases, where detail and natural flesh tones have been eliminated. While Warhol helped his young friends cope with problems caused by their early success, this portrait could be a study for an ancient sepulcher. It suggests that Warhol was almost presciently aware of their impending and sadly premature deaths.

Keith Haring and Juan Dubose 1983

Keith Haring Painting Grace Jones 1984

Keith Haring Painting Grace Jones

1984

Gelatin silver print

10 x 8 in.

The Andy Warhol Foundation for the Visual Arts, New York

PL04.00322

P hotographs such as this one and Warhol's diary entry for July 28, 1984 record his version of the session for *Interview* that brought the artists Keith Haring and Grace Jones (born 1952) together for the first time:

Went to Soho to go to Robert Mapplethorpe's shooting session of Grace Jones for Interview *that Keith Haring was doing special makeup for. . . . Stopped at Central Falls for lunch because they advertise [in* Interview*], they were thrilled to have us. . . . Then wandered around Soho, knowing that Grace would be good and late. Signed autographs. Called Keith and he said to come in forty minutes. So to kill time we went over to Avenue D and 2nd Street where Keith had done a thing called "Candy Store"—he painted a brownstone with a storefront red and green and blue and purple and inside the kids sell drugs. . . . Went to Mapplethorpe's on Bond Street. Keith did Grace's makeup and Mapplethorpe shot her and we were there for three hours. Then went home to watch the opening of the Olympics on TV and it was thrilling. . . .* [51]

Mapplethorpe's work from this fruitful session not only appeared in the October 1984 issue of *Interview* but, as large 19 x 15-inch prints, became part of Haring's own collection. For Haring and Jones, the meeting yielded a productive friendship and an important 1985 collaboration at the Paradise Garage.

Paradise Garage was a Soho club frequented by Haring where he found the newest forms of popular black dance. Haring's inspiration for many of his simple black line figures derived from nights of hip-hop and break dancing at this club. He had also created a piece in 1983 for the Kitchen performance space with black avant-garde dancer Bill T. Jones, covering Bill's body with graffiti as he did with Grace for *Interview*. In 1985 he and Grace put together two performances for the Paradise Garage. These evenings of transient art were recorded by the photographer Tseng Kwong Chi, who observed Haring looking at images of East African Masai body painting before again covering Grace's body with his own designs. Haring's friend, jewelry designer David Spada, contributed to Jones's transformation for the Paradise Garage event as he had for *Interview*. She wore the tall headdress made up of running figures, crosses, and other Haring iconography that they had prepared in 1984. Spada and Haring designed metallic coils to mark her breasts and change color as she performed. Another element of this living sculpture was a coil of metal in bikini-form that may have been in imitation of Alexander Calder's 1920s iron-wire representation of the black cabaret sensation Josephine Baker. At one point in the piece, Jones also wore a raffia-type skirt, albeit one of neon yellow spikes, in apparent homage to Baker.

Warhol clearly enjoyed watching his protégés work. Both Jones and Haring, following his example, immersed themselves in popular culture, made art from it, and made their lives part of that art.

182 **Grace Jones**

1984

Polaroid Polacolor

ER print

4$\frac{1}{4}$ x 3$\frac{3}{8}$ in.

98.XM.168.9

As Andy wrote in his book *America,* published in 1985, ". . . now, it seems like you have to do lots of things really well, and you don't get to stay famous for long unless you're always switching. Grace Jones is an example of this."[52] Indeed, Jones had been a runway model, singer, movie actress, and performance artist by the time she was thirty. She had also gained celebrity status for her individual style, arguably the most prominent reincarnation of the gender-bending sixties. Her six-foot height, love of men's clothing, striking feminine features, and dramatic makeup created attention as well as confusion; was she a man in drag, a woman who had been a man, or the product of an original plastic surgeon?

Born and raised in Jamaica, Jones moved to New York City as a teenager and began making her own dresses from Givenchy couture patterns that she bought at the local Woolworth's. Her modeling career took off in Paris in 1974, where she was declared the new Josephine Baker. Trying to succeed as a singer, she worked in cabarets and made some disco recordings before finding her way to a distinctive half-spoken delivery, mixed with Jamaican music, on the album *Warm Leatherette* (1980). While gaining a reputation as a Pop diva, Jones, in collaboration with French artist and *Esquire* art director Jean-Paul Goude, developed a repertoire of more serious multimedia performances, including her *One Man Show* (1980). The piece called for Jones to appear at times in a gorilla suit, a man's tailored suit with stiletto heels and sunglasses, and a bright, polka-dotted, minstrel-like skirt as she applied her ironic humor to songs and movements

referring to the stereotype of the "primitive" African American.

In addition to early ventures into Italian cinema, Jones achieved Hollywood success in several action-adventure movies. Playing wild-woman warrior Zula in *Conan the Destroyer* (1984), she projects a screen presence that nearly overwhelms her costars, bodybuilder Arnold Schwarzenegger and basketball star Wilt Chamberlain, not to mention the forces of good. In the James Bond film *A View to a Kill* (1985) Jones plays a similar villainous role, that of Christopher Walken's companion May Day. Her offscreen bodyguard/boyfriend Hans Lundgren, an expert kickboxer, helped her train for this athletic part, increasing the range of her acting skills (she told Warhol that she felt she could play any race, sex, or animal).[53]

Warhol was commissioned to photograph Jones for *Vogue* magazine in July 1984. He and fashion critic André Leon Talley waited three hours before a Factory assistant discovered that Jones was at Bergdorf's retrieving one of her furs from storage (in July!). According to Warhol, who thought jewelry a much better investment, Jones spent "all her money on fur coats."[54] It is not surprising, then, that he portrayed her in one during this session. The dark fur collar provides good contrast and framing for her face and the soft yellow scarf that surrounds it. Her cap and gloves, in a more masculine style, give the portrait an androgynous balance typical of Jones and other "crossover" celebrities, such as Marlene Dietrich and Greta Garbo—women whom both she and Warhol admired.

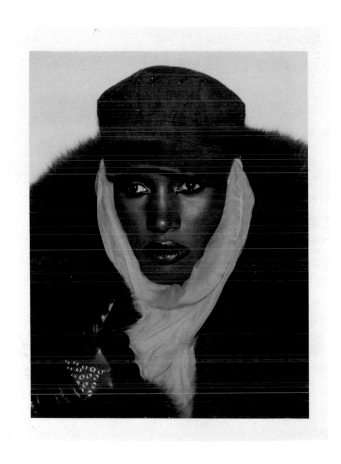

Grace Jones 1984

186

**Jamie Wyeth Painting
Arnold Schwarzenegger
at the Factory**

1977
Gelatin silver print
10 x 8 in.
The Andy Warhol
Foundation for
the Visual Arts,
New York
FL06.00017

*W*hen I got to 860 a big CBS crew was film-
ing Jamie Wyeth with Arnold Schwarzenegger
posing for him for a show called Who's Who.
Cabbed up with Jamie and Arnold to lunch at
Elaine's for Arnold's movie Pumping Iron . . .[56]
ANDY WARHOL, January 12, 1977

Andy Warhol's published *Diaries* open in
November 1976 with a Thanksgiving visit that
he and his current companion, Jed Johnson,
made to Chadds Ford, Pennsylvania. They were
there at the invitation of the painter James
Wyeth (born 1946), son of Andrew, grandson
of N. C., and part of the venerable, that is,
naturalistic, Brandywine tradition in American
art. This Thanksgiving celebration, which
Warhol described as being like an old-fashioned
Christmas, included a buggy ride across
the Brandywine River, a tour of the Dupont-
sponsored Winterthur estate, and a joint news
conference at the Brandywine Museum. Earlier
in the year, Warhol had collaborated with the
younger Wyeth on a series of portraits com-
missioned by the Coe-Kerr Gallery in New York.
The two artists painted each other, and in the
process created a number of preparatory stud-
ies and drawings that were all exhibited in a
show called *Portraits of Each Other.*

This exchange with Wyeth estranged
Warhol even further from the New York art
establishment—particularly that aligned with
the Museum of Modern Art—but it did prove
to be good advertising for Warhol's portrait
business. Wyeth's manner of painting could
not have been further from that of Warhol.

His realistically detailed frontal portrait of the
artist in coat, tie, and vest, holding one of his
dachshunds, was accomplished in the med-
ium of the old masters, oil on panel. Warhol,
however, was an admirer of many styles—his
collection contained a 1963 portrait of Jackie
Kennedy by Norman Rockwell and numerous
examples of naive nineteenth-century American
painting—and his association with Wyeth
extended not only to family gatherings and
social events, but to the loan of studio space
in his Factory at 860 Broadway.

In early 1977 Wyeth spent more than
two months at 860 completing a portrait of
the bodybuilder Arnold Schwarzenegger.
Schwarzenegger had not yet gained star status
in Hollywood, but he had been proclaimed
by author Charles Gaines as "possibly the
most perfectly developed man in the world."[57]
Warhol was, therefore, not unhappy about hav-
ing the bare-chested athlete posing in his
studio, and he took the opportunity to photo-
graph Arnold while Wyeth painted. Warhol's
approach was traditional in its own way, repre-
senting the classic theme of the artist in his
studio. In an informal updating of this motif,
he presents Wyeth at his easel near the win-
dow with his nearly nude subject revealed in
raking light; incongruously, the athlete faces
away from the artist, but perhaps the profile
of his flexed muscle was the real concern for
both Warhol and Wyeth.

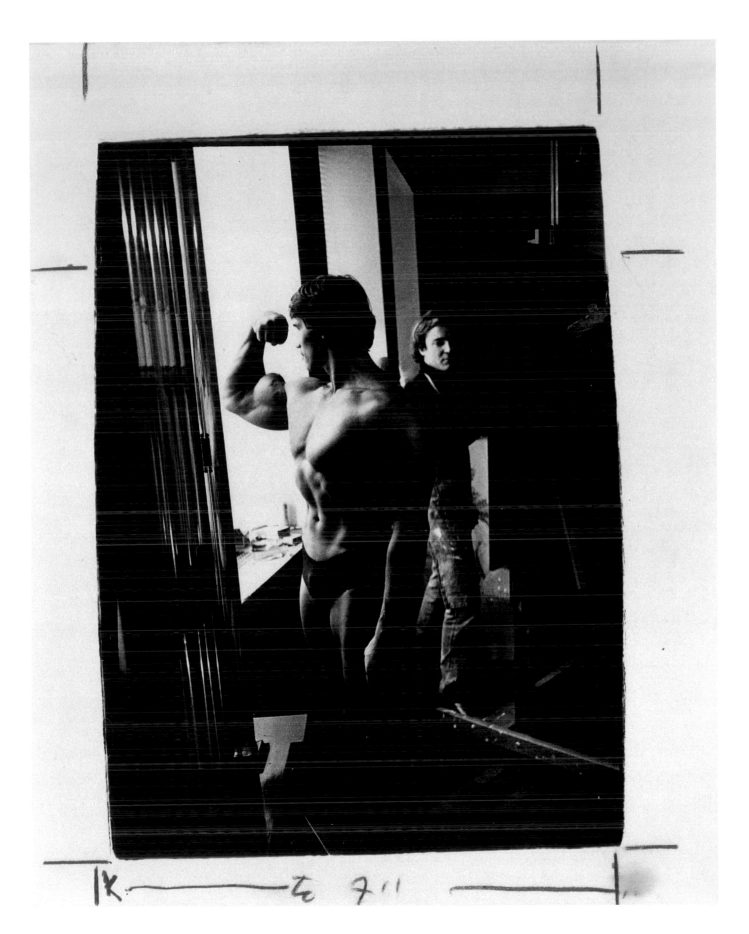

Jamie Wyeth Painting Arnold Schwarzenegger at the Factory 1977

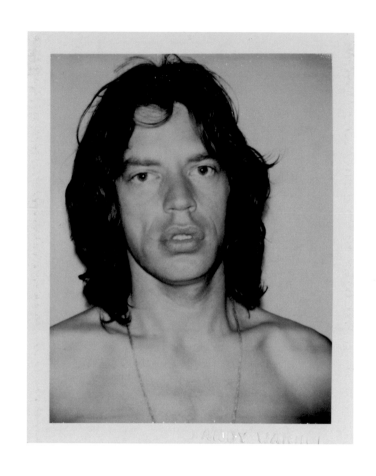

Mick Jagger 1975

Mick Jagger

1975
Polaroid Polacolor
108 print
4¹/₄ x 3³/₈ in.
The Andy Warhol
Museum, Pittsburgh
FB66.014

The same year that Warhol produced his portfolio of drag queen portraits, "Ladies and Gentlemen" (1975), for an Italian sponsor, he created a series of screenprints based on ten different Polaroid portraits of the British rock star Mick Jagger (born 1943) for a London publisher. He and Jagger were by then both celebrities; they were also good friends who celebrated holidays together. Warhol had been introduced to Jagger in the early sixties at the Park Avenue home of Jane Holzer, socialite, model, and, as "Baby Jane," Factory film star. Jagger was visiting with the British photographer David Bailey and, although Warhol didn't know his music, he immediately recognized Jagger's sense of style and appreciated his original way of putting together "regular Carnaby Street sport clothes."[58] The Rolling Stones, with Jagger as lead singer, had made their club debut only the year before and their first single, an adaptation of Chuck Berry's "Come On," had just appeared.

Michael Philip Jagger, who would become known for his rebellious, bohemian lifestyle, began adulthood as an urbane student at the London School of Economics. Rather than follow that track, however, he teamed up with a childhood friend, Keith Richards, who, like him, loved American rhythm and blues music. By 1963 their band included bassist Bill Wyman, drummer Charlie Watts, and Brian Jones on rhythm guitar. Manager Andrew Oldham was arranging television appearances and promoting them as the newest Pop stars, with their image depending heavily on Mick's long-haired, androgynously sexy, always animated stage presence.

The Stones quickly gained a following for their original music, which is based on earlier ballads as well as the blues, but their provocative behavior, onstage and off, was equally responsible for their fame. They were arrested for drug offenses and greeted photographers dressed in drag for a 1966 press conference. The documentary film *Gimme Shelter* (1970) recorded a Stones concert in Altamont, California, during which Hells Angels bikers, acting as security for the group, killed one of the fans. Jagger had another film role that year, starring in *Performance* as a reclusive Pop star who is both evil and kind, seductive and cold, and, possibly, bisexual.

The Stones' anti-authoritarian attitude, nihilistic lyrics, and restless, jet-setting habits came to represent pre-punk rock culture. It also helped them sell seventeen different albums before the mid-1970s. Especially successful was *Sticky Fingers* (1971), an album filled with references to drugs, death, and sex, the latter enhanced by Warhol's sleeve design: a close-up waist-view photograph of a young man in jeans with a working zipper that allowed a peep at the same body in snug white underwear. The eroticism of Warhol's cover design and the Stones' swaggering lyrics is embodied in this offstage portrait of the thin, full-lipped, shaggy-haired Jagger.

189

190 **Helen/Harry Morales for "Ladies and Gentlemen"**
1974/75
Polaroid Polacolor
108 print, 1974
$4\frac{1}{4}$ x $3\frac{3}{8}$ in.
98.XM.168.2

On a European trip in 1974, Warhol and his colleagues Fred Hughes and Bob Colacello visited Turin to meet with art dealer Luciano Anselmino. They were there to complete the process of publishing an edition of two hundred screenprints of Warhol's portrait of the revered surrealist artist Man Ray; Warhol would proof and sign the edition, created in two print sizes. In fulfilling this commission for Anselmino, Warhol had taken dozens of Polaroid pictures of the eighty-four year-old Man Ray, whose own photographs he admired and collected. Anselmino wanted to commission other prints and paintings from Warhol. He suggested that the artist consider the idea of a portfolio of portraits of drag queens. He apparently knew Warhol's drag stars Candy Darling, Jackie Curtis, and Holly Woodlawn—pretty, feminine transvestites—from the Factory films, and at first he suggested them as subjects. When Warhol demurred, Anselmino proposed that he photograph men who are clumsily trying to pass as women. This notion was more appealing to Warhol, and he attempted to talk some of his assistants, including Colacello, into donning wigs and makeup. Colacello objected, and by the time the entourage had returned to New York Warhol had a new idea.

The Factory staff had recently entertained a group of Parisian visitors at the Gilded Grape, a bar on Eighth Avenue and 45th Street with a Black and Latino clientele. Warhol realized that

this would probably be the perfect place to search for less polished drag queens. In the course of that evening, however, Andy had been robbed of his regular shopping bag full of film, cameras, and tape cassettes. So, rather than return to "the scene of the crime," he sent Colacello and other assistants to the Gilded Grape to recruit models for his camera. The men who responded were not told the artist's name and were paid by the half-hour ($50) to pose for Warhol's Polaroid camera. Painted portraits as well as screenprints resulted from sittings by more than ten drag queens. The series, called "Ladies and Gentlemen," was shown only once during Warhol's lifetime, in 1975 at the Municipal Art Center (the sixteenth-century Palazzo di Diamante) in Ferrara, Italy. The portrait of Morales shown here was not one of the ten images used in the final portfolio, which displayed a new element—color accents created with paper stencils; however, Warhol did use it as the image to be screened in black ink over muted shades of green, orange, and blue-gray acrylic on a 14 x 11-inch canvas. From another Polaroid of Morales laughing and smoking, Warhol produced a screenprint separate from the Italian edition; he employed that photograph, as well as a third Polaroid, for creating additional small canvases that complemented his pantheon of drag queens.

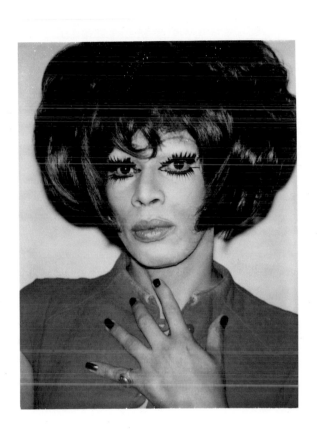

Helen/Harry Morales for "Ladies and Gentlemen" 1974/75

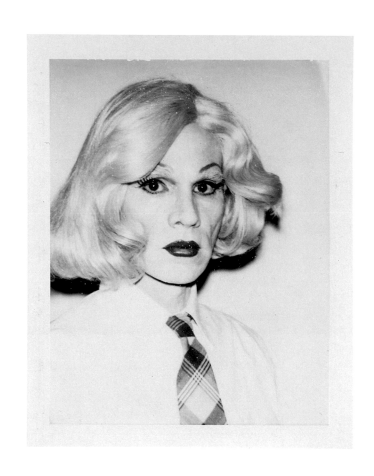

Self-Portrait (in Drag) 1981

Self-Portrait (in Drag)

1981

Polaroid Polacolor 2

print

4¹/₄ x 3³/₈ in.

98.XM.5.2

worked on Myths — *Dracula and the Wicked Witch. I look pretty good in drag, and I thought it would be fun for me to pose for it myself, but Fred said to do myself in drag at a later date, not to use up the idea on this portfolio.*[59]

ANDY WARHOL, February 16, 1981

Warhol took manager Fred Hughes's advice and chose another Polaroid self-portrait, *The Shadow,* to use as he worked on the portfolio of ten screenprints, *Myths,* in February 1981. But he liked dressing in drag for parties, admired "the boys who spend their lives trying to be complete girls," and had previously considered portraying himself in drag. He and a photographic assistant, Christopher Makos, agreed to collaborate on a session later that year that yielded the black-and-white series Makos called "Altered Image."[60] The photographer and Surrealist painter Man Ray, whom they both had known and photographed, was the inspiration for the series. More specifically, Warhol and Makos were updating Man Ray's 1920s work with the French artist Marcel Duchamp in creating a female alter ego for Duchamp. In portraits by Man Ray, Duchamp dressed as Rrose Sélavy (*Eros c'est la vie,* or, "Eros is life") and sometimes signed his work with this feminine name.

As Makos describes the way their sittings progressed in May 1981, they first brought in a fashion makeup artist who attempted to disguise Warhol's masculine features by giving him a more glamorous image. The result was a look that approached drag queen beauty, but did not meet their expectations for an "altered image." However, a number of pictures, both black-and-white and Polaroid, were made of this first try. They hired a makeup person who worked in the theater for the second round of pictures. This stage professional understood better the challenge of transforming a man's face into that of a woman. After the makeup was applied, Warhol tried on curled, straight, long, short, dark, and blonde wigs. He was photographed in a traditionally feminine, bare-shouldered pose and in a conventionally masculine white shirt and plaid tie, as seen here.

Makos exhibited his black-and-white pictures in October 1981 and Warhol worried in his *Diaries* that, if *Time* or *Newsweek* noticed, the exposure would ruin his reputation. He himself did not make further use of the color Polaroids from this collaboration. Although Warhol was always playing a part, wearing a short silver wig and assuming a nearly mute persona, he promoted the role of drag or androgyny in his Superstars and their films, rather than in his own public image.

193

194 **Debbie Harry**
1980
Polaroid Polacolor
108 print
4$\frac{1}{4}$ x 3$\frac{3}{8}$ in.
The Andy Warhol
Foundation for
the Visual Arts,
New York
FA04.04855

But the kids who came all came just to see
Blondie, they didn't care about me, they were a
whole new young crowd.[61]
ANDY WARHOL, June 16, 1979

Although now more than fifty years old,
Warhol was still interested in the newest art
and music—and the stars attached to each.
He liked to be surrounded by the young and
famous at his Factory offices, at parties, and at
the clubs. In the 1980s, Debbie Harry, an influ-
ential New Wave diva, would join the roster
of youthful social companions, including the
artists Keith Haring and Jean-Michel Basquiat
and the designer Stephen Sprouse, that
Warhol needed to replace former protégés like
Superstar Edie Sedgwick, singer/actress Nico,
and the musician Lou Reed. In 1979, when
Warhol made the above comment about their
appearance at a Brentano's bookstore to
autograph the latest issue of *Interview*, he was
just getting to know this new Pop music star.
They had probably met several years earlier,
soon after the release of her group's first album
(*Blondie*, 1976), when Harry was photographed
and interviewed by another of Warhol's Factory
"kids," Christopher Makos. This Polaroid was
made later, at a Factory session in 1980, in
preparation for a 42 x 42-inch painted portrait.

Harry was born in Florida in 1945 and
raised in New Jersey. She was first involved in
several alternative music groups, one of which
produced a "baroque folk/rock" album in
1968. Following a musical hiatus of five years,
she returned to the scene in 1973 to participate
briefly in a girl-group called the Stilettos.
The next year she was fronting a band named
Blondie that she and three musicians, includ-
ing her friend guitarist Chris Stein, had put
together. The band was introduced at the noto-
rious Bowery punk club CBGB and went on to
commercial success in Britain and the United
States. Harry became one of the rare examples,
particularly in the seventies, of a female rock
star. She was a sex symbol admired for her
low, suggestive voice, her heavy eye makeup,
and her wild blonde hair, but she was also
respected for the material she wrote and
her bold fashion sense. Before Madonna and
Courtney Love, there was Blondie. In fact,
Harry's band finally dissolved precisely because
her presence was too strong.

In this Polaroid portrait, less cropped and
less brightly colored than Warhol's painted pic-
tures, she seems to possess plenty of tough,
"punk" attitude while also being a petite, sun-
tanned, bare-shouldered model of femininity.

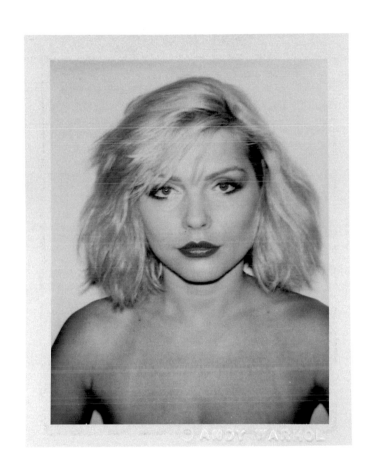

Debbie Harry 1980

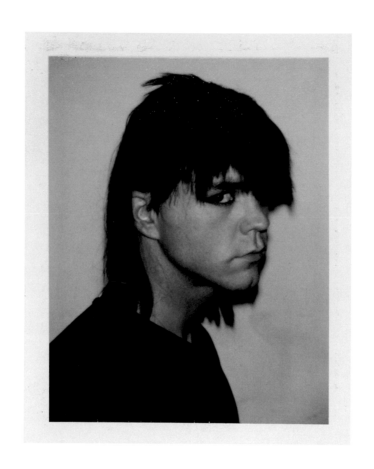

Stephen Sprouse circa 1985

Stephen Sprouse

circa 1985

Polaroid Polacolor

ER print

4¹/₄ x 3³/₈ in.

The Andy Warhol

Foundation for

the Visual Arts,

New York

FA05.02067

Stephen Sprouse (born 1953) came to New York in 1975 after spending only a few months enrolled at the Rhode Island School of Design. A fashion apprenticeship with the prestigious Halston firm was his day job; his nights were spent absorbing the punk music scene. With his first collection, he was able to attract the attention of the fashionable both uptown and downtown because he managed, according to *Interview* magazine, to "reinvent the '60s, taking the look of Courrèges and Paco Rabanne, recharging it with rock-and-roll energy and executing it with sculptural tailoring and exquisite fabrics."[62] In the early 1980s, Sprouse's fashions reflected the style of rock musicians such as the Rolling Stones and Jimi Hendrix, but the line he introduced in 1987 was purely "the Sid Vicious look." Part of his inspiration for this collection may have come from the film *Sid and Nancy* (1986), a re-creation of the life and times of the Sex Pistols' notorious bass player, which he and Warhol watched together in October 1986.

Warhol first mentions the successful young designer in his *Diaries* in the fall of 1984, when he reports sitting next to Sprouse during an event at the Brooklyn Academy of Music: "I'm crazy about him, he's adorable. And we were all wearing Stephen Sprouse."[63] After this meeting they became friends; Sprouse brought him new wigs from time to time, and Warhol continued to acquire Sprouse designs. Warhol told his diary that, in Stephen Sprouse jackets, "I think I finally look like people want Andy Warhol to look again . . ."[64]

Among the many things Warhol and Sprouse would find in common were the loft space at 860 Broadway, which housed Warhol's third Factory. Sprouse became the new tenant in November 1984 after Warhol's move to East 33rd Street, and in May 1985 Warhol returned to his former studio for a fashion show. He told his diary about this show, put on for "*Vogue* and me," and commented about Sprouse that he just wanted to "buy all of his clothes."[65] It seems that he had the opportunity to do exactly that—at least for one season. According to Bob Colacello, Warhol's assistant and biographer, the designer traded Warhol his complete 1985 line of clothes for a portrait.[66] Warhol, of course, had many friends in the fashion world and had painted portraits, for trade or on commission, of Halston, Yves Saint Laurent, Carolina Herrera, Hélèna Rochas, and Diane von Furstenberg, among others.

The painted Sprouse portrait is rendered in severe tones of black and gray, perhaps referring to the designer's preference for things black. The monochromatic painting makes no disguise of its photographic origins: probably a black-and-white negative, rather than a Polaroid like this one, which was no doubt taken at the same session. The Polaroid is less of a three-quarter view and emphasizes Sprouse's jagged hairstyle and dark eyeliner more than the painted view. However, any reference to healthy flesh tones, in evidence in the Polaroid portrait, is eliminated in an appropriately punk manner in the painting.

197

Liza Minnelli

1977
Polaroid Polacolor
108 print
4¼ x 3⅜ in.
98.XM.168.4

Liza Minnelli (born 1946), a Hollywood child who first appeared on-screen as a toddler, was an important part of Warhol's inner circle in the 1970s and 1980s. She frequented Studio 54 and celebrated holidays and birthdays with Warhol, the designer Halston, and Bianca Jagger. Minnelli had formidable show-business parents, singer-actress Judy Garland and director Vincente Minnelli, and achieved her own lead roles in stage productions only after performing with her mother and working as an apprentice on other musicals. She issued her first album in 1964, debuted on Broadway in a 1965 musical, sang in New York cabarets beginning in 1966, and started a film career in 1968. Her famous mother died in 1969 at only forty-seven; by 1972 Minnelli herself was a favorite diva and superstar. That year her reputation soared as a result of the film *Cabaret,* which won nine Academy Awards and put Minnelli on the covers of *Newsweek* and *Time* simultaneously. Soon after, she met her second husband, producer-director Jack Haley, Jr., whose father had played the Tin Man opposite her mother's Dorothy in *The Wizard of Oz* (1939).

Warhol was an admirer of both mother and daughter, saying about Garland what could also be applied to Minnelli:

The same way rich kids fascinated me, show business kids fascinated me even more. I mean, Judy Garland grew up on the M-G-M lot! To meet a person like Judy whose real was so unreal was a thrilling thing.[67]

In the late 1970s, he painted portraits of Garland using Metro-Goldwyn-Mayer publicity photographs and portraits of Minnelli based on his own Polaroids. He also created a diptych, *Judy Garland and Liza Minnelli* (1979, Andy Warhol Museum), which consisted of a composite portrait of the two of them— thirteen different images painted in black on red and repeated in a second, black-on-white, square panel.

Most mother-daughter portraits would be based on photographs drawn from family picture albums. In this case the pictures were probably all made for publicity purposes by studio photographers or the paparazzi. The Hollywood portraits of Garland present her as a beautiful, sultry star, attributes that Warhol would exploit in his large single paintings of her. In Liza he found a more powerfully iconic face, with elements—short black bangs, large dark eyes outlined with heavy makeup, and full lips painted a dark red—ready-made for the Polaroid, which would simplify them even further before they were transferred to silkscreen.

The Getty picture was not the image Warhol finally chose to paint from. Perhaps he felt the red-orange hooded dress (likely a Halston creation) lent the composition a serene, or mourning, quality that was not fitting for a commission destined for the sitter's walls. On the other hand, Warhol must have appreciated the simple lines and religious overtones of Liza's draped head and sad gaze. He portrays her as an alluring celebrity (whose recent accomplishments included the film *New York, New York* with Robert De Niro, and the Broadway musical *The Act*) while suggesting the private burdens of her family and career.

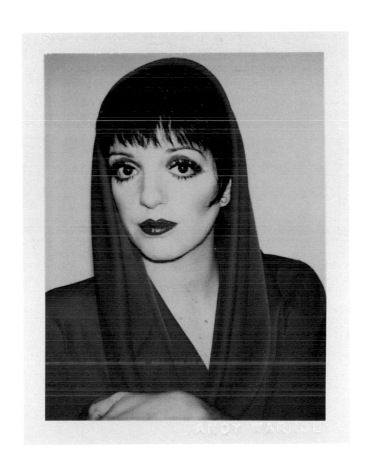

Liza Minnelli 1977

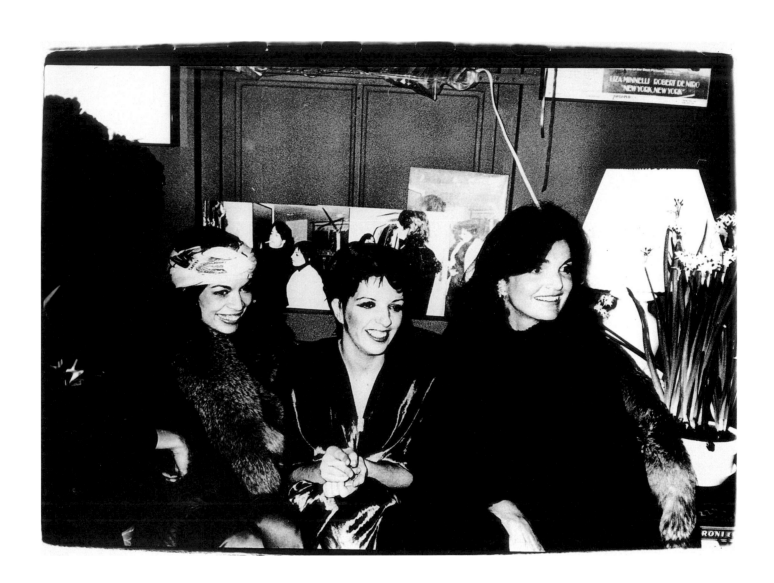

Bianca Jagger, Liza Minnelli, and Jacqueline Onassis in Liza's Dressing Room, New York 1978

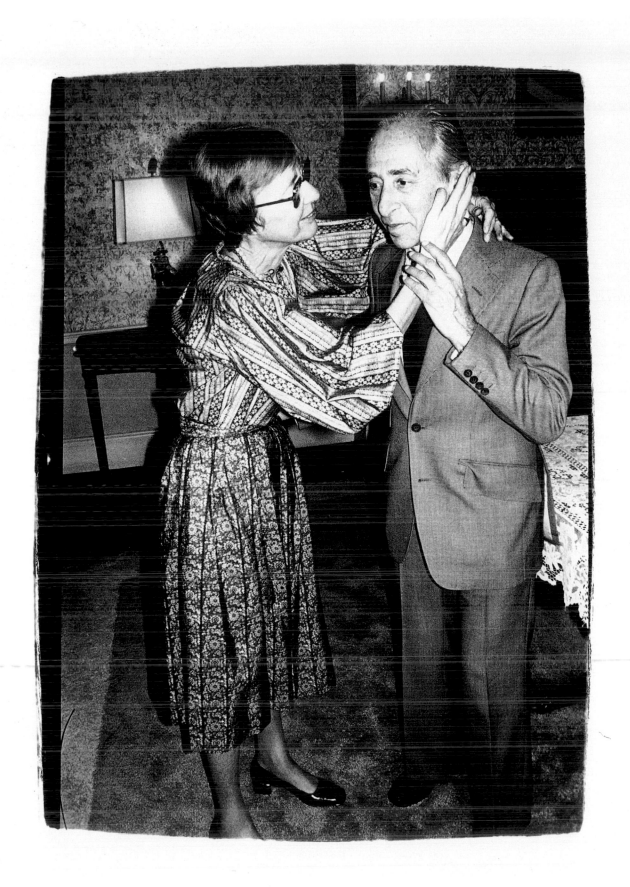

Leo and Antoinette Castelli 1978

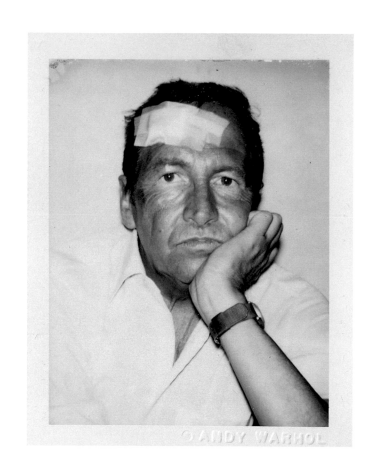

Robert Rauschenberg 1981

Robert Rauschenberg

1981

Polaroid Polacolor 2

print

4¹/₄ x 3³/₈ in.

98.XM.168.5

In depicting his old friend as the wounded artist, Warhol may be referring to Vincent van Gogh's famous *Self-Portrait with Bandaged Ear* (1889, Courtauld Institute, London) and paying tribute to both artists. On the other hand, the naturalism of this less-than-flattering portrait of the Texas-born artist seems closer to Frans Hals's wry seventeenth-century subjects and may be a comic allusion to Rauschenberg's own "combine" pieces, the gauze and bandages adding layers to his visage the way the artist assembled ordinary found objects into major works of art.

After studying art in Paris and at Black Mountain College in North Carolina, Rauschenberg (born 1925) came to New York in 1949, about the same time Warhol arrived. Like Warhol, he supported himself with commercial art, specifically window display design. His reputation as one of the pivotal artists forging the transition from Abstract Expressionism to Pop Art grew with his exposure at Leo Castelli's gallery beginning in 1958. He and Warhol met in 1960 and two years later got together at Warhol's studio in a session that provided inspiration for both. Rauschenberg discovered that the silkscreen process Warhol was already using to transfer photographic images to canvas would suit his purposes as well, and Warhol decided to do a series of paintings based on family snapshots of Rauschenberg, taking him as his first non-celebrity Pop subject. Through large canvases that repeated his portrait as many as twenty-five times, Warhol would make him famous. In fact, Warhol entitled the canvases that included Rauschenberg's family

Let Us Now Praise Famous Men. Walker Evans's 1936 portrait of a tenant farmer's family, *Bud Fields and His Family, Hale County, Alabama* was exhibited that year at the Museum of Modern Art, and Evans's and James Agee's 1941 book *Let Us Now Praise Famous Men: Three Tenant Families* (which contained that picture) was reissued in 1960; either could have been responsible for Warhol's choice of a title as well as his use of photographs of another modest Southern family.

A passion for photographs, including those they made themselves, was at the center of art-making for both Warhol and Rauschenberg. Rauschenberg began producing photograms on large blueprint paper in about 1950, when he was also using a camera to make photographs at Black Mountain College. In 1981, the year Warhol reprised his 1962 portrait of his friend, a retrospective of Rauschenberg's photographic work was traveling in Europe and the artist was creating large-scale black-and-white photographs that he mounted on aluminum and composed in totemic arrangements. It has been suggested that these new multipart "Photems" prompted Warhol to begin enlarging many of his own black-and-white images and stitching them together in patterns that repeated the same picture four to twelve times.[17] Rauschenberg's confidence in photographs as major gallery pieces perhaps signaled Warhol that it was permissible to begin exhibiting some of the hundreds of photographs he had made in documenting his own life.

173

174 **Jean-Michel Basquiat**

1982

Polaroid Polacolor

ER print

4¹/₄ x 3³/₈ in.

98.XM.168.6

Warhol made this portrait in the fall of 1982 on the occasion of formally meeting the newly famous twenty-one-year-old painter Jean-Michel Basquiat (1960–1988). Bruno Bischofberger, one of the most entrepreneurial dealers active in the inflated 1980s art market, had brought Basquiat to lunch. As it turned out, Warhol had already met him in a more informal way, as he describes in his diary:

He's the kid who used the name "Samo" when he used to sit on the sidewalk in Greenwich Village and paint T-shirts, and I'd give him $10 here and there. . . . He was just one of those kids who drove me crazy. . . . And then Bruno discovered him and now he's on Easy Street. He's got a great loft on Christie Street. He was a middle-class Brooklyn kid—I mean, he went to college and things—and he was trying to be like that, painting in the Greenwich Village.

And so had lunch for them and then I took a Polaroid and he went home and within two hours a painting was back, still wet of him and me together. And I mean, just getting to Christie Street must have taken an hour. He told me his assistant painted it.[48]

Basquiat was the son of a Haitian-born accountant and a cultured Puerto Rican-born mother (she spoke three languages and enjoyed visiting art museums). He was sent to an alternative high school, where he got involved with drama groups and invented Samo, a character who promotes his own religion. When he started spray-painting graffiti on subway trains and lower Manhattan buildings with a friend, Al Diaz, he signed his work Samo. He had run away from home and was living in a Greenwich

Village park; yet Basquiat managed to socialize with established members of the art world and was soon showing and selling his expressive, graffiti-inspired paintings and drawings. His imagery often included words commenting on racism and reflecting his mixed heritage. The Annina Nosei Gallery gave him a basement studio to work in and he had his first one-man show there in 1982. The show sold out and another dealer, Larry Gagosian, quickly took him on and sponsored a second sold-out show in Los Angeles that year.

Warhol was one of Basquiat's heroes; the young star, in turn, represented for Warhol the creative sexual energy of the sixties. The two prolific artists carried on an intense friendship in the mid-eighties, partying, traveling, even working out together. This relationship— sometimes rocky because of Basquiat's increasing drug use—culminated in a collaboration arranged by Bischofberger and an exhibition of the results at the Tony Shafrazi Gallery. Warhol enjoyed the stimulation of working on paintings alongside the hyperactive Basquiat, who was often in need of advice about how to handle his meteoric success. At the same time, Warhol must have recognized the same signs of addiction and mental strain that had afflicted some of his brightest Factory companions of the 1960s. Like Superstar Edie Sedgwick, Jean-Michel would be dead by the age of twenty-eight. Warhol warned him against it, but Basquiat seemed to believe that "the true path to creativity is to burn out."[49]

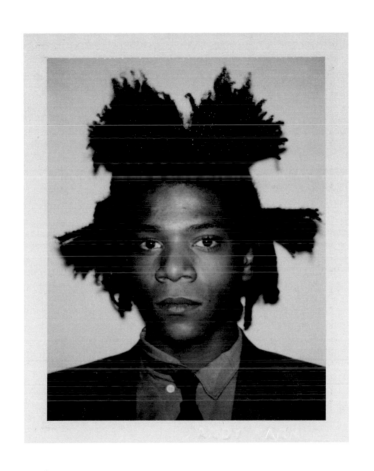

Jean-Michel Basquiat 1982

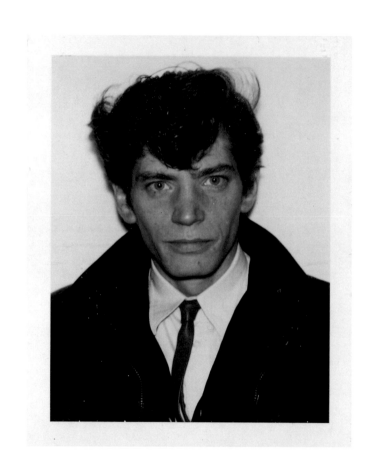

Robert Mapplethorpe 1983

Robert Mapplethorpe

1983
Polaroid Polacolor
print
4¹/₄ x 3³/₈ in.
98.xm.168.8

Inspired by Warhol's film *Chelsea Girls* (1966), Robert Mapplethorpe (1946–1989) moved to Manhattan in 1969 to meet the artist and emulate his art, lifestyle, and material success. Mapplethorpe had grown up in Queens and studied at the Pratt Institute of Art in Brooklyn. His first works were collage and assemblage pieces, which sometimes incorporated photographs. After settling at the Chelsea Hotel (where segments of Warhol's film were shot), he began making photographs, often self-portraits or portraits of his roommate, the poet Patti Smith, with a borrowed Polaroid camera.

Mapplethorpe's interest in photography escalated in the 1970s thanks to the mentoring of two powerful cultural figures, who jointly played the role that the young artist had earlier imagined for Warhol: John McKendry, curator of prints and photographs at the Metropolitan Museum of Art, and Samuel Wagstaff, Jr., art historian and former curator. McKendry's interest in Mapplethorpe was primarily romantic, but he worked to further the young artist's success with photography by introducing him to masters in the Met's collection and giving him a Polaroid camera for Christmas in 1971. The next summer Mapplethorpe met Wagstaff, who encouraged him as a photographer as well as a collector of photographs. Wagstaff and Mapplethorpe had an affair, with the elder man of means helping Mapplethorpe pay the rent and buy camera equipment. Beyond this, they developed an enduring friendship and a passion for collecting. Wagstaff started buying photographs in 1973, the year Mapplethorpe had his first one-man show of Polaroid work. As Wagstaff lobbied collectors such as Robert

Scull to acquire his protégé's work, he was exposing him to photographic artists of all periods, including Nadar, whose mid-nineteenth-century Parisian portraits became favorites with Mapplethorpe.

Mapplethorpe's maturing approach to photography resembled Warhol's in many ways. He had no patience for the technical side of the medium and prided himself on gaining a reputation without ever having made a print himself. Portraiture was his main theme and he used the camera as a means of making connections with celebrities, potential patrons, and possible lovers. Both artists often used their cameras for documentation; Mapplethorpe's photography composed a diary of his sexual encounters, Warhol's a diary of his busy evenings at nightclubs, gallery openings, and fancy dinners. The two also shared a desire to meld painting and photography into one art. Warhol silk-screened photographic images in ink onto large canvases prepared with acrylic paint; Mapplethorpe had his negatives enlarged to as much as 60 x 40 inches and sometimes printed in platinum on linen.

In the 1980s, sales of Mapplethorpe's pictures soared. Warhol was commissioned to paint his portrait, and so Mapplethorpe sat for the preparatory Polaroids, including this one. Warhol subsequently sat for Mapplethorpe's camera in 1986; one of the portraits from that session appeared as the catalogue frontispiece for Warhol's posthumous retrospective at the Museum of Modern Art.

178

**Keith Haring
and Juan Dubose**

1983
Polaroid Polacolor
ER print
4¹/₄ x 3³/₈ in.
98.XM.168.7

The early 1980s saw the emergence of artists whose work originated in or was inspired by graffiti, stylized words and pictures spray-painted by rebellious teenagers on the walls of urban America. These young artists, such as Futura 2000, Kenny Scharf, Jean-Michel Basquiat, and Keith Haring (1958–1990), worked on the street and in subways as well as on gallery walls and canvases. Warhol made Haring's acquaintance in 1982, when the twenty-four-year-old was having his first major one-man show at the Shafrazi gallery, a venue overseen by Tony Shafrazi, who had played a controversial role in the New York art scene since the early 1970s.

Haring grew up in a small Pennsylvania town and described his childhood as one pre-scribed by his parents and television. However, his sheltered existence did not prevent him from having his first LSD experience at fifteen and taking other "trips" in the fields around Kutztown. He attended art school in Pittsburgh before moving to New York City in 1978, where he took classes at the School of Visual Arts. Haring met Scharf and Basquiat at this time and read Beat-movement novelist William Burroughs. This education and exposure no doubt had an impact, but Haring attributed his reductive graphic style, which Warhol would praise as "cartoonist," to the hallucinatory power of drugs, telling Timothy Leary, "The drawing I did during the first trip became the seed for 'all' of the work that followed and that now has developed into an entire 'aesthetic' view of the world (and system of working)."[50]

His reputation as a graffiti artist came pri-marily from the "cookie-cutter" line drawings of babies, dogs, and dancing figures in white chalk that he created on black paper found in the subway. This work started in 1981, when he was also painting on cheap found objects of metal, plastic, or other surfaces that would sustain his decorations. With Shafrazi's help, Haring achieved nearly overnight success in the teeming art market of the 1980s. In 1983 he had his second show at the gallery. More significantly, he was represented that same year in the Whitney and the São Paulo biennials. His fame led to more mural and sculpture com-missions, solo shows, and the opportunity to open Pop Shops to sell his work in New York and Tokyo. He used this increasing celebrity to draw attention to the horrifying spread of AIDS, a disease that caused his own death in 1990 at age thirty-one.

Warhol's Polaroids of Haring and his part-ner Juan Dubose, who died in 1989, were made in preparation for several 40 x 40-inch painted portraits, one of them done in black and white. The strong shadows created by studio lighting and the camera's flash are even more emphatic in Warhol's canvases, where detail and natural flesh tones have been eliminated. While Warhol helped his young friends cope with problems caused by their early success, this portrait could be a study for an ancient sepulcher. It suggests that Warhol was almost presciently aware of their impending and sadly premature deaths.

**Bianca Jagger,
Liza Minnelli, and
Jacqueline Onassis in
Liza's Dressing Room,
New York**

1978
From the portfolio
*Andy Warhol's
Photographs*, 1980
Gelatin silver print
Sheet: 16 1/8 x 20 in.;
image: 12 3/8 x 17 in.
The Andy Warhol
Foundation for
the Visual Arts,
New York
FX08.00001

*Liza had sent six tickets for Bianca who
wanted to see The Act. Bianca disinvited Victor
because she wanted to invite Stevie Rubell and
her dancing teacher who was in from London. . . .
It came out later that Bianca only wanted to
go because she'd heard Jackie O. would be there
and she wanted to get photographed.*[68]
ANDY WARHOL, January 9, 1978

Jacqueline Lee Bouvier (1929–1994) embraced
the media from the time she graduated from
college and assumed her first job as Inquiring
Camera Girl for the *Washington Times Herald*.
Decades later, when Warhol moved in the same
party circuit and befriended her sister Lee
Radziwill, she was an editor for a major trade
publisher, Doubleday. In between, she became
First Lady; when her husband, President John
F. Kennedy, was assassinated in 1963, she
took on the role of icon. Her photographic
image, and Warhol's series of paintings of her
from that year, helped to ensure that this status
would be permanent. Warhol quickly realized
that, after the tragedy she and the country
had suffered, Jackie would be even more
famous as a widow. In fact, it has been pointed
out that this backstage image, one of the few
photographs of Jackie that is part of Warhol's
oeuvre, significantly represents three arche-
typal 1970s celebrities who were "famous as
much for themselves as for the dead or absent
figures they conjured"—namely, Liza's mother
Judy Garland, Bianca's ex-husband Mick Jagger,
and Jack Kennedy.[69]

The same critic has noted that Jacqueline
Kennedy's incarnation as " Jackie O.," the jet-
setting wife of Greek shipping mogul Aristotle
Onassis, exemplified "a kind of 1970s pleasure
allied to Studio 54, the Warhol 'Factory,' and
to a sophisticated, fatigued understanding of
celebrity's commodified nature. . . ."[70] Warhol's
Diaries reveal that he liked the icon Jackie
more than the woman herself. Nevertheless,
he clearly studied her from the sixties on and
may have borrowed heavily from the trade-
mark characteristics of her celebrity persona.
His public attributes—a shy, almost silent
demeanor, a quiet voice, an innocent expres-
sion, and a distinctive hairdo (in his case an
eccentric wig)—echo those of Jackie. The inex-
pressive "spellbound stare" that she often
presented to the paparazzi was not only some-
thing that Warhol himself chose to mimic as
he, too, became a "photographic star," but
he adopted it as a preferred portrait pose for
his own sitters.[71]

201

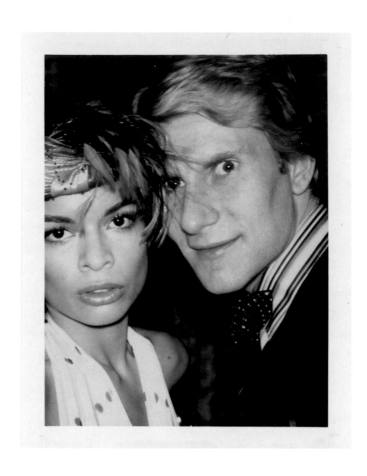

Bianca Jagger and Yves Saint Laurent 1972

**Bianca Jagger and
Yves Saint Laurent**
1972
Polaroid Polacolor 2
print
4¹/₄ x 3³/₈ in.
The Andy Warhol
Foundation for
the Visual Arts,
New York
FL43.00017

In the early seventies, while Mick Jagger was touring and his first wife Bianca (born 1944) was often on her own, Warhol became a close friend and companion for the new Mrs. Jagger. A Nicaraguan beauty with an uninhibited sense of style, Bianca was often the subject of Warhol's photographs. Their friendship extended to work at Warhol's magazine *Interview*. Bianca, one of the glamorous herself, enthusiastically took up the magazine's new form of conversational journalism, which gave readers an intimate glimpse of celebrity life. Frequently accompanied by Andy, who would ask only occasional questions, she would interview famous politicians, film stars, and fashion designers. In January 1973, *Interview* featured Bianca on its cover and described her meeting with the Paris designer Yves Saint Laurent (born 1936) inside.

Saint Laurent was by this time part of the European contingent of Warhol's small clique that included fashion luminaries Halston, Diana Vreeland, Calvin Klein, Diane von Furstenberg, and Oscar de la Renta in New York, and Karl Lagerfeld and Valentino abroad. In the seventies society in which Warhol moved, in fact, the designers seemed to be the stars. And Saint Laurent was definitely at the top of the Parisian fashion world, having gone to work for Christian Dior in the 1950s and gained the position of haute couture designer in 1957 when Dior passed away. The couture house bearing his name opened in 1962, and the now-famous Rive Gauche boutiques for women's wear started in 1966. Signature aspects of his style included bright colors set off against black

and wardrobe elements such as see-through blouses and bolero jackets.

Painted portraits of Saint Laurent, likely done by Warhol on commission, are dated to 1974. They reflect the artist's usual way of working from carefully posed Polaroids. The designer is dressed, as seen here, in his trademark striped shirt and polka-dotted bow tie, but in the painted portraits he is depicted resting his head in a delicate way on his right hand, as if he had been directed by the artist to act "sensitive and abstracted." This Polaroid portrait of him and Bianca was probably produced spontaneously at a social event and reflects Warhol's preference for paparazzi-style snapshots of his celebrity friends. They are not only caught off guard but are captured at awkward moments or surprised by a flash too close to their eyes.

This print comes from one of the Warhol Foundation's more than two hundred "red books" or "flip books" in which the artist stored hundreds of Polaroids. Warhol sometimes filled these small, cheap books with images of one person (like Rudolf Nureyev in rehearsal) or personal favorites (like portraits signed for Warhol by the famous sitters). In addition to these tiny, sixty-cent albums with red covers, Warhol also saved many Polaroids in six larger "family albums," which contain posed pictures from official portrait sessions and more casual social snapshots. From the dozens of prints made during a session with the venerable surrealist Man Ray to snapshots of his early dealers Irving Blum and Leo Castelli in black-tie to this wide-eyed close-up of two of the seventies' most beautiful people—Warhol tucked it all away as documentation and as art.

203

204 **Diana Vreeland**

1973
Polaroid Polacolor
108 print
4¹/₄ x 3³/₈ in.
The Andy Warhol
Foundation for
the Visual Arts,
New York
FA04.04578

The woman who would become variously known as "fashion's high priestess," "the doyenne of style," and "the empress of fashion" was born in Paris, came to the United States in 1914, married a banker and moved to London, then returned to New York and went to work for *Harper's Bazaar,* where she soon became the fashion editor. From 1939 to 1962, Diana Vreeland (1903[?]–1989) not only reported on fashion, she foretold it. Leaving *Harper's Bazaar* in the early sixties for *Vogue,* she ascended to the position of editor-in-chief of yet another powerful fashion showcase and proceeded to publish her own ideas of what the sixties should look like. Her influence was important to the career of many in the fickle fashion world, including the designer Halston and the model Twiggy. After Vreeland retired from *Vogue* in 1971, the Metropolitan Museum of Art hired her as a consultant to its Costume Institute. In 1977 she wrote a text for photographer Irving Penn's *Inventive Paris Clothes, 1909–1939;* in 1980, with the editing help of Jacqueline Onassis, she published a collection of her favorite fashion images under the title *Allure.*

The year *Allure* came out, *Interview* featured Vreeland on the cover of its Christmas issue, dedicated to "Royalty, real and fantastic." Interviewer Jonathan Lieberson described this woman of "immoderate and theatrical gestures" as someone who "speaks one-third of the time like a gangster, one-third of the time like the head of a multinational corporation—and the rest of the time like an émigré from one of the French-speaking pixie kingdoms."[72] Lieberson and Vreeland's discussion about her long involvement with costume and photography revealed that she actually did not think of either as art forms. Although Warhol would have disagreed with her on that point, he probably found reasonable her opinion that editing should extend to everything in one's life; for Vreeland, selectivity was all important, as reflected in her slogan, "Elegance is refusal."

Vreeland "couldn't stand to be around old people, including herself."[73] She preferred the company of designer Halston, his frequent companions Liza Minnelli and Bianca Jagger, and some of Warhol's circle, particularly his young and very sociable right-hand man, Fred Hughes. Over the years, Warhol had many opportunities to photograph Vreeland—in her thoroughly red apartment, at numerous parties, at the Metropolitan Museum of Art. In the ten-episode video program on fashion he produced in 1979–80, she appeared opposite Henry Geldzahler in *The Empress and the Commissioner.* His 1979 book of photographs, *Andy Warhol's Exposures,* devotes a section to her.

This Polaroid portrait is similar in its severe profile pose and simple background to the black-and-white image of Vreeland seated in a throne-like Egyptian chair used in *Exposures.* They may, in fact, be from the same sitting, since she appears to be wearing a comparable light-colored, collarless blouse in both. Warhol seemed to have patience and admiration for the aging. He photographed and painted older artists such as Georgia O'Keeffe and Martha Graham, and he and Vreeland, at least twenty-five years his elder, liked many of the same things: "Vodka, volunteers, perfume, horses, orchids, photographs, Formula 405, Quo Vadis, emeralds, chipped beef on toast, uniforms, and beauties."[74]

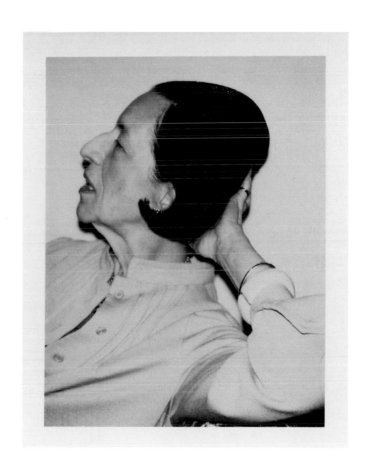

Diana Vreeland 1973

206 **Princess Caroline
of Monaco**
1983
Polaroid Polacolor
ER print
4¼ x 3⅜ in.
98.XM.168.10

Princess Caroline was getting to the office at 9:00 to pose for the December cover of French Vogue. She's the guest editor for this year's Christmas issue and I was asked to photograph her. So rushed. . . . She was already there, but it took her one or two hours to get dressed. And they wanted pictures of me taking pictures of her so I called Chris [Makos] and he came over. She's pretty but she looks forty. She looks like she's really been through the mill. But they know how to pull her together.[75]
ANDY WARHOL, October 13, 1983

Caroline (born 1957), daughter of Hollywood star Grace Kelly and Prince Rainer III of Monaco, was only twenty-six in this Polaroid but had lived, thus far, a very fast life, filled with yachts, discotheques, costly resorts, designer clothes, an early marriage to an older man, and parents who lived apart. Now she was divorced and, since her mother's tragic death, serving as "first lady" of Monaco. Grace Kelly was fifty-two when she was killed near the site of an important scene in her film with Cary Grant, *To Catch a Thief* (1955). The beautiful, elegant movie star reigned briefly in Hollywood, then married a real prince and retired from acting. Although reportedly they didn't live happily ever after, Grace Kelly's fame was assured. Her Hollywood persona was one of cool aloofness, and Warhol portrayed her daughter, who had recently stepped into Kelly's royal shoes, in the same style.

The artist considered royalty another element of the Pop scene. He painted pendant portraits of the new royal couple, the Prince and Princess of Wales, in 1982, the year after their spectacular wedding. The young Diana is presented in an almost casual manner. She wears fancy dress and jewels, but sits with her arms folded and smiles at the camera in a relaxed fashion. Warhol's portraits of Charles and Diana are an apt updating of the eighteenth-century coronation portraits of another pair of British royals, King George III and Queen Charlotte, that he had acquired at auction in 1978. Warhol would also execute a portfolio of four printed portraits of "Reigning Queens" in 1985. However, his representations of Princess Caroline (he did paintings as well as screenprints from his Polaroids of this session) are more in the tradition of Hollywood studio photographers than of court painters.

Warhol had been collecting movie stars' publicity photographs ever since he was a child. Beginning in the 1960s, he would sometimes borrow these images intact for his own silkscreen paintings. In the 1970s, he began using his own photographs, but he continued to imitate the approach of celebrity portraitists who worked for the big Hollywood studios. In this Polaroid, Warhol posed Caroline in profile, as if he were photographing a legendary star like Garbo, her long, soft, wavy hair hanging loose on her bare neck. The lighting on her face casts a deep shadow, creating strong chiaroscuro in 1940s film-noir style, and, along with her downward gaze, makes her appear remote and imperious—even more so than her enigmatic mother, who lived a short but fabled life.

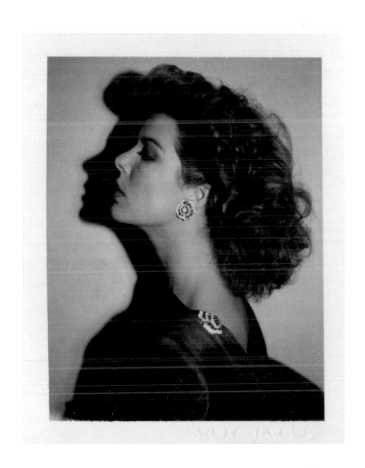

Princess Caroline of Monaco 1983

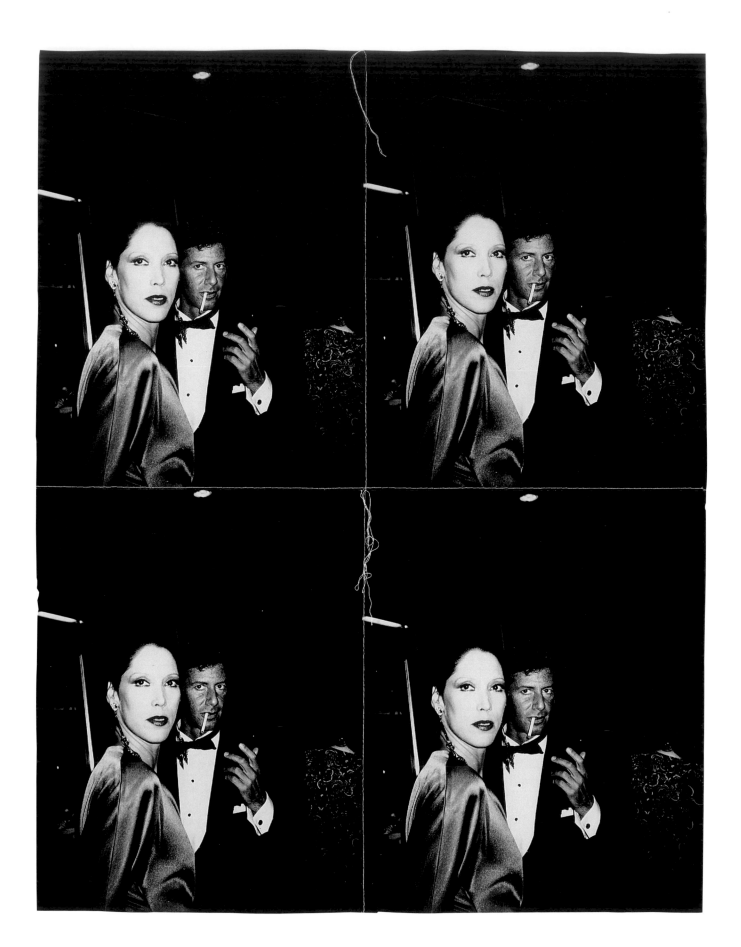

Calvin Klein and Marina Schiano 1982

Calvin Klein and Marina Schiano
1982
Four gelatin silver prints, sewn together with white thread, circa 1982–86
The Andy Warhol Foundation for the Visual Arts, New York
FL08.00012

Calvin's house is right off Ocean Walk [Fire Island] and there's 8000 boys around it, and a lot of girls, too, and they're all walking around wanting to be discovered for a jeans ad.[76]
ANDY WARHOL, July 18, 1982

By 1980, the designer Calvin Klein (born 1942) had become known not only for his fashions but also for his controversial advertising. That year his company used the fifteen-year-old Brooke Shields in jeans ads shot by Richard Avedon and suggestively captioned "Nothing comes between me and my Calvins." Klein's later ads for underwear featuring the singer-model Marky Mark would cause even more debate. Warhol admired Klein's advertising, and his bold lifestyle. The two artists socialized together in the evenings at Studio 54, in the summer at vacation homes, and, of course, at the seasonal fashion shows. Their common interests extended to collectibles, such as Native American rugs and photographs of Georgia O'Keeffe by Alfred Stieglitz.

The grandson of an independent dressmaker, Klein began sketching clothes for women at the age of five. He studied at the High School of Art and Design, the Art Students League, and the Fashion Institute of Technology; then he went to work for a clothes manufacturer. In his free time, he put together a group of expertly made samples from his own designs; he was able to open his own fashion business in 1968. When Warhol questioned him for *Interview* magazine in 1982, Klein's empire, with headquarters on Seventh Avenue, was taking in nearly a billion dollars a year. Klein talked to Warhol about the women he admired:

Katharine Hepburn, who inspired him to develop "an American look, which was easy, casual, sophisticated"; O'Keeffe, who Warhol had put him in touch with; and Nancy Reagan, who was, he felt, a model of beauty for older women.[77]

In this film-noir, paparazzi-style Warhol snapshot, Klein is pictured with a fashion industry colleague, Marina Schiano, who was briefly married to Texas dandy Fred Hughes, Warhol's agent-manager. Although Warhol's creation of sewn pictures of people in the garment trade is apt, he also used this format for joining four, six, eight, nine, or twelve of his images of animals, still lifes, shop fronts, nudes, even wrestling matches to create new patterns and compositions. The use of repetition, particularly for the portraits, refers to Warhol's screenprinted work from the 1960s onward. Christopher Makos, a young photographer who printed much of Warhol's black-and-white work, takes credit for suggesting the stitched technique, and it may well be another of Warhol's borrowed ideas. Whatever the case, the process was typically unorthodox:

I had Brigid stitching away on the new sewing machine I bought because I want to sew my photographs together, but it turned out that the best sewer is my bodyguard, the ex-Marine Agosto, because he worked in a sweatshop in Hawaii before he went into the marines [sic].[78]

209

Ron Galella

1982

Gelatin silver print

10 x 8 in.

The Andy Warhol

Foundation for

the Visual Arts,

New York

FL04.01386

We went in Madonna and Sean's limo to Sardi's. The big bodyguards were with them and they said to the photographers, 'If you take one picture we'll kill you.' And there was Ron Galella and I felt bad, but what could I do?[79]
ANDY WARHOL, August 30, 1986

Ron Galella (born 1931) graduated from the Art Center College of Design in Pasadena with a degree in professional arts. He then spent time at the Pasadena Playhouse learning the art of acting and stage direction. These skills, though seemingly unrelated, probably served him well in the career he finally chose after four years in the United States Air Force as a ground and aerial photographer. In 1955 he became a freelance magazine and newspaper photographer with a specialty in candid views of celebrities— that is, he joined the paparazzi and, as the notorious "Jackie-watcher," ultimately got to be as famous as some of his subjects.

Warhol voiced respect for the work of Man Ray, Irving Penn, Weegee, and other well-known photographers, but his answer for interviewers was usually that his favorite was Ron Galella. The reporters thought this was a joke, but, according to biographer Colacello, it was not. Galella's aggressive shooting style and the action he always managed to capture was something Warhol admired and apparently tried to emulate in his own party pictures. He also photographed Galella, whom he frequently encountered at celebrity events, and included these portraits prominently in two of his books:

America (1985), where this image of Galella appears at the beginning of the section entitled "People" (opposite a picture of Warhol himself with Dolly Parton), and *Andy Warhol's Party Book* (1988), where Galella is interviewed as the "Celebrity Photographer" in a chapter called "Celebrity Parties." Their mutual appreciation for photographing the famous off-guard seems to have encouraged a friendship. Warhol was invited to Galella's wedding in 1979 and decided he would go, although his friend Studio 54 owner Steve Rubell had just filed suit against the paparazzo.

Another reason for the artist's admiration may have been Galella's tenacity in following the life of Jackie Onassis, whom Warhol found so awesome. The paparazzo had chosen to make documentation of Jackie fifty percent of his business and, therefore, he tracked her vigilantly as she moved about New York. In 1972 Galella and Jackie went to court; he had sued her and she countersued. The court ruled in her favor and Galella was ordered to stay at least twenty-five feet from her and thirty feet from her children when photographing them. He was taken back to court for breaking this injunction and ordered never again to photograph, or hire anyone else to photograph, Jackie or the children. *Life* featured this battle on its cover in 1972 and Galella benefited from the recognition that ensued; he was now, like Warhol, a celebrity photographing celebrities.

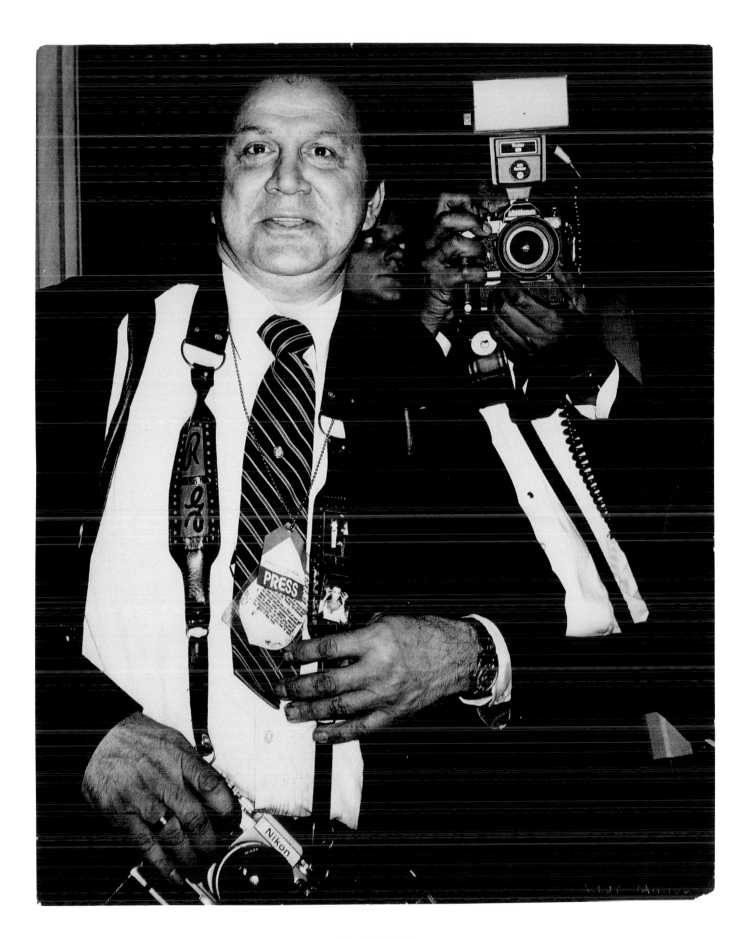

Ron Galella 1982

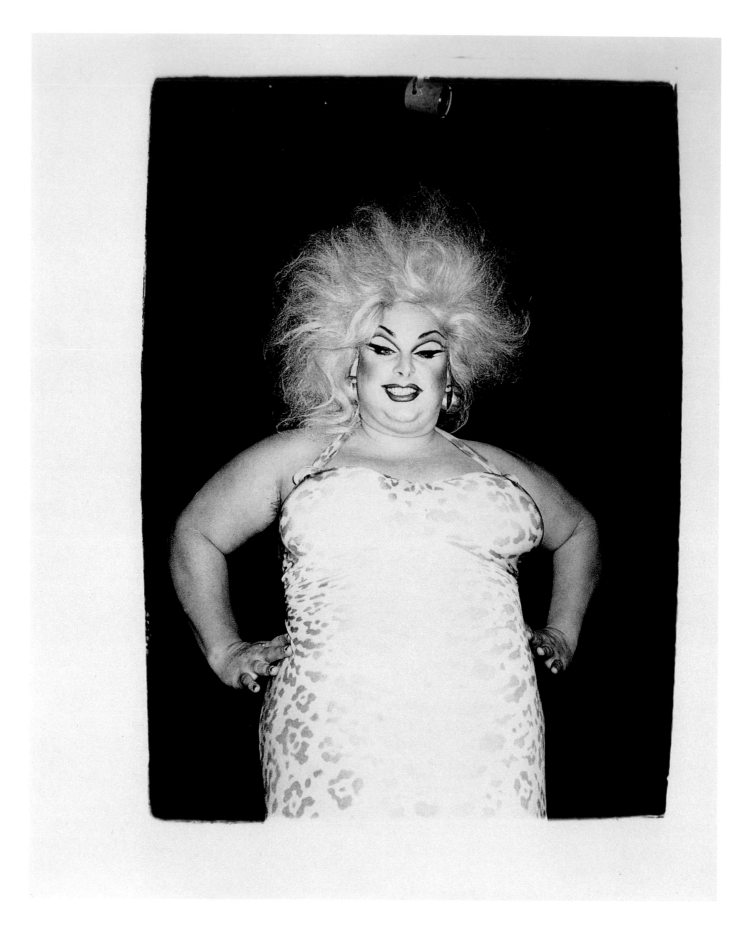

Divine 1978

Divine

1978

Gelatin silver print

10 x 8 in.

The Andy Warhol

Foundation for

the Visual Arts,

New York

FL05.00728

In 1980, after having lunch at the Factory with Ultra Violet and Divine (1945–1988), Warhol talked to his *Diaries* about Divine's success as a drag queen:

Divine really is the only one who you can't tell if it's a boy or a girl. Because of the long earrings, maybe. Like Edie Sedgwick earrings. And actually his face is the Edie type of face, but fat.[80]

This was high praise coming from Warhol, who had used female impersonators in his 1960s films, worked regularly with the drag queens Jackie Curtis, Candy Darling, and Holly Woodlawn, and, in 1972, cast those three as the stars of his parody of the sexual revolution, *Women in Revolt*. Warhol's works, in fact, were partly responsible for Divine's film career as a transvestite. John Waters, the director Divine collaborated with in drag classics like *Pink Flamingos* (1972), *Female Trouble* (1974), *Polyester* (1981), and *Hairspray* (1988), educated himself about cinema by watching the work of foreign masters, as well as underground pioneers like Kenneth Anger and Warhol. Waters and Divine (born Harris Glenn Milstead) were neighbors and classmates in a Baltimore suburb. After an unhappy childhood of torment for being overweight and effeminate, Milstead became a hairdresser. He assumed the persona of Divine when he was cast by Waters and prepared by makeup artist Van Smith for a role in the 1966 film *Roman Candles*. While Milstead thought of Divine as a role and did ocassionally play straight parts, Waters compared him to Jayne Mansfield and promoted him as "the godzilla of drag queens, a drag terrorist, designed to shock both gays and straights."[81]

The idea of drag and, more generally, that of camp—the idea that all gender identity consists of performance, of playing a role—was of perpetual interest to Warhol. He claimed to be "fascinated by boys who spend their lives trying to be complete girls, because they have to work so hard."[82] His casting of three drag queens (Curtis, Darling, and Woodlawn) to play women "in varying degrees and various stages of 'liberation'" in *Women in Revolt* was especially comic, since the identity they normally assumed was that of "the way women used to want to be."[83] Warhol's three starring women's liberationists came to his attention through an off-off-off-Broadway musical satire called *Glory, Glamour and Gold*. The playwright, Jackie Curtis, was raised on the Lower East Side by his grandmother, who ran the bar Slugger Ann's. Curtis had written the play, which also starred Robert De Niro in all ten male parts, for Candy Darling. Born Jimmy Slattery in Brooklyn, Candy started hanging out in Village gay bars and taking hormone injections while still a teenager. Holly Woodlawn also appeared in Curtis's plays. Woodlawn, whose real name was Harold Santiago Rodriguez Franceschi Dankahl Ajzenberg, grew up in Puerto Rico, the Bronx, and Miami Beach. He hitchhiked to New York and, before becoming part of Warhol's tribe, worked as a prostitute, a salesgirl, and a model. Holly and the other transvestites who were part of the Factory entourage would inspire the drag ballad "Walk on the Wild Side," composed by the former Velvet Underground singer Lou Reed.

213

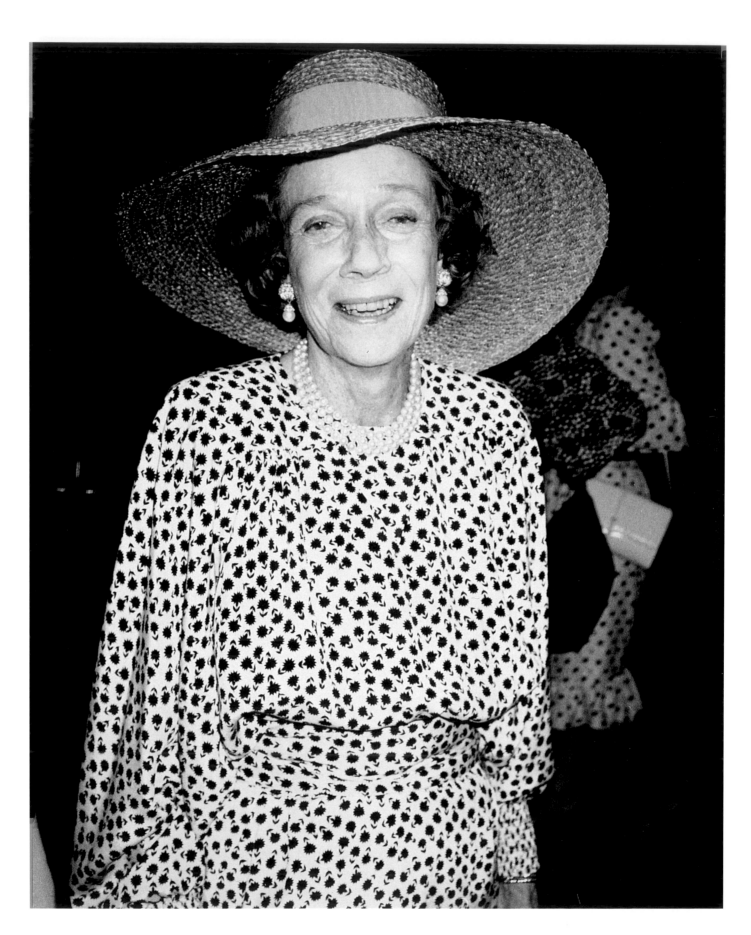

Brooke Astor circa 1979

Brooke Astor

circa 1979
Gelatin silver print
10 x 8 in.
The Andy Warhol
Museum, Pittsburgh
FL04.00043

Vincent Astor, heir to the fortune created in the nineteenth century by financier John Jacob Astor, married Roberta Brooke Russell in 1953. He was her third husband; she would be widowed again by 1959. However, with Vincent's passing, Brooke Astor's career as a major New York philanthropist and president of the Vincent Astor Foundation began. Over the next thirty-five years, her foundation would distribute about $195 million, making some one hundred grants annually to civic and cultural institutions. Her association with old money (and memberships in venerable WASP clubs such as the Colony Club, the Knickerbocker Club, the Century Association, and the Sleepy Hollow Country Club) made her one of the Important people, as far as Warhol was concerned. In fact, the Astor family connection put her in the same league as the Kennedys, who Warhol had designated as the "best family." Members of these East Coast monied families seemed to impress him more than European nobility, Harvard students, entertainers, and other potential celebrities he mixed with. Warhol might also have appreciated the unconventional nature of Astor's youth. Born in 1902 to a socialite and a Marine Corps officer, she was educated by governesses and raised in the midst of disparate cultures in Hawaii, Panama, and China. She married while still in her teens, and, though her husband was alcoholic and abusive, she stayed with him long

enough to have one child and start her work on charity boards. She wrote for *Vogue* and *Pictorial Review,* then *Town and Country* and *House and Garden,* after which she published two novels and two autobiographical books.

Warhol's picture of Astor, evidently made at one of the numerous social occasions she found awkward, presents a woman of good humor who seems to be completely at ease in front of the camera—even Warhol's camera. Her pearls and modestly cut flowered dress reflect her conservative good taste, while the broad-brimmed straw hat provides a touch of flamboyance and old-style glamour. The flash of Warhol's camera also caught two women in the background; their garb and contrasting handbags continue the bright play of patterns and contrasts set off by the brightly illuminated, repetitively ornamented fabric worn by Astor. Perhaps because his subject was a celebrity philanthropist from one of the "best families," Warhol's non-studio portrait is a flattering one. The wide hat frames Astor's face nicely and makes it sparkle. A reference to past high society style seems also to be his intent. Astor herself suggested that her childhood sketch (*Patchwork Child,* 1962) resembled an "Edwardian memoir."[84] Warhol sensed this about her and gave her the role, for an instant, of an Edwardian lady, circa 1980.

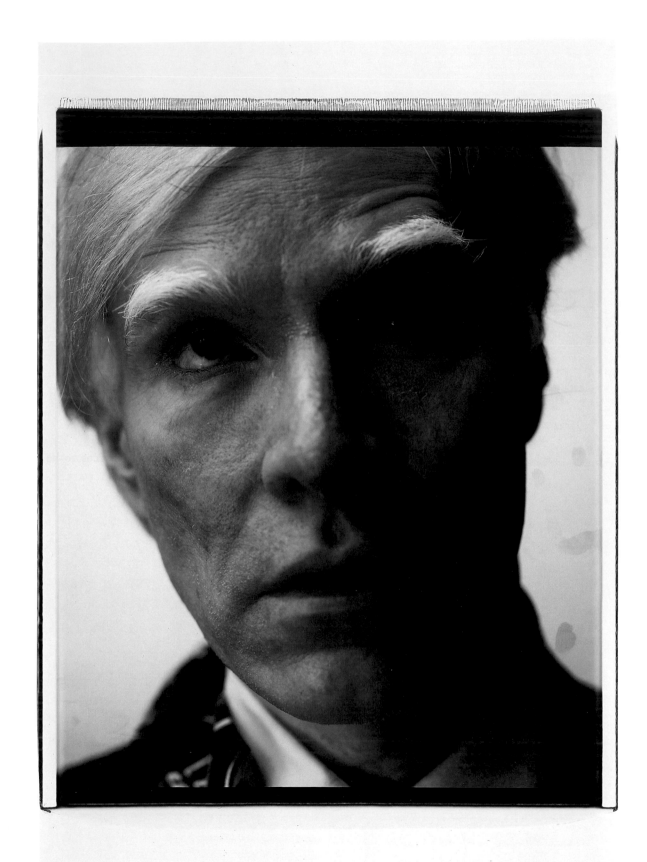

Self-Portrait 1979

Self-Portrait

1979
Polaroid Polacolor
print
Sheet: 32¼ x 22 in.;
image: 24 x 20⅝ in.
98.XM.5.1

From the time it began marketing the first Land camera in the late 1940s, the Polaroid Corporation has collaborated with artists in testing its photographic materials. Over the past sixty years, the company has given away cameras and film to numerous photographers, asking only that they use the equipment and offer an opinion on the results. Beginning with Ansel Adams, the list of master practitioners involved includes Arnold Newman, Yousuf Karsh, Philippe Halsman, Marie Cosindas, Harold Edgerton, Paul Caponigro, and William Clift. In the 1970s, Warhol was the beneficiary of Polaroid's generosity. Manfred Heiting, now a photography collector who worked for Polaroid at the time, visited the artist's studio in 1973 to discuss the company's new sx-70 system and supplied Warhol with at least ten cameras and many packs of film over the next seven years.[85]

In 1979 Warhol was given the opportunity to make portraits in Polaroid's own Cambridge, Massachusetts, studio, which had been set up to accommodate the prototype of a new 20 x 24-inch camera that weighed eight hundred pounds and could produce color photographs in sixty seconds. The bulky apparatus could not easily be moved for compositional changes; it had to remain stationary while the subject was rearranged. When all was ready, Polaroid's technician was on hand to operate it. In spite of these restrictions, Warhol seems to have had fun making more than ten portraits—most of them of himself.

The Getty picture is one of four extreme close-up self-portraits taken that day. Warhol seems to have quickly understood that he had to come to the enormous camera, confront it almost, to get from it a larger-than-life-size portrait that exploited its unusual potential. In the Getty image, his gaze is upward and away from the lens; the left side of his face is in deep shadow. All of this emphasizes and abstracts the simple highlighted lines of his face—of his mouth, nose, and eyebrows. In another of these close-ups (Andy Warhol Foundation for the Visual Arts), he creates a genuinely evil mood: with half of his face hidden in darkness, he grimaces at the camera; a tiny light in his right eye intensifies the cruel expression of his downturned mouth. A third picture (Metropolitan Museum of Art), made equally near the camera lens, presents the artist with eyes closed as if in prayer. The fourth self-portrait in close-up (Andy Warhol Museum) was used posthumously on the cover of *Interview* magazine in February 1989. Warhol looks directly into the camera, his gaze that of an innocent, baffled artist—a preferred pose of this faux-naïf, who was fascinated by the medium of photography and happy to work with it in perpetuating the Warhol myth.

218

Maria Shriver

1986

Gelatin silver print

8 x 10 in.

The Andy Warhol

Foundation for

the Visual Arts,

New York

FL04.00492

I read in the papers that Grace Jones was taking me up to the Shriver-Schwarzenegger wedding in her plane, so I guess Grace called her press agent and put that in so I guess that means we're going.[86]

ANDY WARHOL, April 25, 1986

Maria Shriver was born into a celebrity family, became a news anchor for network television, and married a star of action-adventure movies. She was the daughter of Sargent and Eunice (Kennedy) Shriver, and, thereby, Senator Edward Kennedy's niece and Caroline Kennedy's cousin. After graduating from Georgetown University in Washington, D.C., Shriver (born 1955) became a TV producer and magazine reporter; she moved in front of the camera when CBS *Morning News* made her a coanchor of that program. She then anchored four news shows for NBC and, in 1990, her own program, *Cutting Edge with Maria Shriver.* An accomplished professional woman, she was a rare female personality in the news media when she married Arnold Schwarzenegger, a former Mr. Universe more popularly known for his roles in *Conan the Barbarian* and *Conan the Destroyer.*

The Kennedys represented a longtime Democratic dynasty, while Schwarzenegger was sometimes referred to as Conan the Republican. This severe discrepancy in political views was only one of the excesses in evidence at the wedding in Hyannis that Warhol attended with model-actress-musician Grace Jones in the spring of 1986. They were greeted by what Warhol described as the "biggest mob I've ever seen around a church."[87] The media were thick on the ground and the Barnstable police were

on duty. *People* magazine reported that the airspace, however, was kept clear by a ban imposed on intrusive helicopters under a Celebrity Event rule.

Even before he arrived in Hyannis, Warhol had played an important role in the traditional wedding rituals. At the rehearsal dinner, Arnold presented his future in-laws with a Warhol portrait, a painting of Shriver that he had commissioned in February. According to Warhol's account of the wedding, this gift made a large impact. Andy had brought along drawings of Maria as his own present to the couple. Both painting and drawings were probably based on the Polaroid portraits that Warhol made when Shriver sat for him at the Factory on April 3. Warhol also made black-and-white pictures with another camera (he preferred a Minon with auto focus) during most of these portrait sessions. This more abstract and at the same time more documentary black-and-white image became a record of how his sitters looked while being photographed. Whereas the Polaroid portraits close in on the face and shoulders, these longer views reveal more of the actual circumstances of the sitting. Shriver looks more "naked" and uncomfortable when the loose plaid wrap, ordinary studio chair, and heavy white makeup—all standard for these sessions—are exposed. In spite of the harsh lighting and sparse surroundings, Shriver's youthful beauty still comes through in this photograph, offering a marked contrast to Warhol's black-and-white portrayal of Divine's robust, sexy female persona, Nancy Reagan's thin, determined stylishness, and Brooke Astor's wealthy elegance.

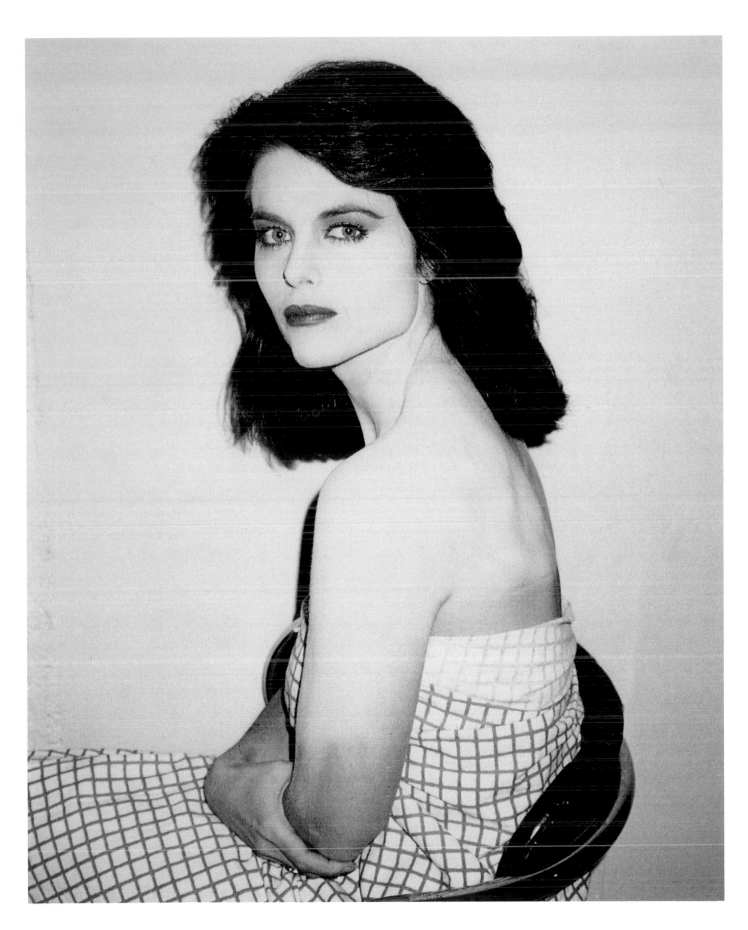

Maria Shriver 1986

Jane Fonda

220

1982

Gelatin silver print,

10 x 8 in.; three

Polaroid 2 prints,

each 4^1/$_4$ x 3^3/$_8$ in.

The Andy Warhol

Foundation for

the Visual Arts,

New York

FL04.00618

FA04.05074

FA04.05044

FA04.05055

Jane Fonda called and she's coming on Thursday for me to do her portrait. I decided to do it after Fred read her husband's bio and political ideas and told me I should.[88]
ANDY WARHOL, April 26, 1982

Although on crutches, Jane Fonda (born 1937) appeared at the Factory at the appointed time. She had hairdresser and makeup person in tow and, Warhol told the *Diaries,* was very charming. She was there for a portrait sitting; Polaroids would be made, one would be selected for transfer to a silkscreen, and the chosen image would be screened onto canvas.

But Fonda had not commissioned a painted portrait at Warhol's standard rate of $25,000. She had, instead, asked him to create a portrait that, after it was painted, would be transferred once again to paper as a screenprint in an edition of one hundred. The prints would then be sold to further the cause of a political campaign, that of Fonda's husband, Tom Hayden, a former antiwar activist who was running for the California State Assembly. Warhol attributed his willingness to donate his art to this radical West Coast candidate to the influence

of his associate, Fred Hughes, but, in fact, he had been supporting liberal, albeit less radical, politicians for at least a decade with artistic contributions. In 1972 he produced a "Vote McGovern" poster (the face of Richard Nixon above George McGovern's campaign slogan); he made Polaroids of Jimmy Carter in 1976 from which the Democratic National Committee published screenprints to help cover campaign costs; and in 1980 he created an edition of three hundred screenprints finished with diamond dust for Senator Edward Kennedy's run for the Democratic presidential primary.

The strategy for the Hayden campaign was slightly different, however. With Warhol's help they were hoping to sell the candidate, based not on his face, which received plenty of press in the sixties and seventies for his antiwar activities, but on Jane's face. At the time, Fonda was better known for her films and her famous Hollywood family than for her political activism (she had been called "Hanoi Jane" in the 1960s for her visits to North Vietnam) and her best-selling fitness guide, *Jane Fonda's Workout Book* (1981).

Jane Fonda 1982

222

Warhol and Fonda were acquainted before she won Academy Awards, broadcast on Radio Hanoi, or built a string of exercise studios. In the mid-sixties, Fonda frequented the Dom, a short-lived nightclub where Warhol's Factory produced the Exploding Plastic Inevitable floor show and his "house band," the Velvet Underground, entertained the New York underground and international jet-set with proto-punk music. When Warhol was in Hollywood in 1969 shopping a movie idea to the studios, Fonda found entertainment for his entourage, including a screening of her brother Peter's new film, *Easy Rider.* Fonda and Warhol got together again for a conversation to be published in his March 1984 issue of *Interview.* She said she had been reminiscing about all of their common acquaintances who were now dead, and she wondered why either of them had survived. Warhol's response: "It just happened accidentally. I didn't want to."[89]

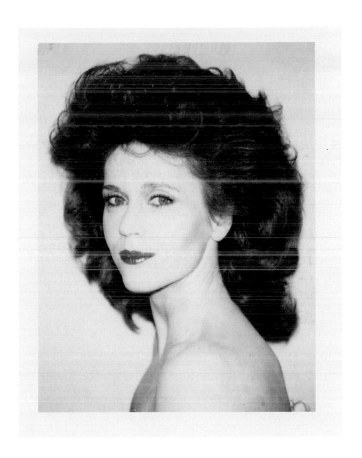

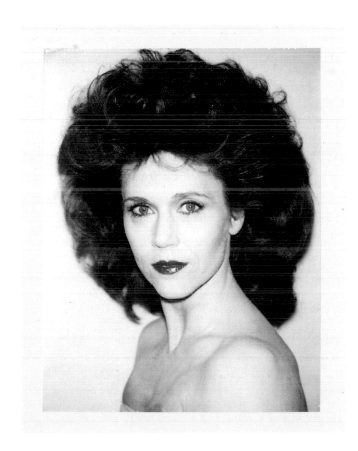

Jane Fonda 1982

224 **Nancy Reagan**
1981
Gelatin silver print
10 x 8 in.
The Andy Warhol
Foundation for
the Visual Arts,
New York
FL04.00458

*T*here's so much in the papers about Ronald *Reagan and it looks like he's on his way to become president, it does look scary.*[90]
ANDY WARHOL, July 16, 1980

Born Anne Frances Robbins in 1923, Nancy Reagan grew up in Chicago, majored in drama at Smith College, and, before making the move to Hollywood, performed in Broadway and off-Broadway shows. She was working for Metro-Goldwyn-Mayer as a contract actress when she met and married the actor Ronald Reagan, who was twelve years her senior. They made one film together, *Hellcats of the Navy,* before Nancy gave up her acting career to have children and concentrate on family. Ronald moved into television, becoming the CBS spokesman for the series *General Electric Theater.* After delivering a campaign speech in 1964 in support of the Republican presidential candidate Barry Goldwater (who lost the election), Ronald attracted the attention of influential—and wealthy—Republicans, who encouraged him to run for governor of California in 1966; he was elected, served two terms, and went on to become President of the United States in 1980.

Warhol had met Reagan in 1979 when the latter spoke in New York at a dinner sponsored by the North American Watch Company. As a non-voting liberal Democrat, Warhol had been worried about the prospect of Reagan being elected. However, he and *Interview* editor Bob Colacello had befriended Ron Reagan, Jr., and his girlfriend Doria before the 1980 election, and Doria became Bob's secretary at the magazine soon after. A cover interview with Nancy was arranged for the Christmas 1981 issue. Nancy

had been heavily criticized for bringing what was seen as an extravagant lifestyle (back) to the White House. At the end of her first year as First Lady, she suffered from a very high disapproval rating. Thus, White House strategists gave the nod to Nancy appearing, in her Christmas-red Adolfo, on the cover of a "young, hip magazine," and *Interview* published the first extensive exchange with the new First Lady. While Andy seemed most interested in learning more about her life before politics, Nancy talked largely about family, her campaign against drugs, her busy schedule, and life in Washington.

This black-and-white snapshot portrait from the White House visit shows a typically poised Mrs. Reagan calmly answering questions. A more animated picture from the same session appears in Warhol's 1985 book of photographs, *America.* Since Andy made all of these pictures in the early 1980s, his view of the United States could also be considered a look at Reagan's America. Interestingly, Warhol includes the Reagan images among the artists, sports figures, fashion designers, and movie stars assembled in the section on celebrities, entitled "People," rather than in a later section on Washington, D.C. Some astute political wisdom is offered, though: in praise of American government and American media, Warhol says that "The President, the newsmagazines, television—they only want to capture America's mood at the moment, reflect it back, and tell anyone who's not in the same mood to get over it and start feeling American like everyone else."[91]

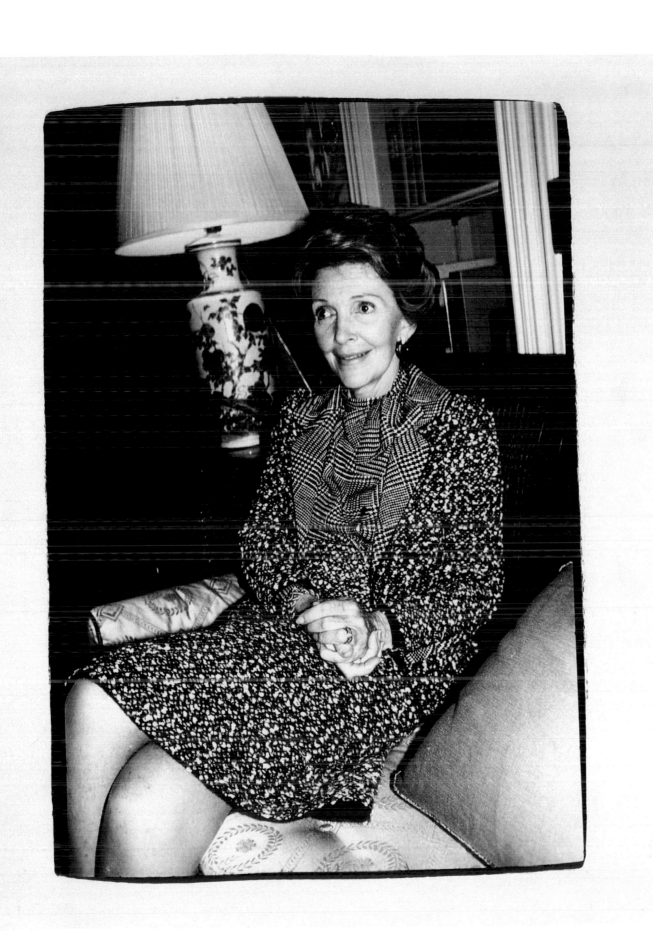

Nancy Reagan 1981

226 **Self-Portrait**

1986

Polaroid Polacolor

ER print

4$\frac{1}{4}$ x 3$\frac{3}{8}$ in.

98.XM.5.3

The role of Andy Warhol was something the artist took quite seriously. A variety of wigs, eyeglasses (including, importantly, sunglasses), and makeup, as well as a subtly changing, but always hip, wardrobe contributed to the part of famous artist that he had chosen to play. However, for some of the last painted self-portraits he accomplished before his death, Warhol selected his platinum "fright wig" and, after making a series of Polaroids, combined his own portrait with a silkscreen camouflage pattern on canvas, thereby disguising his own face rather than illuminating it. In his memorial portraits of the German artist Joseph Beuys of the same year, Warhol joined an earlier Polaroid picture of Beuys with an all-over camouflage pattern to produce ghost-like images in which Beuys's face seems to float somewhere between the background and the foreground. The spectral nature of Warhol's pale face hovering in the midst of a solid black ground punctuated only by wild strands from his reflective wig also has an "in memoriam" sensibility, relating to the mood of the 1986 Beuys portraits, as well as to a 1978 group of Polaroids and paintings called *Self-Portrait with Skull*, obviously based on the traditional memento mori theme.

In this instant portrait of 1986, Warhol was apparently attempting to represent the artist as spirit; his inspiration may have been another artist working nearly a century earlier. In 1895 the Norwegian painter Edvard Munch created a black-and-white lithograph entitled *Self-Portrait with Skeleton's Arm* that was simply composed of his similarly disembodied head surrounded by a black ground, a skeletal fragment lying across the lower foreground being the only element with any weight to it. Warhol never hesitated to appropriate photographs of himself by other photographers for use in his self-portrait paintings or prints. In the case of Munch, he borrowed another artist's face and reproduced it in 1984 as a screenprint, retitling it *Self-Portrait with Skeleton's Arm (After Munch)*.

But there might have been a more modern source for the macabre style Warhol employed for this 1986 self-portrait. Cecil Beaton's book *The Face of the World* (1957) includes a series of five photographs of the Hollywood star Joan Crawford. In each, her face displays a different dramatic expression (as Beaton's text says, "given a moment's preparation, she can transform her features into a kinesthetic marvel") intensified by the fact that her well-known physiognomy is, like Warhol's, circumscribed by a deep blackness.[92] Crawford appears fearless before the camera, while it renders her isolated face in masklike fashion. A British photographer and stage designer who published prolifically, Beaton (1904–1980) was a friend of the writer Truman Capote's and an acquaintance of Warhol's. In the 1930s, his innovative fashion photography appeared regularly in *Vogue* and other Condé Nast journals; from that decade until the 1960s he spent as much time with screen stars as with models, portraying Dietrich, Garbo, and Hepburn. Warhol doubtless envied Beaton his access to the glamorous stars he had revered since childhood and, admiring his theatrical style, sought to emulate it.

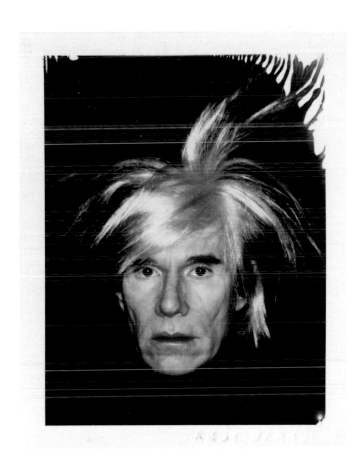

Self-Portrait 1986

Endnotes

INTRODUCTION

1 Joanna Baillie, *The Worth of Fame,* stanza 2 (1790, 1851 edus.).

2 *Oxford Latin Dictionary* (Oxford, 1990), pp. 674, 293–294.

3 See Paul Zanker, *The Mask of Socrates* (Berkeley, 1996); Gisela M. A. Richter, *The Portraits of the Greeks,* 3 vols. (London, 1965).

4 See Julia K. Murray, "The Hangzhow *Portraits of Confucius* and Seventy-Two Disciples: Art in the Service of Politics," *Art Bulletin* 74 (1992), pp. 7–18; Audrey Spiro, *Contemplating the Ancients: Aesthetics and Social Issues in Early Chinese Portraiture* (Berkeley, 1990).

5 Ernest Hatch Williams, *The Triumph of Petrarch* (Chicago, 1962), pp. 73–90; see, also, Eva Kushner, "From the Triumphus Farnese to the Pléiade's Lists of Honour," in *Petrarch's Triumphs: Allegory and Spectacle,* Konrad Eisenbechler and Annilease A. Iannucci, eds. (Toronto, 1990), pp. 335–345.

6 Andrea Fulvio, *Illustrium Imagines,* Rome 1517; see Martina Housmann, "Andrea del Castagnos Zyklus der 'Uomini famosi' und 'Donne famose': Geschichts verstandnis und Tugenideal im florentinischen Fruhhumanismus," *Bonner Studien zur Kunstgeschichte* 4 (Münster, 1992); Patricia Simons, "Portraiture, Portrayal, and Idealization: Ambiguous Individualism in Representations of Renaissance Women,"

in Alison Brown, ed., *Language and Images of Renaissance Italy* (Oxford, 1995), pp. 263–311.

7 Stephen K. Scher, ed., *The Currency of Fame: Portrait Medals of the Renaissance,* exhibition catalogue (New York, The Frick Collection, 1994); see also the review by Ingrid D. Rowland, "Character Witnesses," in *The New York Review of Books* (Dec. 1, 1994), pp. 27–31.

8 See Eugene Dwyer, "André Thevet and Fulvio Orsini: The Beginnings of the Modern Tradition of Classical Portrait Iconography in France," *Art Bulletin* 75 (1993), pp. 467–480; Oreste Ferrari, "L'iconografia dei filosofi antichi nella pittura del sec. XVII in Italia," *Storia dell'Arte* 57 (1986), pp. 103–181. These collections also inspired assemblies of distinguished contemporaries; see Andrew McClellan, "D'Augiviller's 'Great Men' of France and the Politics of the Parlements," *Art History* 13 (1990), pp. 175–192.

9 Alois Riegl's seminal work on the Dutch group portrait, *Das holländische Gruppenporträt* (Vienna, 1902), has not yet been translated into English; for a well-translated excerpt, see Benjamin Binstock, *October* 74 (Fall 1995), pp. 3–35; on the informal group portrait, see Mario Praz, *Conversation Pieces: A Survey of the Informal Group Portrait in Europe and America* (University Park, 1971).

10 See Dagmar Eichberger and Lisa Beaven, "Family Members and Political Allies: The Portrait

Collection of Margaret of Austria," *Art Bulletin* 77 (1995), pp. 225–248.

11 Gerard Vaughn, "The Townley Zoffany: Reflections on *Charles Townley and His Friends,*" *Apollo* (November 1996), pp. 32–35.

12 For example, Richard Shone, *Bloomsbury Portraits: Vanessa Bell, Duncan Grant, and Their Circle* (Oxford, 1975); David Piper, *The Image of the Poet: British Poets and Their Portraits* (Oxford, 1982), especially chapter 4, "The End of Fame: Tennyson and After," pp. 146ff.

13 Theodore Reff, "Manet's Portrait of Zola," *Burlington Magazine* 117.862 (1975), pp. 35–44.

14 Carol Armstrong, "Reflections in the Mirror: Paintings, Photography, and the Self-Portraits of Edgar Degas," *Representations* 22 (1988), pp. 108–141.

15 See Elizabeth Legge, "Posing Questions: Ernst's *Au Rendez-Vous Des Amis,*" *Art History* 10 (1987), pp. 227–243.

16 See Donna C. Stanton, *The Aristocrat as Art: A Study of the "Honnête Homme" and the Dandy in Seventeenth-and Nineteenth-Century French Literature* (New York, 1980); also Denys Sutton, "Henri Fantin-Latour: In Search of the Ideal," *Apollo* (January 1984), pp. 30–37; idem, "Edouard Manet: The Artist as Dandy," *Apollo* (October 1983), pp. 330–341.

17 The topic is very large, but see Judith Weschler, *A Human Comedy: Physiognomy and Caricature in Nineteenth-Century Paris,* exhibition catalogue (Chicago and London, 1982); reviewed by Anne McCauley in *Art Bulletin* 66, 1984, 342–344; and Wendy W. Reaves, *Celebrity Caricature in America* (New Haven, 1998).

18 *Othello,* Act 2, Scene 3, line 264.

19 In the *London Review of Books* (November 5, 1992), p. 24; see also J. Rose, "The Cult of Celebrity," *London Review of Books* (August 20, 1998), pp. 10–13.

20 See the remarks on recent publications of Cartier-Bresson's photographs by Anne Hollander in the *London Review of Books* (May 7, 1998), pp. 19–20; and by Ernst Gombrich in *The Art Newspaper* 78 (February 1998), pp. 30–31.

NADAR

The following standard biographical references have been consulted in the writing of the catalogue entries and are not specifically cited in these notes unless directly quoted: J. Balteau et al., *Dictionnaire de Biographie Française* (Paris, 1932–1994); Pierre Larousse, *Grande Dictionnaire universal du XIXe siècle,* (Paris, 1866–1879); Berthélot et al., *La Grande Encyclopédie* (Paris, 1886).

1 To the two longstanding principal accounts of Nadar's life, those of Roger Greaves, *Nadar, ou le paradoxe vital* (Paris, 1980), and of Jean Prinet and Antoinette Dilasser, *Nadar* (Paris, 1966), has now been added that of Maria Morris Hambourg, "A Portrait of Nadar" in *Nadar* (New York, 1995) and an analysis of his intentions by Elizabeth Anne McCauley in *Industrial Madness, Commercial Photography in Paris, 1848–1871* (New Haven, 1994). From all of these I have drawn for this sketch of his life.

2 Among the titles were works, in many volumes, by Buffon, Diderot, and Rousseau. Greaves, op. cit., p. 19. Victor Tournachon's catalogue also listed books in five languages other than French.

3 Ibid., pp. 24–25.

4 Ibid., p. 209. His height was given at 1.78 meters on his passport in 1848. Alphonse Karr's described Nadar as a kind of giant. Ibid., p. 111.

5 Puccini encapsulated and perpetuated Mürger's fiction with his opera of 1898, *La Bohème.*

6 Nadar writing in *Histoire de Mürger* (Paris, 1862), as quoted in Greaves, op. cit., p. 62. Greaves discussion of Nadar's place in this period is illuminating.

7 Prinet, op. cit., p. 22.

8 These short stories would be gathered and published in 1856 as *Quand j'etais étudiant.*

9 The envelope is reproduced in Prinet, op. cit., p. 157.

10 A perhaps analogous explosion of short-lived but vital publications can be found in the mimeographed poetry magazines of the 1950s, 1960s, and early 1970s in New York and San Francisco, such as those edited by Ted Berrigan, Diane di Prima, and Larry Fagan. They had, however, fewer readers and less political content.

11 A photograph of Victor Hugo, then in exile in Jersey, was the basis for his caricature, a painting for that of George Sand (she refused to sit for Nadar, whom she did not yet know). For Hugo, Prinet, op. cit., p. 99. For Sand, Greaves, op. cit., p. 150.

12 McCauley, op. cit., p. 116, argues that Nadar's decision to set up shop was heavily influenced by Ernestine's desire for bourgeois respectability.

13 The descriptions of the rue Saint-Lazare premises differ in Prinet, op. cit., p. 118, and Greaves, op. cit., p. 182, with Greaves favoring the garden as the exclusive site for photography. Hambourg, op. cit., p. 23, thinks both spaces were employed.

14 Neither seems to have been well heated judging by the number of sitters who wear overcoats.

15 The court documents are quoted in Greaves, op. cit., pp. 175–176.

16 McCauley, op. cit., p. 121.

17 As red was to Nadar, so, for a time, silver to Warhol.

18 Greaves, op. cit., p. 226.

19 Prinet, op. cit., p. 140.

20 Greaves, op. cit., p. 251.

21 In prose flamboyantly suited to the occasion Nadar wrote of the disaster in his 1864 Mémoires du Géant, transcribed ibid., pp. 259–269.

22 Le Gray also disdained these small but lucrative photographs.

23 Greaves, op. cit., p. 283.

24 Ibid.

25 See, for example, George Sand's introduction to Nadar's 1865 Le Droit au Vol, as translated in Jane M. Rabb, Literature and Photography; Interactions, 1840–1990 (Albuquerque, 1995), p. 72.

26 Nadar seems to have used Botany Bay as a metaphor for a verdant (and safe?) harbor at the end of the world rather than as a reference to the prison settlement that was founded nearby after its discovery by Captain Cook. His words are to be found in his Mémoires du Géant (Paris, 1864), and are transcribed in Greaves, op. cit., pp. 237–238. He published several such litanies of his life.

27 Nadar's decision to isolate a sitter in what was either the crowded studio or the garden filled with animals is reminiscent of Josef Sudek's austere still lifes made in the chaos of his living quarters.

28 Plain black clothing also characterizes some denizens of the late twentieth-century art world.

29 McCauley points out that the absence of hands may be a legacy from the daguerreian period and its manuals, which counseled their omission lest proximity to the camera produce distortion. McCauley, op. cit., p. 129.

30 Nadar may have adopted this way of posing the figure at an angle to the camera from Le Gray, whose treatise of 1851 recommended it.

31 His court testimony as given in Greaves, op. cit., p. 176.

NADAR CATALOGUE

32 Greaves, op. cit., p. 216.

33 Greaves, op. cit., p. 384. Some of this may be hyperbole attributable to her imminent death.

34 Nadar's account of the disaster is given in Mémoires du Géant (Paris, 1864), p. 361 et seq.

35 Ibid. Nadar's account makes oblique reference to his wife's attire being conventional and the November 7, 1863, cover of Le Monde Illustré illustrating the disaster shows her in normal clothing. Reproduced in Benoît Peeters, Les Métamorphoses de Nadar (Brussels, 1994), p. 132. When she posed for another carte-de-visite with Nadar in his studio in a pretend balloon, she wore a shawl, veil, and hat. Reproduced, Prinet, op. cit., p. 147.

36 Nadar's great balloon, the Géant, was also woven of wicker-like elements, but it had two levels including a closed cabin and could carry eleven people. In other photographs in this series Nadar used a different, seemingly more plausible wicker basket. One of these is reproduced in Joanna Richardson, La Vie Parisienne, 1852–1870 (New York, 1971), p. 77.

37 Nadar signed and dated the original print, which was oval in form. He inscribed Mürger's name on this print and appears to have strengthened its composition by darkening Mürger's wrist to produce an unbroken dark area in its lower half. An undated oval print from the original negative, in the collection of the Bibliothèque Nationale, is reproduced by Hambourg, op. cit., p. 113.

38 For her life, see, among others, Anthony Levi, Guide to French Literature: 1789 to the Present (Chicago, 1992, pp. 568–578.

39 The bust of her he drew was taken from a portrait by Couture; it is placed at the head of the procession of writers. Hambourg, op. cit., p. 246.

40 Greaves, op. cit., p. 312.

41 As translated in Rabb, op. cit., p. 72.

42 She wore different clothes in others. Cf. Hambourg, op. cit., fig. 42, and plate 85.

43 I am indebted to Dale Gluckman for her observations about Sand's clothing and those of Nadar's other sitters.

44 Called Dumas père to distinguish him from his (illegitimate) son Dumas fils, also a well-known playwright.

45 On the respective merits of his writings, cf. Levi, op. cit., p. 209.

46 A few years later, in 1836, Nadar wrote a letter to his mother seeking an excuse for going to visit Dumas. Greaves, op. cit., p. 31.

47 Ibid., p. 36.

48 Ibid., p. 207.

49 Nadar writing in "Une Page de Mémoires inédits" in Sous l'incendie as quoted in Hambourg, op. cit., p. 10.

50 See "Une Page de Mémoires inedits," in Sous l'incendie (Paris, 1882), p. 60.

51 "...ma voix me faisait pleurer," as quoted in Jacques Boulanger, Marceline Desbordes-Valmore; d'après ses papiers inédits (Paris, n.d., but circa 1909), p. 287.

52 Ibid, p. 317.

53 As quoted in McCauley, op. cit., p. 137.

54 The posthumous photograph is illustrated in Hambourg, op. cit., pl. 88.

55 See for example, Robert Snell, Théophile Gautier: A Romantic Critic of the Visual Arts (Oxford, 1982).

56 "Les clichés de Gautier furent nombreux, chez moi et ailleurs. Presque tous sont beaux comme était le modèle." Nadar in Paris Photographe, vol. 1, no. 1, April 25, 1891, p. 17.

57 Hambourg, op. cit., p. 9.

58 Nadar, Quand j'étais Photographe (Paris, 1900), p. 8.

59 Gautier himself was an occasional photographer, having made daguerreotypes with Eugène Piot in Spain in 1840. Dale Gluckman helpfully pointed out the nature of Gautier's headgear.

60 Cf. Levi, op. cit., p. 190.

61 Nadar traveled to Brussels in September 1862 to attend a dinner honoring Hugo, who was then in exile, and the publication of Les Misérables. Hambourg, op. cit., p. 253.

62 Cf. Françoise Heilbrun and Philippe Néagu, "L'atelier de photographie de Jersey," in Victor Hugo et les images (Dijon, 1989), p. 186.

63 The strip, "lanterne magique des auteurs," is reproduced in Hambourg, op. cit., p. 16.

64 The circa 1870 and 1884 portraits are illustrated in Philippe Néagu and Jean-Jacques Poulet-Allamagny, Nadar (Paris, 1979), pp. 321–322.

65 The sketch is in the Getty collection.

66 Reproduced in Hambourg, op.cit., p. 16.

230

67 Cf. exh. cat., *Souvenirs de Jersey, photographies de Charles Hugo et Auguste Vacquerie* (Paris, 1980), for a selection of the images of the Jersey atelier and Heilbrun and Néagu, op.cit, pp. 184–195, for a discussion of the photographs made in Hugo's circle.

68 Ulrich Keller assumes that those photographs that were heavily retouched disappeared into the hands of Nadar's clients rather than remaining in the studio. Keller in "Sorting Out Nadar," in Hambourg, op.cit., p. 79.

69 An unretouched print from the same negative is in the Getty collection.

70 Published by J. Bry, *ainé* (Paris, 1853). The preface states that the works within are intended as the first flowers of spring.

71 The article and its illustrations were reprinted as *Photosculpture* (Paris, 1864), pp. 1–15.

72 The photograph of Laurent is reproduced in Hambourg, op.cit., pl. 64.

73 As quoted in Julia Cartwright, *Jean-François Millet; His Life and Letters* (New York, 1896), p. 79. Cartwright's biography perhaps overstates the difficulties of Millet's life.

74 Reproduced in Etienne Moreau-Nélaton, *Millet: raconté par lui-même* (Paris, 1921), figs. 55–56. Daumier was also a friend, Corot less so. The Barbizon school has been much studied; see, among others, Jean Bouret, *The Barbizon School and Nineteenth-Century French Landscape Painting* (London, 1973).

75 Millet was so described by the American painter Edward Wheelwright (1824–1900), who lived in Barbizon in the mid-1850s. as quoted in Cartwright, op. cit., p. 151. Others, like Gustave Geoffroy, writing in *Paris Photographe* in 1892 thought Millet looked like one of the peasants he painted.

76 Reproduced in Moreau-Nélaton, op. cit., fig. 78.

77 Wheelwright quoting Millet in an *Atlantic Monthly* article; September, 1876, as quoted in Cartwright, op. cit., p. 161. Millet was also the subject of a daguerreotype of 1849. See Moreau-Nélaton, op. cit., fig. 53.

78 Leopold II, whom Nadar would travel to Brussels to photograph in 1856. Hambourg, op. cit., p. 34, note 100.

79 For the connection with the House of Savoy and Molin's style, see the entry for Molin by Hambourg, drawing on research by François Lepage, in Hambourg, op. cit.; p. 235.

80 McCauley, op. cit., p. 138. Another print of this image in the Getty collection is inscribed by Nadar *a mon ami Molin*. There is also a second Nadar portrait of Molin, which was made at another sitting close in date to this. Greaves, op. cit., p. 42, notes their early friendship and distant relationship.

81 As quoted in Glenn F. Benge, *Antoine-Louis Barye, Sculptor of Romantic Realism* (University Park, 1984), p. 1.

82 For accounts of Barye's life see, among others, the talkative Charles De Kay, *Barye: Life and Works...* (New York, 1889), and Théophile Silvestre, *Les Artistes Français*, vol. I, Romantiques (Paris, 1926).

83 Stanislaus Lami, *Dictionnaire des Sculpteurs de l'école Française du dix-neuvième siècle* (Paris, 1914), vol. 1, p. 73.

84 Cf. Silvestre, op. cit., vol. 1, p. 100.

85 De Kay; op. cit.; frontispiece. by Flameng.

86 Silvestre, op. cit., vol. 1, p. 154.

87 Cf. the exhibition catalogue, *The Second Empire, 1852–1870: Art in France under Napoleon III* (Philadelphia, 1978), pp. 238–239.

88 Ernest Chesnau, *Peintres et Statuaires Romantiques* (Paris, 1880), pp. 147, 149. Silvestre, op. cit., includes numerous others.

89 Ibid, p. 142 Louis Veuillot, another Nadar sitter, in 1856 wrote to his sister anticipating dinner with Préault at Nadar's house. Greaves, op. cit., p. 190.

90 Louis Dezé, *Gustave Doré, Bibliographie et Catalogue complet de l'oeuvre*, Paris, 1930, p. 8.

91 The variant is illustrated in Hambourg, op. cit., pl. 43.

92 Cf. the description of Doré by Théophile Gautier's daughter Judith quoted in Millicent Rose, *Gustave Doré* (London, 1946), p. 10.

93 There are three Nadar caricatures of Doré in the Getty collection. For Nadar's collection, McCauley, op cit., p. 138.

94 Reproduced in Néagu and Poulet-Allamagny, op. cit., p. 131.

95 Henri Dumesnil, *Aimé Millet: Souvenirs Intimes* (Paris, 1891), p. 6. Dumesnil does not name the photographer but a salt print by Le Gray of Millet's drawing is in the Getty Museum collection. At this period the spectrographic limitations of photographic materials could not accurately render the intensities, much less the hues, of colors. A photograph of a black-and-white drawing of a painting better represented the color balance of the original than a photograph of the original.

96 Ibid, p. 6.

97 Hambourg, op. cit., p. 20.

98 Françoise Heilbron in "Nadar and the Art of Portrait Photography" has persuasively argued that this portrait should be attributed to the brothers together. Ibid; pp. 43–44.

99 On Rousseau's monastic consecration to nature, see Silvestre; op. cit., vol. 1, p. 182.

100 Hambourg, op. cit., p. 64.

101 Reproduced in Néagu and Poulet-Allamagny; op. cit., p. 180.

102 Françoise Heilbrun identified the sitter as Marie Jamet rather than Jeanne Jugan, Hambourg; op. cit., p. 240. On the verso of the print Nadar inscribed the sitter's title, but not her name.

103 Reproduced in Néagu and Poulet-Allamagny, op. cit., p. 572.

104 The variant is in the Getty collection.

105 A print of the portrait of the sinister Narvaez is in the Getty collection.

106 Avis Berman astutely first correlated this photograph of Finette with Whistler's mistress of the same name. See Stanley Weintraub, *Whistler: A Biography* (New York, 1974), p. 54, and Gordon Fleming, *The Young Whistler* (London, 1978), p. 128, for very brief accounts of Finette's life. In the second etching, apparently asleep, she lies nude in an untidy bed. For reproductions of both etchings see Edward G. Kennedy, *The Etched Work of Whistler* (San Francisco, 1978, reprint of New York, 1910 edition), plates 58, 59.

107 Charles Baudelaire, *Correspondance* (Paris, 1973), II, p. 326, as quoted by Geneviève Lacambre in her essay "Whistler and France," in Richard Dorment and Margaret MacDonald, *James McNeill Whistler* (London, 1984), p. 40.

108 Royalty seldom sat to Nadar. For another example such visit to Nadar's studio—by the sister of the king of Hanover—see Nadar's *Quand j'étais photographe*, op. cit., p. 46 et seq.

109 Richard Cobden, the advocate of free trade, as quoted in Harold Acton, *The Last Bourbons of Naples* (London, 1961), p. 171.

110 This velvet cloak was a studio prop that Nadar used to clothe other sitters like Sarah Bernhardt, Marie Laurent, and Christoll Terrien. Portraits of the latter two are reproduced in McCauley, op. cit., figs. 47, 48.

111 I am indebted in this entry to Maria Hambourg's brilliant exposition of the series of photographs Nadar made of Deburau. Hambourg, op. cit., pp. 224–227.

112 Greaves, op. cit., pp. 52–55.

113 Edmond and Jules de Goncourt, *Journal* (Paris, 1935), vol. 1, p. 73.

114 These can be found in the Getty collection. Others, no doubt, are elsewhere.

115 Reproduced by Heilbrun in Hambourg, op. cit., p. 45. Heilbrun discusses its authorship and that of the other (Hambourg, fig. 34) in the collection of the B.N. but seems to have been unaware of this third image. Adrien is known to have shown a portrait of Janin in Brussels in 1856.

116 As to their quarrel, Hambourg, op. cit., p. 235. As to Janin's gout, Goncourt, op. cit., vol. 1, p. 26.

117 For an extended discussion of the principal tenets and evolution of Cousin's philosophy, see *The Encyclopaedia*

Britannica (eleventh edition, Cambridge, 1910) pp. 330–335.

118 For a later portrait see Néagu and Poulet-Allamagny, *Nadar* (Paris, 1979), vol. 1, p. 268.

119 See Nadar's memories of this sitting in *l'Hôtellerie des Coquecigrues* (Paris, 1880), pp. 286–287.

120 Accounts in the standard sources vary somewhat as to his role.

121 For her opinion see *l'Hôtellerie des Coquecigrues*, op. cit., p. 286.

122 *Grande Dictionnaire universal*, op. cit., vol. V, p. 487.

123 The distinctions among the types of surviving Nadar prints has been usefully laid out by Keller, Hambourg, op. cit., pp. 77–94.

124 There may have been, of course, variant, closer-in images of her.

125 As noted in Richardson, op. cit., p. 125.

126 Ibid, p. 66.

127 The other photograph is in the collection of the Bibliothèque Nationale, Paris.

128 F. W .J. Hemmings, *The Theatre Industry in Nineteenth-Century France* (Cambridge, 1993), p. 3.

129 Mark Hawkins-Dady, *International Dictionary of Theatre-2, Playwrights* (Detroit, circa 1994), pp. 858–861.

130 Reported in the Goncourt journal, op. cit., vol. 2, p. 252.

131 For a generous sample of these depictions see exh. cat., *Sarah Bernhardt and Her Times* (New York, 1984).

132 Néagu observed that Bernhardt liked posing for the camera more than any other actor or actress of the nine-teenth century. Pierre Spivakoff, *Sarah Bernhardt vue par les Nadar* (Paris, 1982), n.p.

133 Levi, op. cit., p. 39.

134 Cf. Hawkins-Dady, op. cit., p. 50.

135 Nadar's photographic por-trait of Augier was presumably made in 1857 as a reproduction of it was published in the August, 1857 issue of *L'Artiste*. McCauley, op.cit., p. 123.

136 The variant is reproduced by Philippe Néagu in "Nadar and the Artistic Life of His Time" in Hambourg, op. cit., p. 92. Augier would again sit for Nadar in the early 1860s and in 1885. He sat also for Adolphe Braun about 1878, reproduced in Les Fourchambault: analyse de la pièce . . . (Paris, 1878), at p. 28.

137 Goncourt, op. cit., vol. 1, p. 170.

138 The *Grande Dictionnaire Universel* entry for her relies on Gautier's account of the disas-ter. Rossini also sat to Nadar at about this time.

139 Ibid, describes her as a contralto. Spire Pitou, *The Paris Opéra: an Encyclopedia* (Westport, circa 1983), p. 1266, says she was a mezzo-soprano as does *The New Grove Dictionary of Opera* (New York, 1992), vol. 4, p. 548.

140 Françoise Heilbrun compared Stoltz to Callas in conversation.

141 Quoted in Hambourg et al., *Nadar: Les Années créatrices*; (Paris, 1994), p. 14.

142 De Prémaray announced the creation of Nadar's *Panthéon* in *La Patrie* in December, 1853. Ibid, p. 316.

143 G. P. Labiche, *Eugène Labiche* (Paris, 1938), p. 15.

144 Philippe Soupault, *Eugène Labiche* (Paris, 1964), p. 20.

145 For analysis of the content of some of his plays and lists of his works, see Levi; op. cit., pp. 341–344, and Hawkins-Dady, op. cit., pp. 580–585.

146 Nadar; *Quand j'étais Photographe* (Paris, 1900), p. 131.

147 Cf. his entry in Henry Lyonnet, *Dictionnaire des Comédiens Français* (Geneva, n.d, but circa 1910), vol. 1, pp. 155–158.

148 Heilbrun identified the clothes as those of a miller. Hambourg, op. cit., p. 47.

149 Ibid, p. 241.

150 Collodion-on-glass negatives did not have full spectral sensitivity and colors were apt to register as darker than they were. His hair was flaming red and it here appears to be dark.

WARHOL

1 *The Andy Warhol Diaries*, Pat Hackett, ed. (New York: Warner Books, Inc., 1989), p. 315.

2 *Andy Warhol*, Andy Warhol, Kasper König, Pontus Hultén, and Olle Granath, eds., exh. cat. (Stockholm: Moderna Museet, 1968), n.p.

3 Selected sources for his biog-raphy and the chronology of his career would include, in order of publication: Patrick S. Smith's *Andy Warhol's Art and Films* (1981), Victor Bockris's *The Life and Death of Andy Warhol* (1989), *Warhol* (1989) by David Bourdon, and Bob Colacello's *Holy Terror: Andy Warhol Close Up* (1990). Extensive chronologies of his life and work appear in these two exhibition catalogues: the 1989 *Andy Warhol Retrospective*, Kynaston McShine, ed. (Museum of Modern Art, New York) and the 1996 *Andy Warhol, 1956–86. Mirror of His Time* (Museum of Contempo-rary Art, Tokyo), which also includes a bio/critical essay by Mark Francis, "From Gold Leaf to Silver Screens, White Light to Black Shadows: Andy Warhol and His Time." Three valuable compilations of critical writing on Warhol are: *The Work of Andy Warhol*, Gary Garrels, ed. (Seattle: Bay Press, 1989); *Pop Out: Queer Warhol*, Jennifer Doyle, Jonathan Flatley, and José Esteban Muñoz, eds. (Durham: Duke University Press, 1996); and *The Critical Response to Andy Warhol*, Alan R. Pratt, ed. (Westport, Connecticut: Greenwood Press, 1997).

4 This information comes from Matt Wrbican, Assistant Archivist, The Archives of the Andy Warhol Museum. I would like to thank Mr. Wrbican for his generous and timely attention to my many questions regard-ing Warhol and photography.

5 *The Andy Warhol Diaries*, p. 601.

6 The more than six hundred "time capsule" boxes and file cabinets now housed at The Archives of the Andy Warhol Museum have yielded many photographs, those Warhol col-lected as well as those he made. The "time capsules" are boxes Warhol filled as he reviewed the announcements, invitations, newspapers, and magazines that he accumulated each week. He kept much of this paper material and added to it photobooth and Polaroid studies that may have been part of the week's production. The Archives staff is in the process of cataloguing the con-tents of every so-called time capsule, and as they do more of Warhol's world, including his photography, is revealed.

7 Andy Warhol, "Say hello to the Dirty Half Dozen, Sierra Bandit, The American Play-ground and all the Superstars of the New Theatre," *Esquire* (May 1969), pp. 144–147.

8 Carter Ratcliff, *Andy Warhol* (New York: Abbeville Press, 1983), p. 114.

9 Andy Warhol, with text by Andy Warhol and Bob Colacello, *Andy Warhol's Exposures* (New York: Andy Warhol Books/Grosset and Dunlap, 1979), p. 19.

10 Ibid.

11 Ibid.

12 *The Andy Warhol Diaries*, p. 459.

13 Andy Warhol and Pat Hackett, with additional photographs by Paige Powell, Sam Bolton, Wilfredo Rosado, Jeffrey Slonim, Edit de Ak, and C. J. Zumwalt, *Andy Warhol's Party Book* (New York: Crown Publishers, Inc., 1988).

14 Ibid., p. 103.

15 Ibid., pp. 6, 151.

16 I would like to thank Timothy Hunt, Curator, The Andy Warhol Foundation for the Visual Arts, for telling me about this first exhibition of Warhol's photographs and for furnishing me with a copy of the Gotham Book Mart and Gallery checklist. Both Mr. Hunt and his colleague, Curator Sally King Nero, were vigilant in responding to my requests for information and reproductions.

17 Stephen Koch, *Andy Warhol Photographs* (New York: Robert Miller), 1986.

WARHOL CATALOGUE

18 Cecil Beaton, *Ballet* (Garden City, New York: Doubleday and Company, Inc., 1951), p. 74.

231

19 Cecil Beaton, *Cecil Beaton's Scrapbook* (New York: Charles Scribner's Sons, 1937), pp. 39–43.

20 "On the Fringe of a Golden Era," *Time* (January 29, 1965), p. 56.

21 "Kidsch Stuff," from *Time's* in-house newsletter, 1964, 6. A copy of this one-page article was generously provided by Frederick Voss, Historian/Curator, Smithsonian Institution, National Portrait Gallery.

22 Conversation with the author, New York, December 19, 1997. My thanks to Gerard Malanga for graciously sharing information about his work with Warhol and the production of the Screen Test films and painted portraits, as well as the photobooth pictures and black-and-white Polaroids of the early 1960s.

23 Andy Warhol, "New Faces, New Forces, New Names in the Arts," *Harper's Bazaar,* 96:3019 (June 1963), pp. 64–67.

24 David Bourdon, "Andy Warhol and the Society Icon," *Art in America,* 63:1 (January–February, 1975), p. 42.

25 Tom Wolfe, *The Pump House Gang* (New York: Farrar, Straus and Giroux, 1968), p. 181.

26 Jean Stein, ed., with George Plimpton, *Edie: An American Biography* (New York: Alfred A. Knopf, 1982), p. 447.

27 Gerard Malanga, *Chic Death* (Cambridge, Massachusetts: Pym-Randall, 1971), p. 8.

28 *The Andy Warhol Diaries,* p. 665.

29 Tom Wolfe, *The Kandy-Kolored Tangerine-Flake Streamline Baby* (New York: Pocket Books, 1965), pp. 176–77.

30 Andy Warhol, *The Philosophy of Andy Warhol (From A to B and Back Again)*

(New York: Harcourt Brace Jovanovich, 1975), p. 5.

31 "Kevin Sessums Talks to Brigid Berlin," *Interview,* XIX:2 (February 1989), p. 56.

32 Gerard Malanga discussed Lita Hornick's patronage and her photobooth session with the author, December 19, 1997.

33 Lita Hornick, *Night Flight* (New York: The Kulchur Foundation, 1982), p. 183.

34 Ibid., p. 184.

35 Ibid.

36 Ibid.

37 Ibid., p. 175.

38 "Brigid Berlin Talks to Factory Co-Worker Paul Morrissey," *Interview,* XIX:2 (February 1989), p. 60

39 *The Beats: Literary Bohemians in Postwar America, Part 2:* M–Z, Ann Charters, ed. (Detroit: A Bruccoli Clark Book, 1983), p. 403.

40 Bob Colacello, *Holy Terror: Andy Warhol Close Up* (New York: HarperCollins, 1990), p. 42.

41 Andy Warhol with Bob Colacello, *Andy Warhol's Exposures* (New York: Andy Warhol Books/Grosset and Dunlap, 1979), pp. 143–44.

42 Andy Warhol and Pat Hackett, *Popism: The Warhol '60s* (New York: Harper and Row, 1980), p. 193.

43 John Wilcock and a cast of thousands, *The Autobiography and Sex Life of Andy Warhol* (New York: Other Scenes, Inc., 1971), n.p.

44 *The Andy Warhol Diaries,* p. 397.

45 David Bourdon, *Warhol* (New York: Harry Abrams, Inc., 1989) p. 214. There is also an account of this in Jean Stein, *Edie, An American Biography,*

George Plimpton, ed. (New York: Alfred A. Knopf, 1982), p. 245.

46 David Bourdon, "Andy Warhol and the Society Icon," p. 42.

47 See essay by Charles Stuckey in *Andy Warhol: Heaven and Hell are Just One Breath Away! Late Paintings and Related Works, 1984–1986* (New York: Rizzoli, 1992), p. 11.

48 *The Andy Warhol Diaries,* p. 462.

49 Anthony Haden-Guest, *True Colors: The Real Life of the Art World* (New York: The Atlantic Monthly Press, 1996), p. 129.

50 Keith Haring, *Journals* (New York: Viking, 1996), p. 105.

51 *The Andy Warhol Diaries,* p. 588.

52 Andy Warhol, *America* (New York: Harper and Row, 1985), p. 33.

53 Andy Warhol and André Leon Talley, "Fighting Her Own Battles: Grace Jones," *Interview,* XIV:10 (October 1984), pp. 54–61.

54 *The Andy Warhol Diaries,* p. 587.

55 Ibid., p. 83.

56 Ibid., p. 14.

57 Quote from Charles Gaines, *Pumping Iron: The Art and Sport of Bodybuilding* (New York: Simon and Schuster, 1974) in *Contemporary Authors* (Detroit: Gale Research Co., 1987), vol. 21, p. 401.

58 Andy Warhol and Pat Hackett, *Popism: The Warhol '60s,* p. 59.

59 *The Andy Warhol Diaries,* p. 358.

60 Andy Warhol, *The Philosophy of Andy Warhol*

(From A to B and Back Again), p. 54.

61 *The Andy Warhol Diaries,* p. 227.

62 Edit deAk, "Art and Commerce: Stephen Sprouse," *Interview* (September 1987), p. 123.

63 *The Andy Warhol Diaries,* p. 616.

64 Ibid., p. 635.

65 Ibid., p. 647.

66 Bob Colacello, *Holy Terror: Andy Warhol Close Up* (New York: HarperCollins, 1990), p. 477.

67 Andy Warhol and Pat Hackett, *Popism: The Warhol '60s,* p. 101.

68 *The Andy Warhol Diaries,* p. 95.

69 Wayne Koestenbaum, *Jackie Under My Skin: Interpreting an Icon* (New York: Plume, 1996), p. 143.

70 Ibid.

71 Ibid., p. 61.

72 Jonathan Lieberson, "Diana Vreeland, Empress of Fashion," *Interview,* X:2 (December 1980), p. 25.

73 *The Andy Warhol Diaries,* p. 111.

74 Andy Warhol, with Bob Colacello, *Andy Warhol's Exposures,* p. 64.

75 *The Andy Warhol Diaries,* p. 535.

76 Ibid., p. 451.

77 Bianca Jagger and Andy Warhol, "An American Dream: Calvin Klein," *Interview,* XII:12 (December 1982), pp. 39–40.

78 *The Andy Warhol Diaries,* p. 441.

79 Ibid., p. 755.

80 Ibid., p. 272.

81 Wayne Douglas, " 'Divine Trash' Full of Worthy Nuggets," *Variety* (via the Internet), April 15, 1998.

82 Andy Warhol, *The Philosophy of Andy Warhol (From A to B and Back Again),* p. 54.

83 Ibid.

84 Cynthia Burgess, review of *Patchwork Child* by Brooke Astor (via the Internet), January 13, 1998.

85 Manfred Heiting discussed Polaroid's arrangement with Warhol in a conversation with the author, July 31, 1998. He emphasized the artist's preference for the Polaroid Big Shot camera. Warhol found it useful for studio portraits because it was designed for flash color pictures composed only of one or two sitters. He had to focus the camera by moving it back and forth until two images of the sitter coincided in one distance rangefinder/viewfinder. The camera was evidently not as popular with other portraitists. It was available in stores only briefly, from 1971 to 1973. However, Warhol enlisted Heiting's help in maintaining a supply of them and accumulated dozens, sometimes through trade.

86 *The Andy Warhol Diaries,* p. 727.

87 Ibid.

88 Ibid., p. 440.

89 Maura Moynihan and Andy Warhol, "Cause Celebrity: Jane Fonda," *Interview* (March 1984), p. 35.

90 *The Andy Warhol Diaries,* p. 304.

91 Andy Warhol, *America,* p. 152.

92 Cecil Beaton, *The Face of the World* (New York: The John Day Company, 1957), p. 189.

232

Index

234

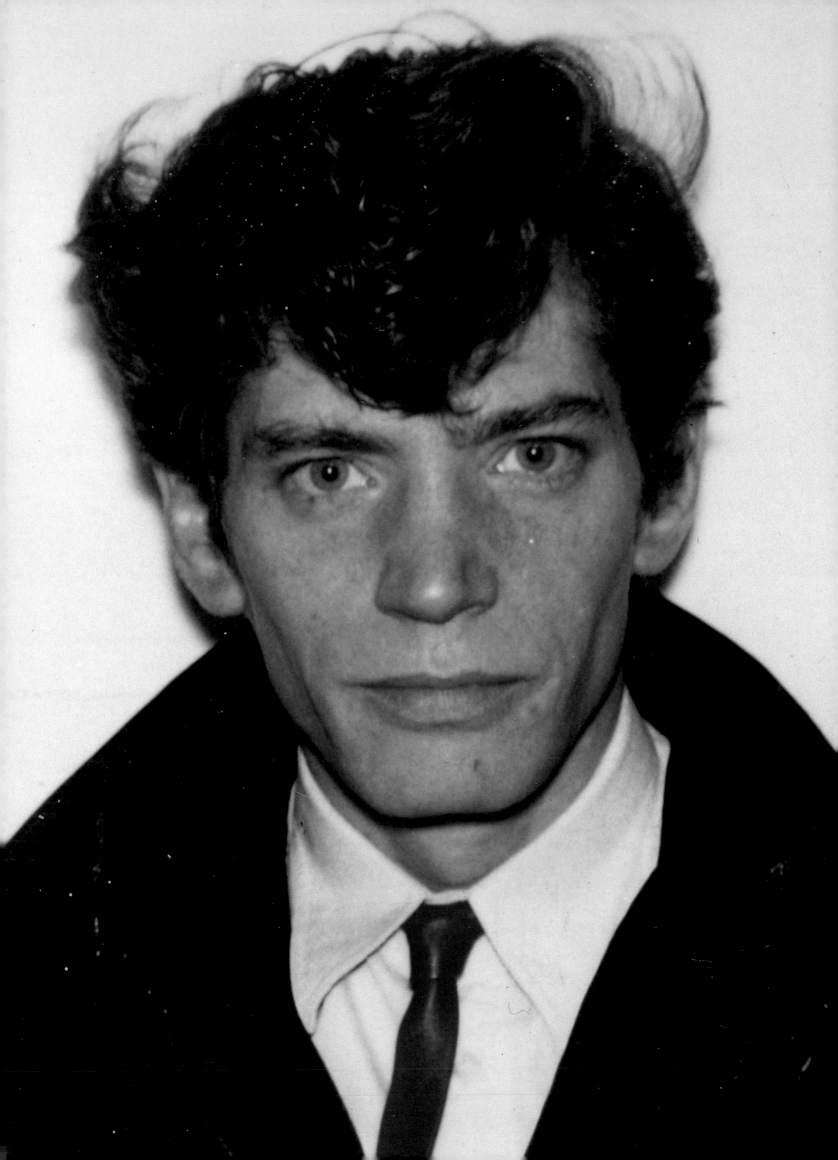

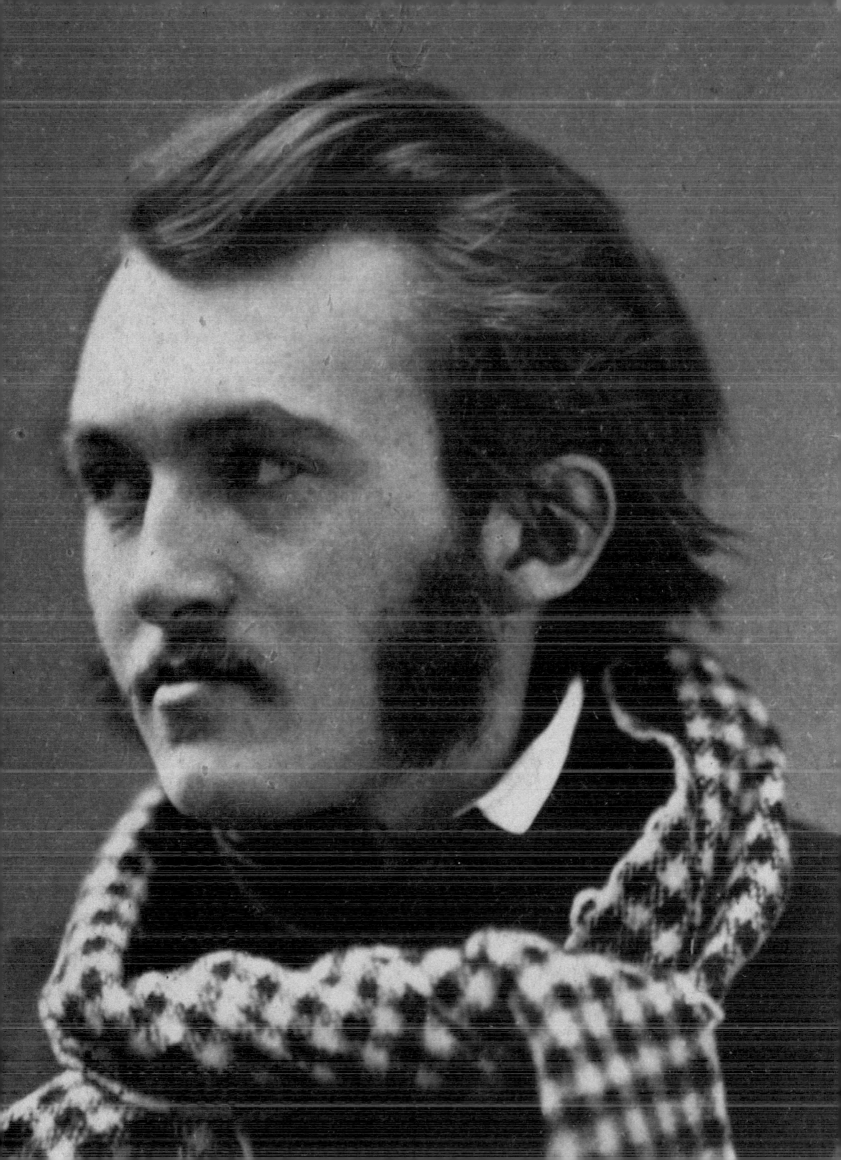

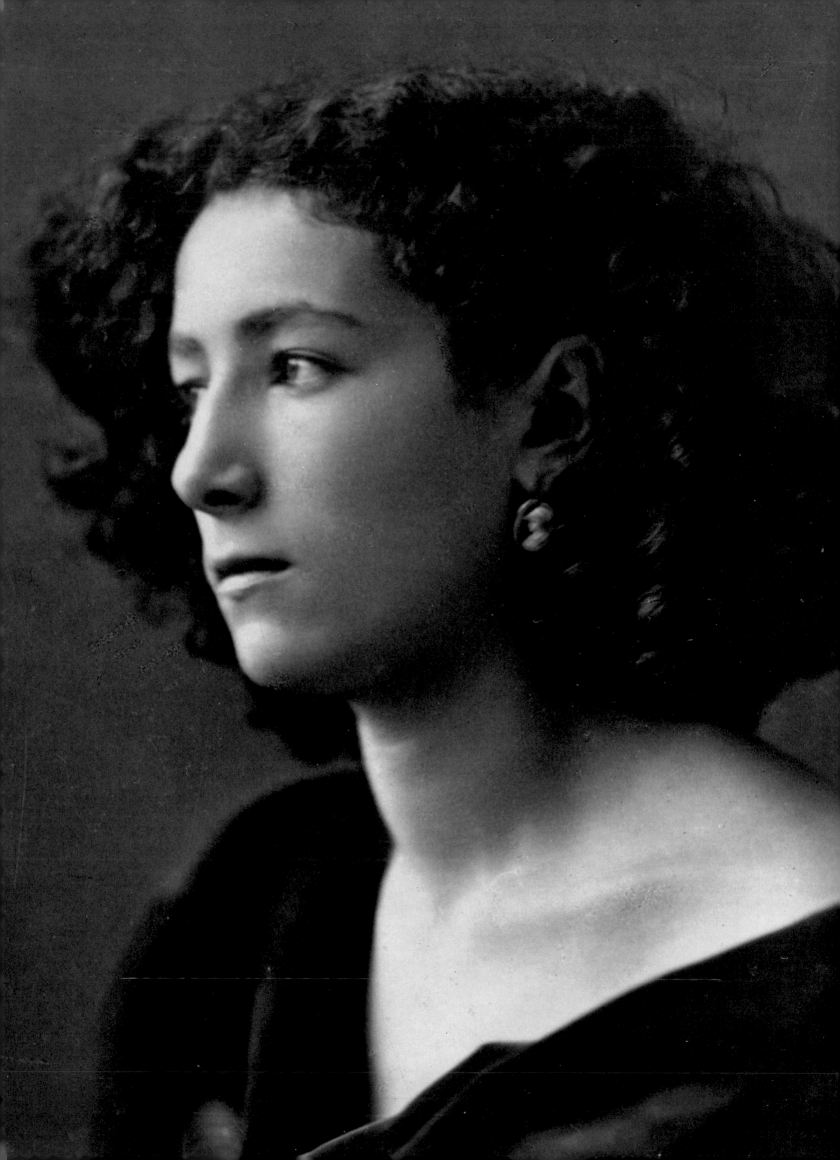

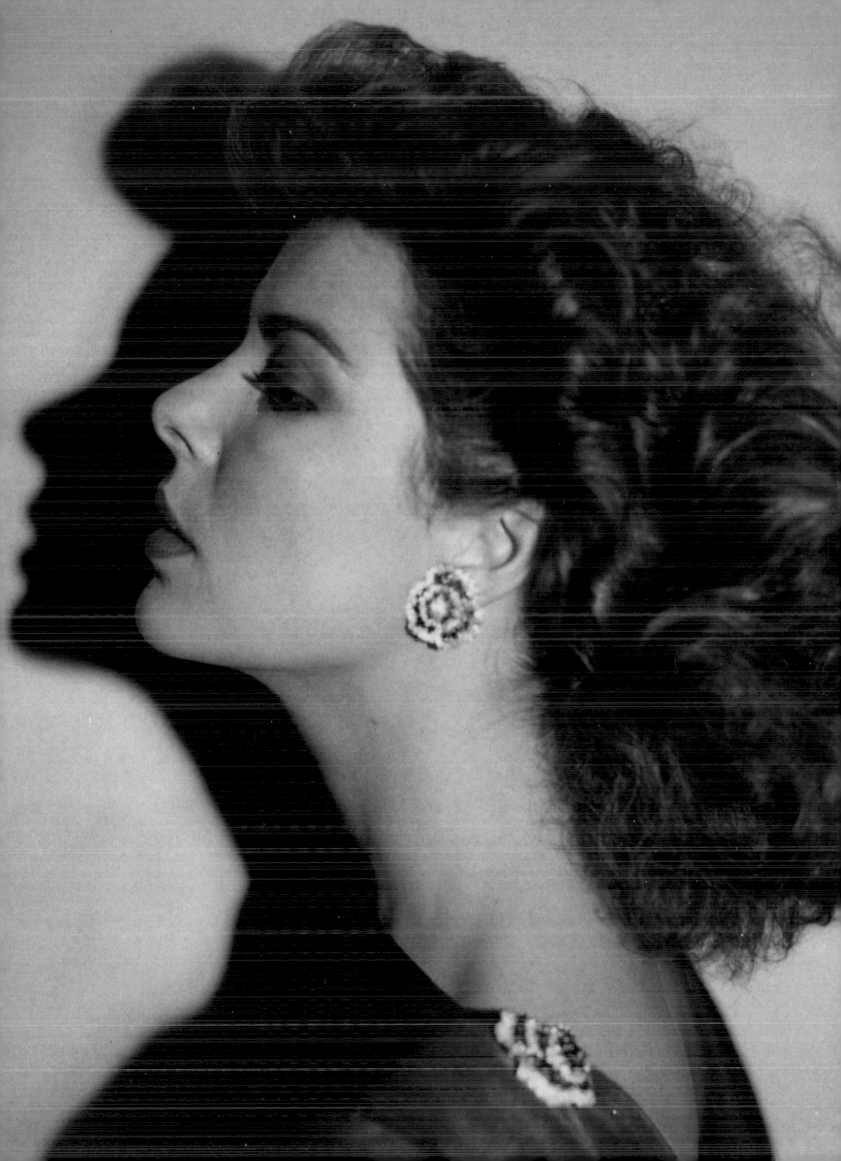

Colophon

Christopher Hudson *Publisher*

Mark Greenberg *Managing Editor*

Mollie Holtman *Editor*

Pamela Patrusky Mass *Designer*

Stacy Miyagawa *Production Coordinator*

Theresa Velázquez *Production Assistant*

Ellen Rosenbery *Photographer*

Printed by Gardner Lithograph

PAGE 236
Warhol, *Robert Mapplethorpe*,
1983 [enlarged detail; see
p. 176].

PAGE 237
Nadar, *Gustave Doré*, 1856–58
[enlarged detail; see p. 85].

PAGE 238
Nadar, *Sarah Bernhardt*, 1864
[enlarged detail; see p. 117].

PAGE 239
Warhol, *Princess Caroline
of Monaco*, 1983 [enlarged
detail; see p. 207].